101

TOP TIPS FOR

FANTASY
PAINTERS

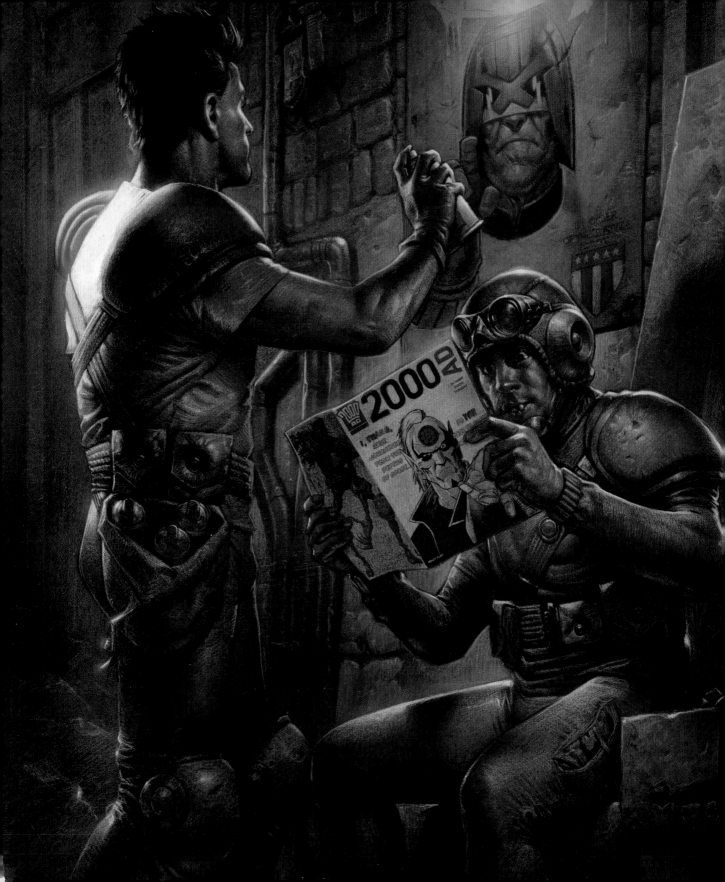

101

TOP TIPS FOR

FANTASY
PAINTERS

KEVIN CROSSLEY

BARRON'S

For Fiona and Aidan

First edition for the United States, its territories
and dependencies, and Canada published in 2012
by Barron's Educational Series, Inc.

All inquiries should be addressed to:
Barron's Educational Series, Inc.
250 Wireless Boulevard
Hauppauge, New York 11788
www.barronseduc.com

ISBN: 978-1-4380-0104-3

Library of Congress Control Number: 2011936432

This book was conceived,
designed, and produced by:

ILEX
210 High Street
Lewes, East Sussex
UK, BN7 2NS

Publisher: Alastair Campbell
Creative Director: James Holywell
Managing Editor: Nick Jones
Senior Editor: Ellie Wilson
Art Director: Julie Weir
Designers: Chris & Jane Lanaway

Colour Origination: Ivy Press Reprographics

Printed in China

9 8 7 6 5 4 3 2 1

CONTENTS

Preface

The creation of art can be seen as an act of alchemy, conjuring meaning from that most barren of beginnings, the blank canvas. Fantasy art in particular is a foreboding subject, as it takes reality as a starting point and expands it into any number of wild possibilities that rely acutely on the imagination of the artist. To succeed requires hard work, focus, and diligence in controlling how far a flight of fancy can fly. As a result there is a lot of passion and excitement involved, as well as torment and, quite often, feverish frustration, too. It's an intense process that can seem mysterious and magical to those who look upon the finished creations. As a young fan trying to develop my own artistic skills, I spent a lot of time trying to understand how my heroes produced their amazing artwork. It was a constant source of wonder to me, but it was frustrating, too, when their secrets constantly eluded me. In spite of this, I remained completely spellbound by each new piece of art I discovered. The mystery was part of what made it so special, so . . . fantastic!

The book you're holding in your hands is the sort of book I dreamed of finding when I was a child. This informed my decision about what sort of a tone I wanted to strike within the text. Although there will be plenty within these pages for the advanced artist to get to grips with (and I have certainly learned a few new tricks in my meetings and discussions with the other artists featured herein), I felt it was important to explain the tips in such a way that the novice or young professional would not be intimidated by any of the terminology or techniques that were discussed. Therefore, I have endeavored to ensure the book is written in a fluid and engaging style, and for every complex tip there are several easier ones just a page or two away!

During the planning, I felt the book should be arranged to reflect the creative process. There is a journey involved during the birth and maturation of a piece of art. The artist must employ all the skills, tricks, and techniques they have and, perhaps, learn a few new ones along the way. It all adds to the end product, and I wanted this book to capture that journey as much as possible.

With the numerous artists involved, each bringing their own skills and styles, it was tempting to simply show a series of pieces of art, one after another, to illustrate tip after tip. While there isn't anything especially wrong with a collection laid out in this way, it seemed that, for the purposes of this book, such an approach has the potential of becoming a little bit tedious or even lifeless. It wouldn't have any flow to it, or any real direction other than being a simple collection of images and ideas.

Therefore, I felt it was far better to arrange the book in a linear manner, mirroring the process of creating a piece of art from start to finish. So, the opening chapters deal with preparation and sketches. We then move on to detailed drawing and painting, and end with finishing techniques. This felt like the most logical solution, and it offers a connective narrative thread throughout the book. The result, hopefully, is an intuitive reference guide, with stages of the creation process located in relevant areas.

However, just as art is an organic thing, there must be some plasticity within the book structure to mirror that. Therefore, natural areas of overlap occur, with finished art appearing in early chapters, and sketches in later ones. There will also be instances in which complete artworks are illustrated from start to finish and explained within chapters throughout the book, just to mix things up a little, but the overall structure retains a logical progression. I confess that this is more a reflection of my own working methods; while some artists might focus on completing one painting at a time before starting the next job, I frequently jump to and fro between projects and illustrations, sometimes leaving months between visits to a particular painting. However, I find my way of working immensely satisfying and I hope some of that passion has found its way onto these pages.

As for the tips themselves, there were a few options about how to structure them. One idea was to simply list 101 tips, loosely grouped into themed sections. It was a straightforward solution, but also had the potential to become a little wearying after a few chapters. It made much more sense to present the tips as flowing chapters that were integral to the rest of the text. This means that the book can be read through, as if the tip markers weren't there at all, because the transition between one to the next is fluid. Also, for the most part, tips from the various artists in the book are presented as if described by the same voice. This was done to retain a cohesive character throughout the text, but it can be assumed that when art by a particular artist is used, much of the advice and ideas presented are theirs.

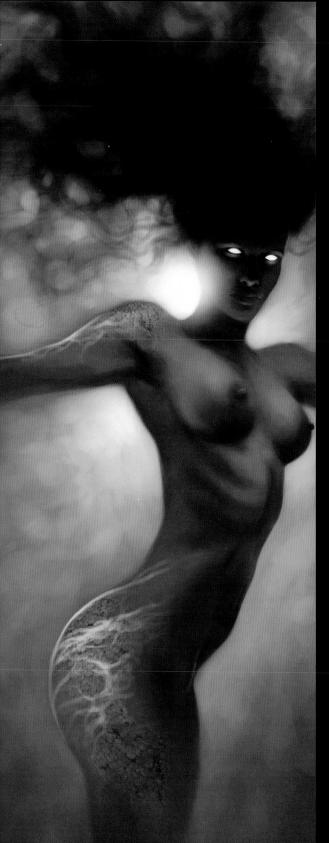

Another important decision made at the outset was that the book should focus on digital and traditional painting techniques in equal measure. The former will naturally appeal to the ever-growing digital generation, some of whom have perhaps grown up without the knowledge of any other way of working. However, with an interest in "real" painting enjoying something of a renaissance, those curious about acrylics, inks, and watercolors will find plenty here to learn from. Because there are fundamental principles that apply to painting in any medium, it will often be the case that lessons learned while painting digitally can be applied to traditional practices, and vice versa, so focusing on one preference should not necessarily be seen as more advantageous than the other.

Although painting techniques will be the focus, the important supporting skills of drawing and sketching will be covered in great detail, along with the other preliminary aspects of the creation process. Therefore, I have tried to include pencil- or digital-sketch versions of the finished paintings featured in the book whenever possible. Such inclusions will always offer valuable insight into the early stages of a piece of art, plus quality pencil art has a certain alluring charisma all of its own.

A finished painting reveals little of the processes involved during its completion, so the chapters on drawing and composition are deliberately expansive explorations of the foundations responsible for the resulting fantastic art we love so much. It is important to keep in mind the fact that, had the artists not spent long years studying these subjects, there would be no paintings to inspire such a book in the first place. It might, indeed, be a long journey to becoming a professional fantasy painter, but the book you're holding is a good place to start!

decades, been a regular sight on the covers of records and CDs, book jackets, posters, and clothing. Over recent years, fantasy art has enjoyed full, visceral life in compelling and immersive video games, comics, films, and animations. It has transcended its pulpy, niche beginnings to become a subject dear to the hearts of many different audiences.

Anyone aspiring to become a painter of the fantastic is walking in the wake of giants . . . not only artists such as those featured in this book, but the artists that they, in turn, were inspired by, and then the artists that inspired those artists. Fantasy art is a relatively recent term, coined to describe content that has, in fact, been around for thousands of years. When the first storytellers immortalized the first proto-myths, fantasy art was born. Ever since, successive generations within human communities have been inspired by, terrified by, worshipful of almost endlessly inventive tales of gods and monsters, of nature and the heavens. In essence, as the human mind became self aware, it gained the ability to wonder about its own nature and place within the world. It was perhaps only natural that such an abstract concept should inspire equally abstract methods of explanation, for what is fantasy art, after all, but an abstraction of reality? And so, in time, those age old fables and creation myths would find immorality in the great epics such as those told by the ancient Greeks, Romans, and Egyptians, to name the most obvious of those ancient civilizations.

The Odyssey by Homer is one of the first great works of Western literature, dating back almost 3000 years. Following on from the Iliad, which recounts the events of the Trojan War, the great hero Odysseus (Ulysses to the Romans) meets such creatures as the fabled cyclops, cannibalistic giants called the laestrygonians, sirens, and a very cool creature called Scylla. The Scylla was a sea monster with six long necks ending in grisly heads, each of which contained three rows of sharp teeth and four eyes. Her body consisted of 12 tentacle-like legs and a cat's tail, with four to six dog heads ringing her waist. It sounds like something from John Carpenter's The Thing. Simply fabulous!

incredible and terrifying beasts and monsters have been passed down to us from the forgotten past, along with great warriors, demons, angels, and demi-gods.

And so as the history of humankind has advanced, it has carried with it those ancient stories that, in turn, inspired new stories and fantasies. Even William Shakespeare was not averse to introducing fantasy into some of his works—the witches in Macbeth and the faerie host in A Midsummer Night's Dream spring readily to mind.

However, stories are but a part of the whole, for what started with words would inevitably be given flesh by the hand of the artist, and so fantasy art has traveled alongside the tales that inspired it, culminating in humble works like, well, 101 Top Tips!

We now live in an era in which the fantastic is commonplace, and with so many new fantasy acolytes arming themselves with pencils, brushes, and Wacom Cintiq tablets, the demand for instruction is high, which is where this book comes into its own!

As a four-year-old growing up in a grimy part of 1970s northern England, I soon learned that it was far more fun to explore the landscapes of my burgeoning imagination than to contemplate the dreary offerings presented by real life. Creating incredible worlds populated by interesting new configurations of living creatures (usually made flesh with the help of plasticine or crayons on the bedroom wall), I was able to escape the long, gray days and enter into brighter, far more colorful places, where dreams brushed against waking reality, and past and future mingled with the present.

Among those stories were epic adventures involving armies of dinosaurs doing battle with hordes of Daleks. Martian tripods stomping across crayon landscapes zapping matchstick people with fizzing heat rays were commonly witnessed on the surfaces of my bedroom. Occasionally the Hulk would save the day by pulling the legs off the Martian war machines, rendering them inert . . . but not before vast swathes of my bedroom walls had

been laid to waste. It was pretty basic stuff, but I was fascinated as much by the act of drawing these stories, worlds, and characters as by the adventures themselves.

Ambition far outstripped ability, however, and I remember being frustrated when I couldn't draw a dragon quite as fierce as I saw it in my mind, or when one of my Daleks came out with a lop-sided head. It's hard being a seven-year-old struggling artist, but I was lucky. My dad could draw. The lessons I learned by studying his biro doodles in the margins of his newspaper, or from watching over his shoulder as he carefully formed a face from a framework of ovals, lines, and squares soon enlivened my own infantile drawings. It was the groundwork for what was to become my first great love in life, my first great journey. Over the following 30 years I would discover many fantastic artists, taking lessons from each one in an attempt to feed my appetite to create better art, and to do it more convincingly.

This book is the culmination of nearly 40 years of study and practice, but more than that, it is a natural progression of all that I've learned, something only made possible thanks to help from all those great artists who have inspired me over the years. So, the function of *101 Top Tips* is dual: to offer inspiration and support to anyone interested in becoming a fantasy artist themselves, and as a humble homage to those who came before.

Above: A meeting of fantasy themes and legends with Zombie Viking Elvis, the unofficial Mascot for Mam Tor Publishing.

The Basics

When I was a kid, awe-struck by the amazing paintings I saw in comics and books, it never occurred to me to wonder how an artist had become capable of achieving such wondrous things with pencils, inks, and paint. It seemed like magic to me, a mind-boggling alchemy that embodied a vital imaginative spirit and vivid alternate normality. Knowing that I could escape into wild, evocative worlds etched with pencils, pen, and brush made life in the dreary everyday seem more endurable, somehow.

As I lost myself more and more in this wondrous art I began to discover a new facet of myself. These worlds made sense to me, the effort to create them seemed like a worthwhile venture, and as I realised I wanted to create my own windows into other places, I began to look at the work of those amazing artists through different eyes, wondering what I had to do to follow in their footsteps. And so the seed of my life's ambition was sown.

Right: This pencil drawing of a demonic tree is one of the first professional illustrations I produced.

THE BASICS:
PREPARATION

Preparation

To prepare for a day's work, there are obvious considerations to take into account. Are the kids at school? Check. Did you buy a new tube of cadmium blue paint? Check. Have you had your usual pint of coffee to start the day? Better make that two pints, eh? It might sound obvious, but if you're thinking about becoming an artist, there are fundamental things to take into account right at the start.

TIP 001

Have a Dedicated Workspace

Whether you work in an office, a studio, your bedroom, at the kitchen table, or on the sofa, it's important to treat that space as separate from the environment around it while you are working. It is the space in which your art is created, and it should both inspire you and help focus your mind on the act of drawing, painting, or whatever activity your work requires.

The best environment by far is your own dedicated studio. Many artists I know have converted their attics or basements into a studio, but some have built sheds at the bottom of their gardens, thus creating a more convincing separation between home and the work space. Some artists rent studio space, and if several artists do this together it can establish a wonderfully fecund and productive environment in which to work—as long as you don't steal one another's cookies.

With your own studio you have somewhere you can fill with books, comics, magazines, models (toys!), and all the materials and tools you need. Function defines the form of the studio, and in time it becomes molded into a shape that best suits the way you work and, importantly, the way you move through the space. Just as any cook will have their kitchen configured in such a way that it facilitates the most economic movement between sink, work surface, refrigerator, and stove, an artist's studio should be similarly organized. Entering your studio should be like climbing into a machine with the controls for everything you need at your fingertips, that is perfectly in tune to your requirements. It becomes the crucible for everything you aspire to create.

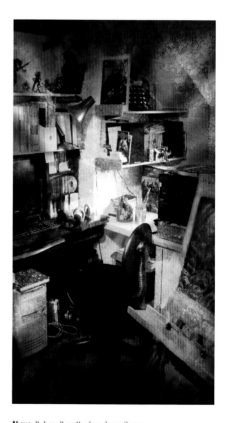

Above: It doesn't matter how decrepit your studio is, it's what you do in it that counts.

TIP 002

Avoid Distractions

While most professional artists spend a lot of time working at home (and this is what many see as a bonus of being a freelance illustrator), there is danger there. And not just the fire truck your son left on the stairs. Perhaps the main culprit when it comes to a day's work being derailed, and focus being lost, is distraction. Home is filled with distractions. As I type this, I know there are video games, DVDs, books, magazines, and comics around the house that I could easily spend a little while immersed in, and I'm only ever a click away from that most insidious eater of hours—the Internet!

To the unwary, working from home can be a minefield, so, to make another obvious point, I can't stress enough the importance of avoiding distractions during your daily work regime. Set yourself a goal for the day, a target to reach. There is no reason to totally deny yourself all the fun stuff that helps you unwind, but I find treating it as a "reward" for a few hours' hard graft is a good way to strike a balance and improve your all-important discipline. In fact, why are you reading this? Haven't you got work to do?

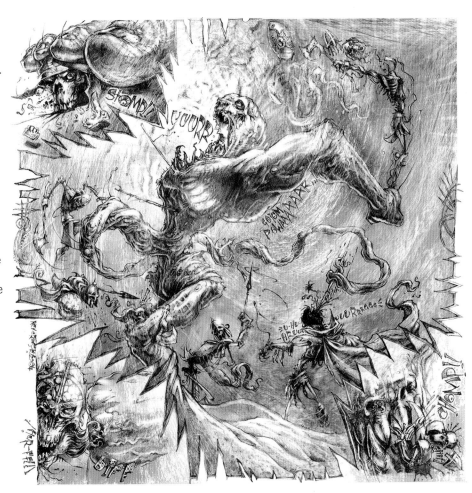

Above: Here we see what happens if a client has to wait too long for their artwork to be delivered. Think of the poor publisher's staff before you choose procrastination over work . . .

THE BASICS:
TOOLS, EQUIPMENT, AND MATERIALS

Tools, Equipment, and Materials

TIP 003

Rack Up

An artist needs equipment and, if you're like me, you'll need lots of it. As you can see from the photograph below, I have quite a collection of paints, inks, pens, pencils, and various art tools—just about everything I could possibly need for any given job. However, what you see here is the result of 25 years of collecting. I didn't simply go out one day and buy a tabletop full of stuff!

When I was 15 my parents bought me my first set of watercolors and colored drawing inks. I had no idea what I was doing, but within a few months I'd figured out how

to use them well enough to produce passable pictures that were hugely inspired by the discovery of some amazing artists (about whom you'll read more in the next chapter).

I've included one of the first paintings I ever produced with my first set of paints. It was based on the tutorial sheet that came with the watercolor box, which guided you step by step through the process of painting a farm house on a hill. Even then I couldn't resist adding a huge spaceship in the sky. It was a step in the right direction, I remember thinking.

At about the same time my parents ordered a stack of books from a mail-order book club. When they arrived I was drawn to a large, squared volume wrapped in a dust jacket emblazoned with a striking painting. It depicted exotic trees with gnarly roots growing from the walls of a strange canyon, while, in the background, a golden bridge crossed above shining waterfalls. Even the text had a stylized flourish I hadn't seen the like of before. I immediately immersed myself in this amazing book, whose contents were even more fabulous than the cover. The title of the book, by Rodney Matthews, was *In Search Of Forever*.

Right: This picture shows a small selection of the sorts of materials an artist might aquire over time.

Opposite Left: This is my first official fantasy-themed painting, which was made when I was 15 years old.

Opposite Right: This copy of Rodney Matthews' Bloated Hobgoblin is a good example of learning through mimicry.

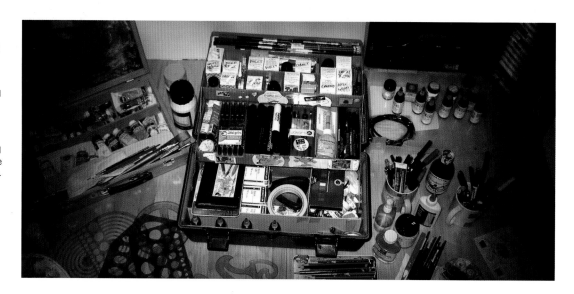

The fantasy visions in that book just blew my head open. I remember being too stunned to actually do any drawing for a week or so, but when I picked up my pencils again I just didn't stop and, for a while, I became a Matthews clone, albeit a very poor one! I've included another of my early paintings, a copy of a picture in Rodney's book called *The Bloated Hobgoblin*. I loved the character of this goblin, sat warming his feet in front of the fire while mushrooms and tree roots grow out of the walls. My version ended up a little different to the original, but it was by trying to replicate, then adapt a picture in this way that I learned a few more lessons and tricks. (Apologies and humble thanks to Rodney Matthews!)

Then, a few years later I became an art student, and between all the sleeping in and propping up the bar in the Student Union, I expanded my collection of materials and bought a large fishing-tackle box to store it in. (It was much cheaper than a proper "art box" and is still in use 20 years later! It's the big black box in the photograph.) This process of gathering equipment will continue throughout the career of every artist and, in fact, the airbrush you can see in the photograph is brand new, but I've yet to try it out as I type this.

The greatest mistake an artist, or would-be artist can make when just starting out is to buy as many kinds of paints, equipment, and materials as possible without having experience of using any of it. There is then the danger of having so many media and tools to master all at once that no progress is made with any of them. Owning an art-store's worth of equipment does not make a person an artist. Instead, the acquisition of art materials and equipment should be an organic process—you become comfortable with one medium or tool before moving on to something new.

For the past few decades there has been an extra tool for artists to consider using, of course, and this is the computer.

Whether you have a Mac, a PC, an iPad, or any other digital device, it should always be treated as a part of your tool kit just like everything else. I have always felt that to rely too heavily on one method over another introduces weak links to the skill chain. Working digitally has great benefits, and the same is true of using traditional tools, but non-exclusive mastery of the best of both approaches is the key to honing a rounded range of abilities. These issues will be explored in later chapters.

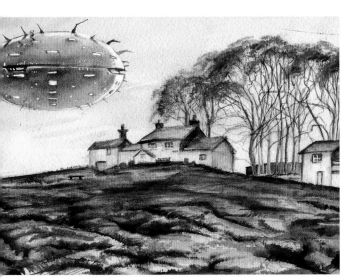

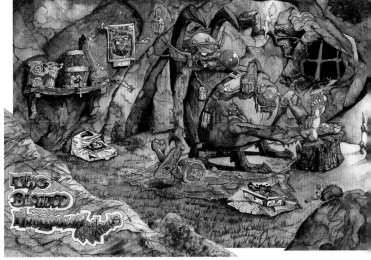

THE BASICS:
INSPIRATION

Inspiration

It's tricky to know where to start when it comes to talking about inspiration, as there are various distinct sources in which it can be found. I think I was first inspired as a young child by the stories told to me by my father. My dad had a love of mythology—invented mythologies like *The Lord of the Rings*, science fiction, and monster movies—and would tell me stories about orcs, barrow-wights, alien races, and other incredible, scary, and fascinating creatures, times, and worlds. His ability as an artist was inspirational, too, and he encouraged me to visualize the stories he told and the stories I subsequently created myself.

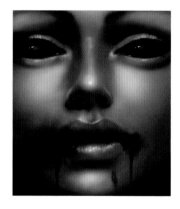

Left: The wet blood on the lips of this cherubic vampire by Manon contrasts starkly with the porcelain skin.

Below: A long-time personal favorite of mine, Inverted Landscapes by Rodney Matthews is a showcase of high-fantasy informed by the natural world.

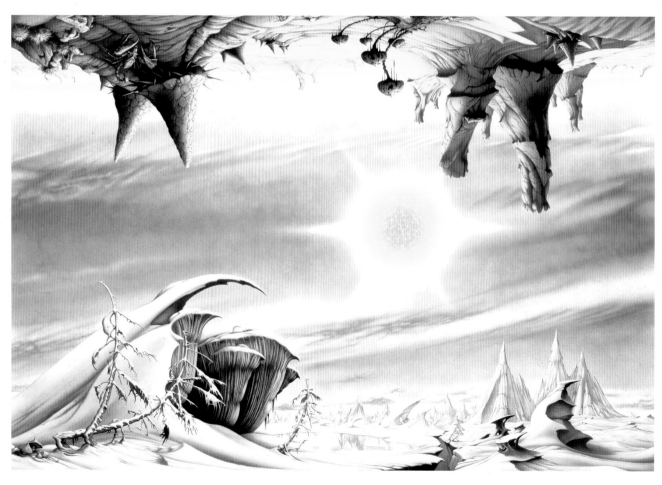

TIP 004

Read Lots and Build a Library

Because my parents read a lot, I was forever surrounded by books, comics, and magazines, and I read everything I could get my hands on. This hugely expanded the reservoir from which my creativity flowed. As the saying goes, you get out what you put in, so I put in a lot. There are thousands of years' worth of folk legends, mythologies, and stories that exist in the world, a seemingly inexhaustible supply of inspiration that fuels thousands of fantasy artists every day.

As well as reading, of course, there is also a massive collection of art out there, ready for you to discover and be inspired by. (There's a fair bit of it in this book too.)

Right: You never know what sort of inspiration will come to you when you open a book.

Below: This picture shows a very small selection of my collection of books, comics, and magazines.

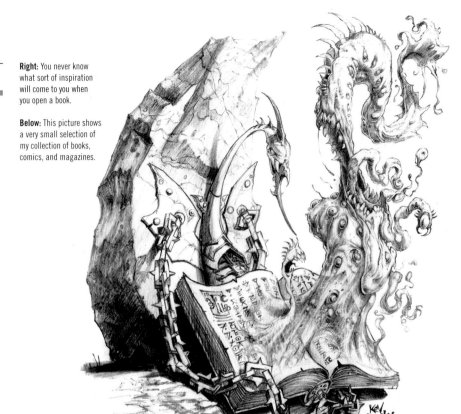

The images that have inspired me over the years include book covers, comics, posters, movie or TV stills, magazine articles, advertisements . . . the list goes on and on. Gradually, as I collected more and more comics, art books, and magazines I found I was building a library—the very best kind of library, because it was filled with all my favorite subjects. Although, today, the Internet is a great repository for art and reference images of all kinds, it's still incredibly useful to have a physical collection of material from which to draw inspiration.

The importance of instructional books, periodicals, and Internet articles should also be taken into account. Just as a doctor continually strives to keep up-to-date with new medical breakthroughs in an attempt to improve his diagnoses and treatments, so an artist must continually keep refreshing their knowledge of techniques and materials. Monthly art magazines like *Imagine FX* offer superb, regular collections of fantastic new art and advice, as do books like this one.

So collect art books, comics, and graphic novels. Fashion supplements from newspapers, hair magazines, body-building magazines, natural history books, beer coasters from the bar, just about anything can feed into your art, so learn to see the inspirational potential in everything and anything.

THE BASICS:
INSPIRATION

TIP 005

Climb onto the Shoulders of Giants

Art, of course, is a huge inspiration for myself and every other fantasy artist. Although I was interested and mesmerized by art I saw as a child, it wasn't until I began reading the British sci-fi weekly *2000 AD* in the mid-1980s that I began to put names to those artists who would quickly become lifelong heroes to me. Although I can't list every single artist who has ever inspired me here (I would need an entire book for such a task), I would like to pay homage to a few key people who taught me so much and who continue to do so to this day. Among those first artists were people like Kevin O'Neill, Brian Bolland, Mike McMahon, Bryan Talbot, Massimo Belardinelli, Glenn Fabry, and, of course, the fantastic Rodney Matthews, whose incredible paintings were the reason I started painting in the first instance. A little later I discovered Liam Sharp, Simon Bisley, Greg Staples, Kev Walker, H. R. Giger, Boris Vallejo, Syd Mead, Roger Dean, Frank Frazetta, Michael Kaluta, Chris Moore (fantastic spaceships), and Berni Wrightson. With each one exhibiting a unique style and approach, I soon had a collection of art I could draw upon to help me attack whatever creative job I set myself.

As a point of interest, my method of studying the artists who inspired me was quite simple, yet intense: I would immerse myself in their artwork, then produce drawings in the style of their work, trying hard to make my linework look similar to theirs, and adding detail

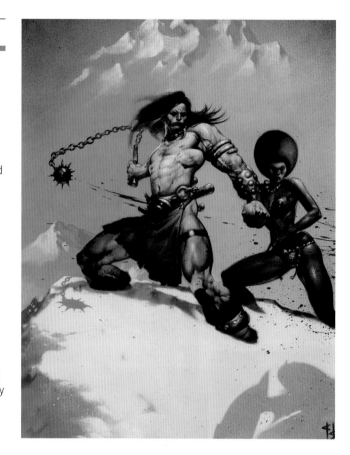

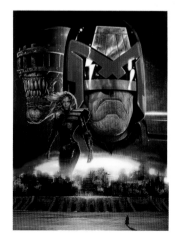

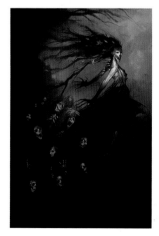

and texture in a similar way. In particular, the work Kevin O'Neill did on *Nemesis the Warlock* for *2000 AD* made a lasting impression on me. I never managed to fully emulate the crisp, disciplined line art he was such a master of, but he balanced this with such anarchic attention to detail and his creature design was so outrageous, it taught me that anything and everything was allowed in fantasy art. Of everyone I have ever been influenced by, his is the style I can most readily see coming through into my art to this day.

In later years, when I became friends with several of my heroes, I learned of the artists that they, in turn, had been inspired by and, very quickly, I realized the lessons I had taken from these people had, in some way, been handed down from generations far removed. It also taught me an important fact about becoming a professional artist: You become additive to this process of passing down ideas and lessons. Just as you were inspired, those who see your work might also be inspired, and this realization brings with it a sense of responsibility.

Therefore, I work as hard as I can to pay homage to those that came before, and to justify the interest paid by those who might follow. So, work hard, practice often. You never know who might be watching.

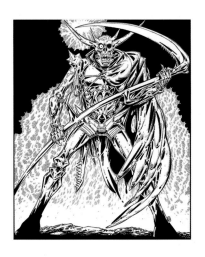

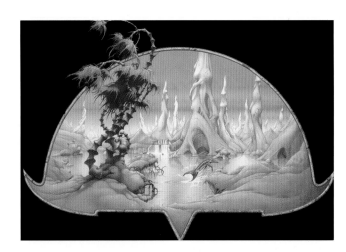

Opposite Top: This painting of *2000 AD's* Slaine by Greg Staples demonstrates an old-school fantasy style.

Opposite Bottom Left: Judge Dredd, Anderson, and Death by Liam Sharp in a masterwork of detail and texture.

Opposite Bottom Right: Soul Catcher by Aly Fell captures the horror aspect of fantasy art beautifully.

Far Left: This fantastic ink drawing by Kevin O'Neill from the *2000 AD* strip *Nemesis the Warlock* (Book 1) inspired a lifelong interest in macabre comic art.

Above Right: This wonderful painting by Rodney Matthews inspired me to create countless "spot illustrations" picturing all sorts of fantastic creatures and places.

Left: Colony by Gary Tonge is a great example of epic futuristic fantasy art.

THE BASICS:
INSPIRATION

TIP 006

Know Your History

Although this book concerns itself with fantasy art, it's worth taking a quick look back at a few artists and art movements that would seem to sit outside the fantasy remit, but who, in fact, have had a lasting, if subtle, effect on it. A hundred years ago Europe was in the grip of a movement called Art Nouveau, which means "new art." It was as much a philosophy as an art movement, and was born in part as a counter movement to the formal style of art produced by the European Academies of the 19th century. Art Nouveau was inspired by the flowing lines seen in nature, and the graceful forms and structures of plants were particularly evident in Art Nouveau pieces of work.It not only encompassed painting and printmaking, but influenced architecture and product design also, in an attempt to harmonize urban spaces with the natural world. Major exponents of the scene were Gustav Klimt, Charles Rennie Mackintosh, Alphonse Mucha, and Antoni Gaudí, artists that are all well worth looking up.

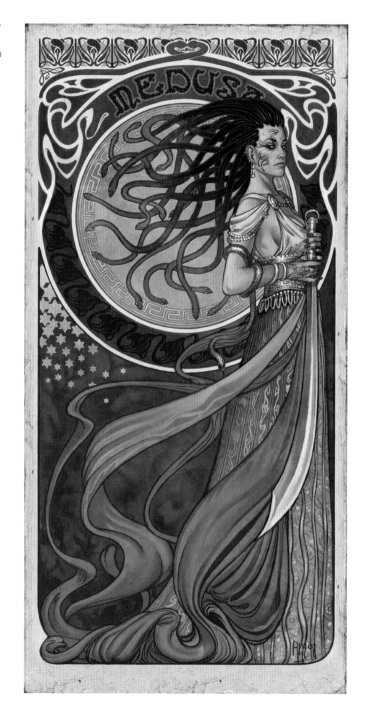

Right: Alphonse Mucha remains a huge influence for many fantasy artists, as this stunning painting by Aly Fell shows.

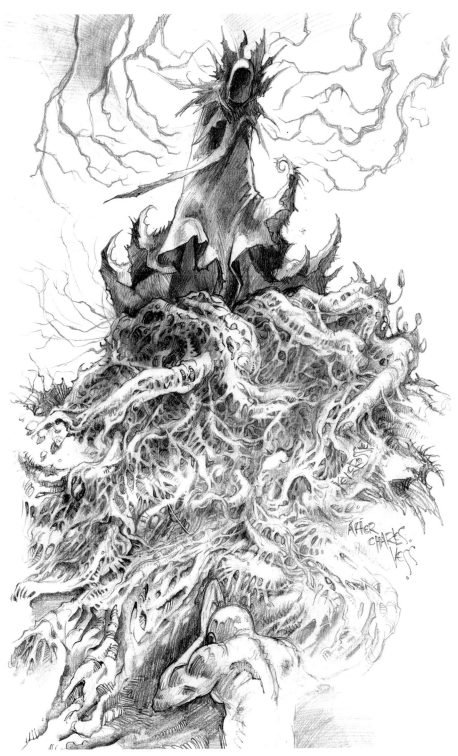

An art movement that followed Art Nouveau was called Art Deco, or Art Decorative. This was predominant throughout the 1920s and 1930s and was responsible for inspiring some of the most beautiful buildings, paintings, and designs of the last century, many of which can still be seen in cities today. One fascinating aspect of Art Deco was its remit of taking bits of art and design from throughout history and bringing them together into a cohesive whole to create an entirely new aesthetic. This is essentially what fantasy art does. It takes inspiration from what is real to create something astonishing and fantastic.

As well as these movements, there are many thousands of incredible images that pepper art history that have something of the fantastic about them. Find your nearest gallery or museum and see what you might discover. You will be amazed. Fantasy art has been around for far longer than you might have supposed.

Left: This detailed pencil study shows how, in my work, I am following in the footsteps of artists Charles Vess and Arthur Rackham.

THE BASICS:
INSPIRATION

TIP 007

Study the Natural World

The natural world is a great place to look for inspiration for the fantastic. All you have to do is pick up a book about plants, animals, or insects and you'll discover a whole world of the weird. A particular interest of mine that has proved to be a rich source of inspiration for fantasy landscapes and creatures was inspired by a school project, for which I chose a subject completely at random to study and draw. I ended up with "mushrooms and toadstools," and I soon found myself immersed in some of the most bizarre of nature's creations. It seemed to me, as I read up on these strange organisms and the odd forms they took, that they would look perfectly at home in a Rodney Matthews landscape, or any one of a hundred alien worlds. I was quickly hooked, and began to produce painstaking watercolor paintings of various mushrooms and toadstools and, by extension, I also produced various paintings of animals and insects. This was all carried out purely as a hobby, but I soon discovered that it was, in fact, excellent practice for my fantasy pieces. Studying how to paint in a naturalistic way like this was supremely instrumental in my understanding of how plants and animals fit together. This imparted a greater authenticity to everything I did afterward and, if you look, you will see that fungi, in particular, appear frequently in my work.

A particular favorite of mine is the Cordyceps fungus, of which there are

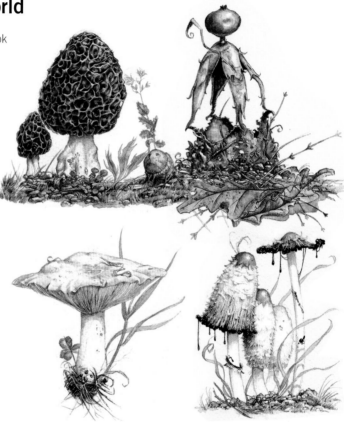

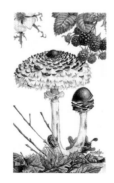

Left: Examples of various fantastic fungi forms.

Bottom Left: This painting of a parasol mushroom includes many other elements, all of which require particular skills to render.

Bottom Middle: Lessons learned while painting animals like this nightingale are transferable to fantasy subjects.

Bottom Right: A new trick is learned with each painting. In this one, I learned how to paint water droplets.

Opposite Top: This poor moth has been devoured by a Cordycep fungus, resulting in a scene that wouldn't look out of place in a fantasy horror piece.

Opposite Right: The result of years studying natural history, this pencil study was completed after over 60 hours, and features a bewildering collection of plant and leaf types mingled with various fantasy elements.

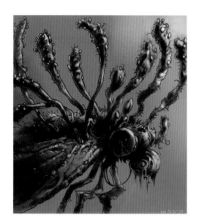

numerous kinds, but all are truly horrific. The fungus spore invades a living animal, usually an insect of some kind, then feeds on the living tissues of the host as it grows into a mature fungus. Eventually, it invades the brain of the insect and actually alters the behaviour of the animal! Usually, this results in an involuntary act on the part of the insect to climb as high up as it can, using a grass blade or a tree and, there, the insect is finally consumed and dies. Finally, the fungus is ready to produce a fruiting body, and this usually grows directly out of the insects brain. Horrific and fascinating!

Such is their vile nature, they have been utilized many times in sci-fi and fantasy stories and TV shows, and if ever an alien race were to try to conquer this planet, surely this is the organism they would use to achieve that end!

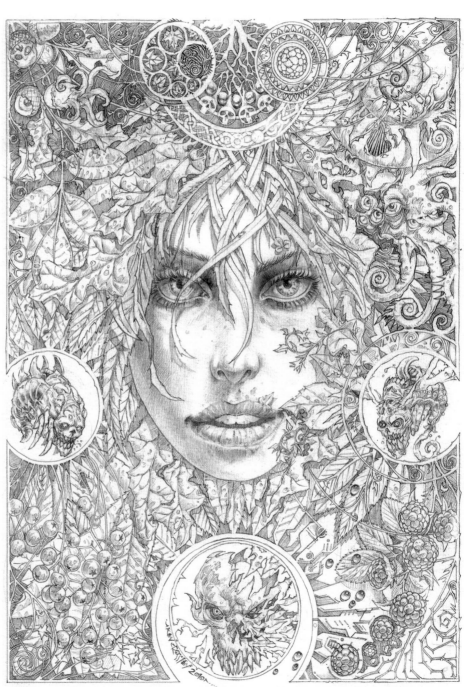

THE BASICS:
INSPIRATION

TIP 008

Pervert the Natural World

Of course, this being a book offering instruction on fantasy art, I had to follow a section on natural history with one showing examples of how you can twist it around. Because of my particular fondness for all things mycological, here are two images inspired by our fungoid friends.

The first (below) is a quaint village painted digitally directly over the top of a photograph I took of some Cep mushrooms on a sunny autumn day. After picking them, I cut the bases off so I could arrange them without their falling over. I thought they looked like small houses poking out from the leaves and grass between the roots of the trees, and so conspired to create a scene that accentuated this illusion—or delusion (you be the judge!). I took a few photos, thinking that they might come in useful as inspiration for a job one day and, well, here's the result. Proof that an afternoon walk in the woods can provide creative inspiration, sometimes for work you might produce years into the future.

The second image (opposite left) is a page from my dragonfly story. In it a character awakens in a strange forest,

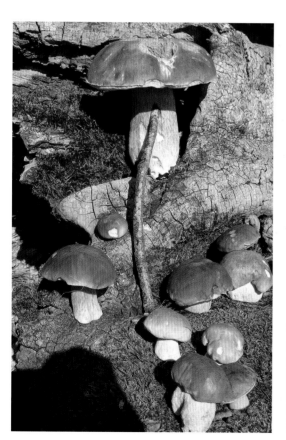

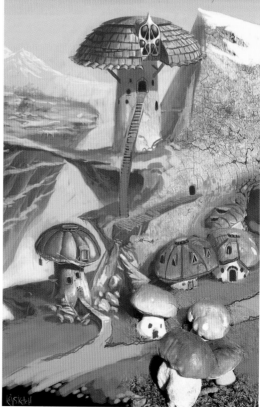

Left: This village began life as a cluster of Cep mushrooms.

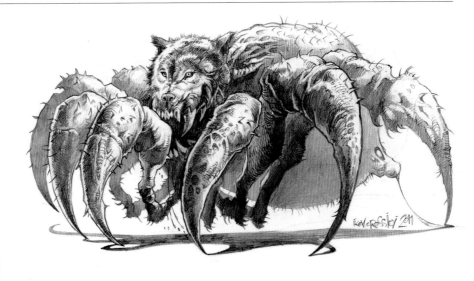

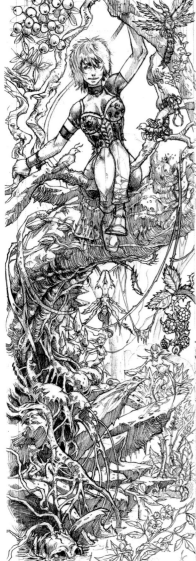

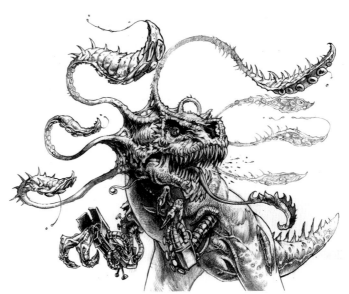

where gigantic toadstools replace trees, and fungal growths of every shape and color replace plants. This place even has seasons. I imagined that, each autumn, the "tree-shrooms" would shed their gills (the radiating spore-producing structures beneath the caps) and fall to the ground, just like leaves in real forests. It's rather eccentric, perhaps, but another fine example of fantasy inspired by reality.

Also included here are a few examples of freakish monsters formed from numerous parts of other animals. You may have heard of a wolf spider, but have you ever actually seen one? For good measure I've thrown in a T-Rex with octopus legs on its head and cybernetic arms grafted to its chest. Yes, I made that up as I typed it. I now have to go and draw it, and I hope it looks as cool as it does in my mind!

THE BASICS:
INSPIRATION

TIP 009

Painting a T-Rex

It's worth mentioning that the ancient past is also a fabulous place to draw inspiration from. I'm talking specifically about the first of all monsters, the dinosaurs. An obvious genesis, perhaps, of the dragons you'll see later in the book, their sheer monstrous scale and variety of forms have inspired many creatures seen throughout the fantasy genre, including in films, comics, games, TV, and art. Dinosaurs are also perennial favorites of kids, so I thought I'd include a quick tip on how to paint a T-Rex, as it's my son's favorite dinosaur. It will also provide a valuable insight into how a bit of knowledge of the natural world can be turned into a great monster painting.

For this project I began with a doodle made in 2005 using a blue Col Erase pencil with a bit of graphite on top. I scanned this into Adobe Photoshop, then transformed the image into grayscale by opening the Hue/Saturation dialogue box and moving the saturation slider to zero. Removing the color from a pencil scan like this creates a neutral starting point for the painting. Then I blocked in the underpainting in rusty ocher colors, which included working out how the T-Rex would be shaded.

I started to think about how light would play on the skin surface and, using lighter yellows, I sketched some reflected highlights into the shadowed areas and strengthened the overall balance of tone. Using my grid technique (discussed later on pages 152–153), I began marking out where some scales might go around the

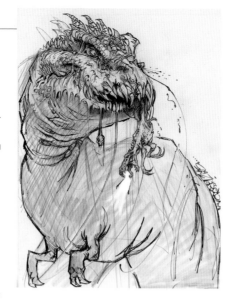

neck and started painting the background around the T-Rex to further define its outline. A volcanic mountain was painted into the distance to suggest the fiery landscape that this monster inhabited.

I then started to think about the skin texture. Although the pencil drawing had a fair bit of detail in this regard, it needed adding to, so I etched a few more scale grids onto the skin, then refined this impression of scaled skin by painting over and into the grids and the existing pencil work, suggesting the shadowed and highlighted parts of the scales as I did so.

Because this was a digital painting I could, of course, import photographs to add texture, so I added a photograph of rusted metal into a new layer, changed the Blending Mode to Multiply, then adjusted the color so it added a reddish overlay. I gradually erased and enhanced areas of this photograph, working it into the image. This is always an interesting challenge because, ideally, you want the texture to integrate into the painting rather than be an obvious counterpoint. A line marking the upper edge of the photograph remained visible at this point, but that will be removed later.

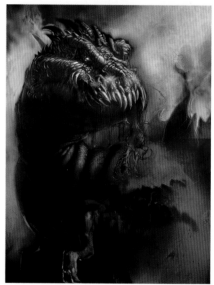

Top Left: The original sketch.

Top Right: Color is quickly and loosely blocked in.

Above: Lighting and first-pass highlights are added. Photographic texture is then applied, and more detail is worked into the head.

Opposite: The image is tidied up and the final details are added.

The placeholder highlights on the shadowed side of the creature were then toned down with a broader swathe of lighter ocher, suggesting softer ambient light, and similar ocher hues were painted onto the head, which was still predominantly just a tinted version of the original pencil scan. This undercoat provided the depth and weight necessary to carry the lighter detailed brushstrokes, which were then added, using the still-visible pencil work as guides. This detail around the face created a primary focal point for the image and there won't be too much extra detail added anywhere else, ensuring visual legibility.

Next, the periphery of the dinosaur head was given more definition by painting brighter sulphurous yellows around it, more forcibly separating the monster from the background and further disguising the redundant parts of the photographic layer. At the same time, the back and shoulders were lightened to make them recede, thrusting the unfortunate smaller dinosaur dangling from the mouth of the T-Rex into the foreground. The initial sketchy highlights that had been toned back were then repainted in using softer brushstrokes to give body to the shaded side of the head and neck.

To finish, additional misty background color was painted over the flanks, rear leg, and chest using a soft, medium-opacity brush to bolster the head as the focal point of the painting. Detail was added to the various dregs of meat hanging from the mouth, including that poor smaller animal, of course. A few extra highlights here and there and the painting is finished.

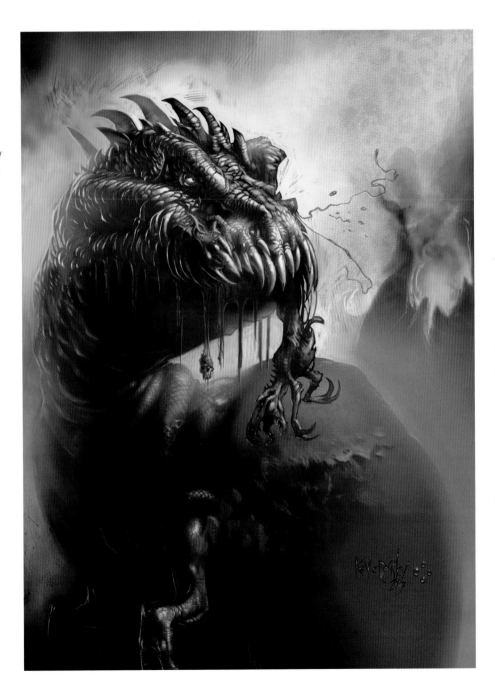

THE BASICS:
GETTING STARTED

Getting Started

TIP 010

Warming Up

A few years ago, I went through a stage in which I didn't paint regularly for quite some time. It was fair to say I was a little rusty. I devised an exercise to get myself back into the swing of painting, and it also turned out to be a good way to get warmed up. The idea was to set myself a brief and a time limit to achieve it. Nothing too complex, but just something I could easily tackle as I pressed long-atrophied muscles back into service. Subjects included landscapes, woodland scenes, ogres, monsters, even spaceships, but it soon became clear that there was a lot that could be learned through the process. The way reflected light bounces around, for example, casting subtle color flushes onto areas in shadow, and how secondary light sources work against the primary illumination to create naturalistic lighting. To my shame I'd found such principles were easily forgotten. Mindful observance of how light works within an environment, and how it molds people or objects within that environment, can make the difference between a mediocre and an accomplished painting. (Mastery of lighting principles allows you to break them convincingly, of course, but that is a lesson for another chapter . . .)

Illustrated here is an example of such a brief. I found a rough marker sketch of a temple in a sketchbook, scanned it into Photoshop, and set myself an hour to paint it up. I began by shifting the focus of the image, then quickly brushed translucent blue over the picture. A composition like this just cries out for a moon to be added, so I used a large, hard-edged brush to "spot" a big, pale moon into the background. A darker shade of blue was used to block in the mountain walls that frame the temple, and also to scuff in clouds over the surface of the moon.

Next, I used a bold blue with a slightly greater saturation to paint in the details of the temple and hill. Rather than paint each "dome," I simply copied and pasted the same one into various positions, adjusting scale and size as I went, before painting in the arch-supported walkway.

Finally, I finished painting the temple complex, pushing some areas back by painting in lighter tones, and pulling some areas forward using darker shades. A little touch of the moon coloring here and there beds the structure into the environment, and a bit of ambient illumination on the underside of the domes completes it.

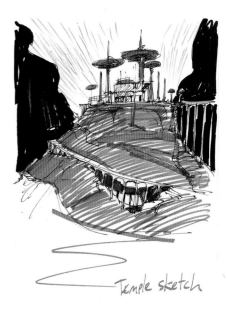

Temple sketch

It might seem obvious to say, but your painting should look like a painting. The whole point of an exercise like this is fluidity of purpose while creating what is essentially an expressionistic interpretation of something. An hour was all this painting required to turn a dodgy doodle into a satisfying idea that may well form the basis for a future painting.

Above: The painting begins with a very rough drawing.

Opposite Top Left: Photoshop is used to paint over the scanned sketch.

Opposite Bottom Left: Detailing is quickly painted on.

Opposite Right: A few finishing touches and the paint sketch is complete.

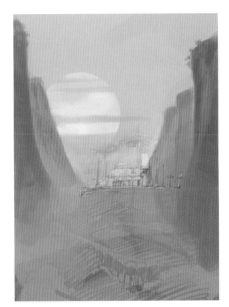

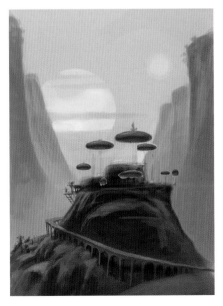

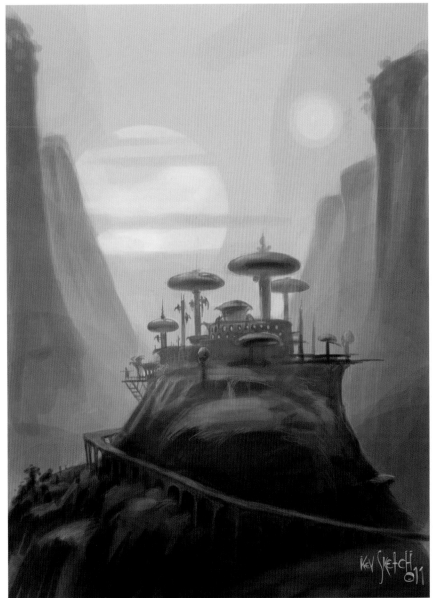

THE BASICS:
DIGITAL VERSUS TRADITIONAL

Digital versus Traditional

When contemplating how to approach a painting, we are presented with a choice that simply wasn't an option 25 years ago, and that is whether we produce it digitally or traditionally. Each method has unique attributes that can produce very different finishes, so it might be the case that a particular method is preferable in some cases. Taking these two drawings as a starting point, in the next two tips I'll show how each approach has its own merits.

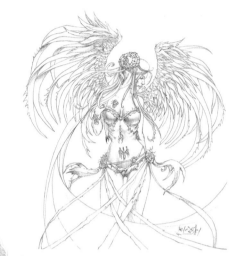

TIP 011

Get the Most out of Digital Painting

Personally, I've found that painting digitally can be a bit quicker than doing a traditional painting. There is no "actual" paint, for a start, no brushes to clean, and definitely no chance that the cat might jump onto the table and spill the brush water all over the place! (Or, as in one particularly memorable instance, step onto the palette and leave a trail of tiny, perfectly formed kitty paw prints right across an almost finished painting.)

Above: A light pencil drawing of a woman with Manga-inspired wings.

Left: An ogre-type beast.

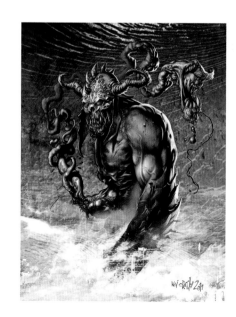

Right: Rendered digitally, The Beast differs considerably from the acrylic version.

Opposite Left: The digitally painted faerie is augmented with various Photoshop tricks.

Digital painting also offers limitless "undo's," should you make a mistake (Control-Z), plus a whole range of layer effects, blending modes, and filters to enhance your image. Photoshop also allows you to mix bits of photographs or scans from other images into your painting, so the possibilities really do spiral into the heavens.

Shown here (below) are the completed digital versions of the two drawings I started with. Each features a range of Photoshop tricks, filters, and overlays as well as brushwork to produce a finish that's quite distinct compared to a traditional approach.

Below Middle: The Beast is given life with acrylic paint.

Below Right: Scorpion painted using inks, gouche, acrylics, and watercolor pencils.

TIP 012

Get the Most out of Traditional Painting

With traditional painting, you get something a little bit different, though. You get dirty for a start, and it's a far more physical activity, especially if you use an easel. You can't, for example, sit on top of a hill during a rainstorm and paint the landscape on your laptop or iPad, but watercolors or acrylics offer this extra dimension that really shines through in the finished image. Plus, if you slap the paint on really thick, it catches the light in ever-changing ways as the day progresses, perpetually changing in character and mood. A digital painting can be printed out onto canvas or any number of textured kinds of paper, but it will only ever be printing ink, whereas an oil painting really does have something special when you look at it close up.

I've painted the traditional versions of the drawings using watercolors, acrylics, and inks to create texture and atmosphere unique to such methods.

In spite of the differences between the two approaches, there are similar painting rules that apply to both, so don't feel during the course of this book that a digital tip isn't applicable to the traditional approach, and vice versa. With practice, you'll soon learn there are fundamental principles that are transferable between the two methods, and the lessons learned while working in one medium are transferable to the other. They might be very different, but they are essentially the same. (I'll cover the methods involved in painting these images later in the book.)

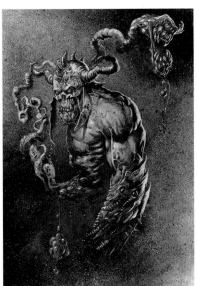

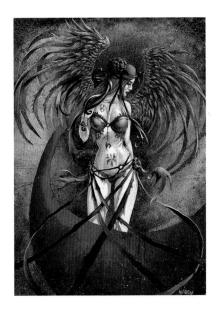

Sketching and Drawing

Although this book is primarily concerned with painting, I feel it is important to spend a fair bit of time covering the subjects of drawing and sketching, which are extremely valuable skills that underpin every half-decent painting. Therefore, over the next few pages, you won't see much colored painting or finished art, but you will see a lot of black-and-white drawing, preliminary sketches, pages from sketchbooks, and doodles of all kinds. I feel it's essential to see art like this—stripped of flesh, the bones reveal much about why the finished pieces look and function the way they do. In a few instances you'll see how some of the sketches or drawings featured are developed into finished paintings in later chapters.

If an artist doesn't develop solid drawing skills, there will seem to be something lacking in everything they do. An ability to convincingly portray a range of subjects in this most basic of media is an essential skill in the arsenal of any artist, and the only way to develop such a skill is to practice, practice, study, watch, take notes, and practice, practice, practice (the so called "three Ps").

While drawing can be done on any scrap of paper, paper bag, beer mat, or sidewalk, the best place to deposit your gems of sketchy excellence is within the pages of a sketchbook. A sketchbook becomes a useful repository, allowing you to keep all your drawings in one place for easy reference. Sketchbooks also serve to document your artistic development, revealing at a glance your improvement, sketchbook by sketchbook, year by year.

After 25 years of artistic endeavor I have a vast collection of sketchbooks, notepads, journals, and scrapbooks, but I have to admit it wasn't an easy habit to get myself into . . .

Right: Norse myth and 20th-century horror collide in this image capturing the transformation of zombie Viking elves.

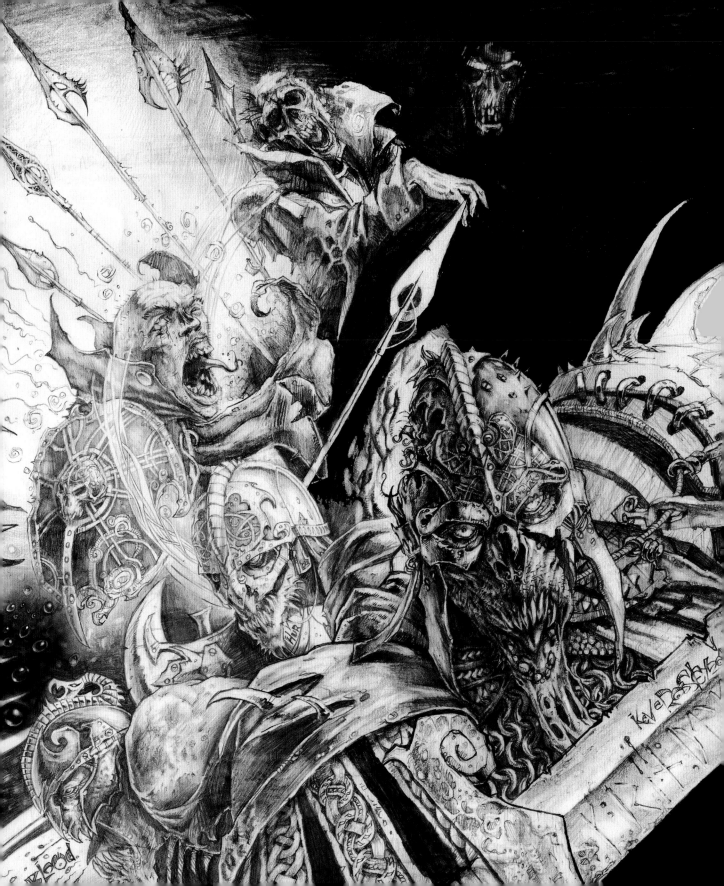

SKETCHING AND DRAWING:
THE SKETCHBOOK

The Sketchbook

TIP 013

Get a Sketchbook

Until I went to art school, I'd never kept a sketchbook. I didn't really need one back then, as most of the drawings I did became finished works. Then, while I was working on the final art exam, I was told I had to supply preliminary work to support my finished painting and to illustrate my working processes. I was baffled by this. I didn't know I had any "processes" at that time. It was totally alien to the way I worked and, in the end, the "preliminary" material I submitted was actually completed in one evening *after* I'd finished my painting. (Sorry Mr Carver!) Still, it taught me an interesting lesson and, after that, I made a point of making preparatory studies and sketches of things before I committed to finishing a drawing. As a result, I found my understanding of anatomy improved, and I was able to pick better poses for my characters from the variety I would doodle beforehand.

Scraps of paper served this purpose for a while but, one week on, I took the plunge and bought my first hardbound Windsor & Newton sketchpad. This exciting new object seemed to instill a greater purpose to my drawing, which in turn influenced my decision to take it all a bit more seriously. It certainly didn't make me a better artist overnight, but it inspired me to strive to become one.

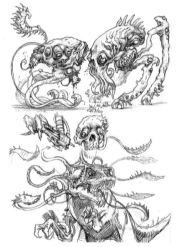

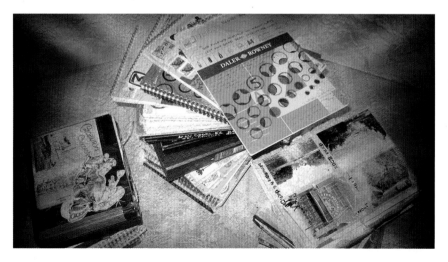

Left: This picture shows approximately a third of the sketchbooks and art folders that I have amassed over 20 years.

Above Top: A page of sketches from one of my sketchbooks.

Above: More sketches.

TIP 014

Fill a Page with Sketches Every Day

Since my art-school days I've amassed shelves and shelves worth of sketchbooks. It's worth holding onto them, as they serve as a great indicator of how much you learn and, hopefully, how much you improve as you progress. My early sketchbooks aren't very good, to be sure, but they were a starting point. As I got used to simply using one, I soon began to produce work that was much better. It seemed to make a difference having a number of sketches all together in one place; the evolution of an idea was more visible, somehow, plus I got faster at exploring those ideas, too.

So, things were fine for a while, University came and went, then I got myself a job as a video-game artist, which was great, but with it came a sacrifice. Long hours at work (and a new social life) left little time for pursuance of artistic improvement and, slowly, I became rusty. Like muscles that atrophy if they aren't used often enough, artistic skill deteriorates.

To combat this, I set myself a goal to try to fill a page with sketches and ideas every day. Sounds easy but, back then, I was still struggling a little with motivation. The mind was willing but the body was too lazy, to be honest! (Delicious malty beverages and lots of late nights might have had something to do with it, too . . .)

So, in spite of how busy my life was, I tried to fit in a bit of drawing every day. It took a good few months to get back into the swing of it but, soon, I was enjoying it again, and the sketchbooks were falling off the conveyor in no time

(much to the satisfaction of the art shop cash register).

It's a great exercise to set yourself—it improves focus, gets your imagination sparking, and you end up with pages and pages of material that you will find a use for down the line, as you'll see.

Here (right) are a range of sketches from my sketchbook collection. I'm, frankly, a bit embarrassed to be showing some of this stuff, but let my shame be your lesson. You can clearly see how different my early sketches were compared to the stuff I produced in later books. Someone once said that when you first start out as an artist, nothing you produce is any good. At all. That might sound harsh, but in hindsight I think it's true. At the time I was filling those first sketchbooks, I thought my stuff was okay, but then again, I didn't seriously feel like I was ready to do a proper comic book or produce professional poster art. What did matter, however, was that I enjoyed what I was doing. I enjoyed the process of drawing and redrawing, of studying anatomy and botany (and lots of other subjects ending in "y") in my endeavor to constantly improve. It was this blind devotion to my self-imposed task that would eventually help me change from an enthusiastic amateur into an enthusiastic amateur professional.

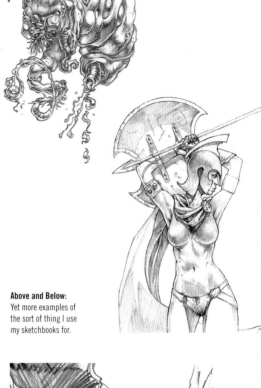

Above and Below: Yet more examples of the sort of thing I use my sketchbooks for.

SKETCHING AND DRAWING:
DEVELOPING A CONCEPT

Developing a Concept

Once you have a few sketchbooks filled with ideas, the groundwork is laid to experiment and push things a little further. I still refer back to my sketchbooks from fifteen years ago and find ideas that are surprisingly useful. This is a fundamental benefit of spending so many years drawing.

TIP 015

How to Push a Sketch

Here is a pencil sketch of a demonic creature with a scythe from an old book. I think it dates back to 1989. It's rather basic and betrays a distinct lack of finesse, but I liked the thought process behind it and decided to see how it might develop if I used it as a starting point for a new piece of art.

My first step was to produce a sketch approximating the pose of the character. The result was a slight departure from the original, but retained most of the elements, with the major change being the free hand, which I changed from pointing at the viewer to holding . . . something. (At this stage, I had no idea what it was holding!) I then made a few slightly more resolved versions of the sketch, experimenting with new heads and adjusting the posture until I had a selection of versions to choose from. I even produced a sketch with a totally different pose, but felt this was too far removed from the essence of the original. Quite often, a client will want to see a variety of different concepts for a job, so this sort of exercise is a good habit to get into.

Next, I chose elements from the new sketches I liked the most and produced a finished drawing using a 2H pencil, with HB used to add body to the shadows and weight to some of the linework. When the new drawing was almost completed I still had to resolve the question of what the demonic character was holding, and the answer came out of my pencil almost without any conscious input on my part —it was holding a weird, rat-type leech thing. Of course! Finally, I took the drawing into Photoshop to give it a digital-color makeover, creating atmospheric drama to complement the demon and its delightful pet.

This new version captures the essence of the creature in a way I just didn't have the skill to achieve back when I was 17, and it was curiously satisfying to finally do justice to an idea I had 22 years ago!

Top Right: The original doodle.

Right: New posture inspired by the original.

Opposite Top: Design variations.

Opposite Center: A totally different pose study, ultimately abandoned.

Opposite Bottom: The fully rendered pencil art for the new version.

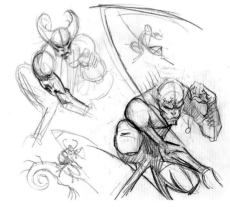

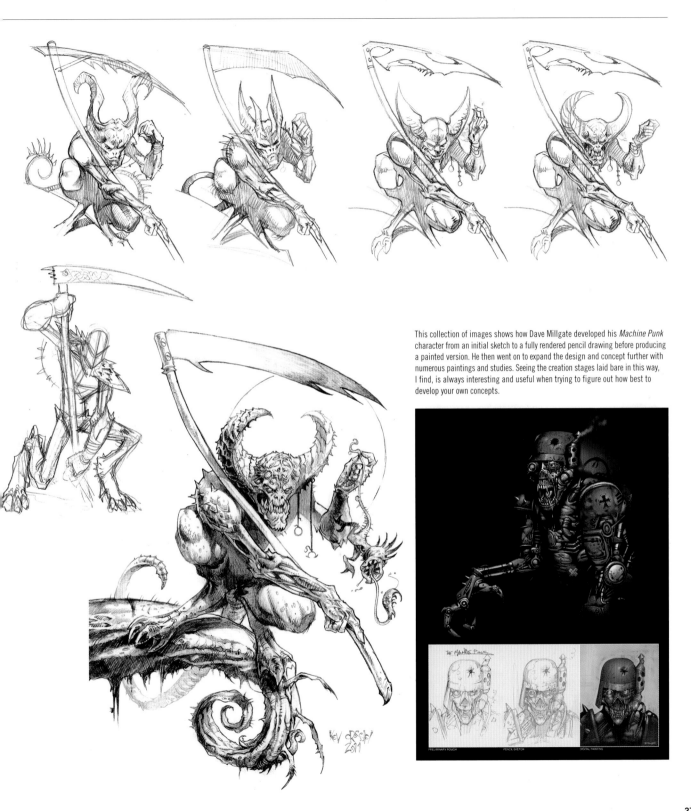

This collection of images shows how Dave Millgate developed his *Machine Punk* character from an initial sketch to a fully rendered pencil drawing before producing a painted version. He then went on to expand the design and concept further with numerous paintings and studies. Seeing the creation stages laid bare in this way, I find, is always interesting and useful when trying to figure out how best to develop your own concepts.

SKETCHING AND DRAWING:
DEVELOPING A CONCEPT

TIP 016

Working to a Brief 1: Do Your Research

A particular feature I wanted to include in this book was to illustrate every stage during the creation of one painting, from start to finish. Although there are other paintings featured throughout the book with a few stages included to illustrate their development, I thought it would be useful and interesting to show, in minute detail, precisely what is involved in bringing a painting to life.

With this in mind I began thinking of a cool image to paint. Lots of my favorite subjects came to mind—dragons, ogres, orcs, demonic landscapes—but with so many interesting ideas, the choice was difficult. Perhaps unsurprisingly, I decided that I would tackle a subject involving lots of monsters, and set about producing a few drawings to see if anything might grab me. I soon settled on the image of a glowing orb being beset by various demons, including a monstrous hand. The idea was inspired by an old project, and although I developed the drawing to quite a finished degree, it just didn't seem to have the spark I was looking for. So I started to think again about what I might do.

Luckily, the decision was made for me in the shape of a commission. I was asked to paint the Four Horsemen of the Apocalypse, an imposing subject, to be sure, but one I instantly knew would make an ideal subject for the book.

Before I started to make any drawings, I began with a bit of research; there are many clichés that surround the Four Horsemen legend, and I felt it was important to go back to the source material for my painting. What I discovered was very interesting.

There are many versions and interpretations of what and who the Horsemen are, or what concepts they embody—Pestilence, Famine, War, Death, etc. Similarly, the way they have been visually represented has greatly varied with personal favorites tending to lean heavily toward fantasy art. However, of the Four Horsemen, only Death is implicitly named. Although theological opinion varies, the first three Horsemen are most commonly named as Conquest (carrying a bow and riding a white horse), War (carrying a sword while riding a "fiery red horse"), and Famine (carrying a set of scales for weighing grain, and riding a black horse).

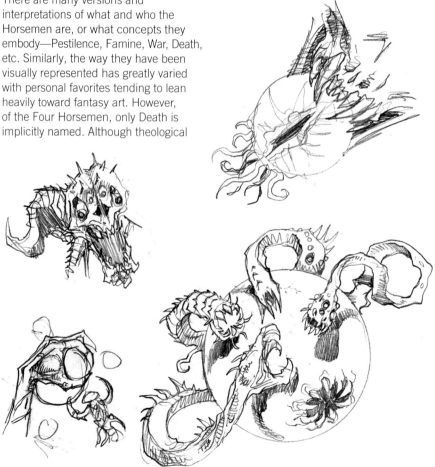

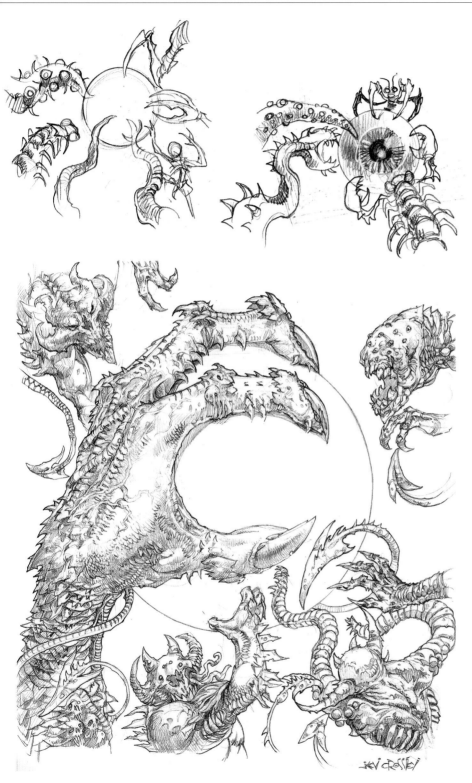

Accounts of these enigmatic riders were detailed enough to offer solid descriptions to work from, but there was plenty of room to add a little artistic license too—perfect! But the most exciting part was this following section about the figure of Death:

"When the Lamb opened the fourth seal, I heard the voice of the fourth living creature say, 'Come and see!' I looked and there before me was a pale horse! Its rider was named Death, and Hades was following close behind him. They were given power over a fourth of the earth to kill by sword, famine and plague, and by the wild beasts of the earth."

— Revelation 6:7–8

As soon as I had read that, I knew I had to incorporate this vision of Hades into the composition, creating a feature of horrific magnificence to supplement the grand vision of the riders themselves.

Opposite and Left: Sketches and the finished drawing for my initial idea.

SKETCHING AND DRAWING:
DEVELOPING A CONCEPT

TIP 017

Working to a Brief 2: Sketching the Composition

So, armed with a good idea of what I wanted to achieve I started to make a few thumbnail sketches, no larger than an inch or so high. The idea was to try to capture all the fundamental elements without being troubled (or tempted to get distracted) by too much detail. At first, it seemed like a landscape orientation was the best layout, but although this would allow me to feature the riders in the largest possible size, it wouldn't have left much room to fit the "Hades" feature in. As I'd not yet decided what this would look like I left the thumbnails to do a few sketches to try to firm up my ideas for this horde from Hell. There are many images of demons and devils throughout art, and very quickly I settled on a mixed selection of all sorts of devils, faeries,

imps, dragons, and creatures, some of which were inspired by classical portrayals mingled with things from my own fevered imagination. Basically, I drew that which has always been dear to my heart: monsters. And lots of them.

With a few ideas down for what the monsters would look like, I produced a new set of thumbnails, all of which had a portrait orientation, and already the composition felt more evenly balanced. Another feature I established in these new thumbnails was the shape of the Hades horde itself: I settled on a curve swooping away and up from beneath the raised cape of the Death horseman, then following a spiraling line into a focal point in the sky.

Next, I concentrated on the riders themselves. Although I had collected their descriptions to work from, I wanted to produce designs for their physical forms that were all mine while, at the same time, keeping true to certain aspects as they were recorded. The page of studies I produced for the riders presented some interesting concepts, all of which were monstrous and, in one case, I narrowly avoided the downright ridiculous. (For a while I considered giving War an Axe for a head! It seemed appropriate somehow . . .) I wanted to create a look for them that was bestial, but almost cyborgish, too, a hybridizing approach that, in fact, paid homage to the sci-fi and fantasy comics I loved as a teenager.

 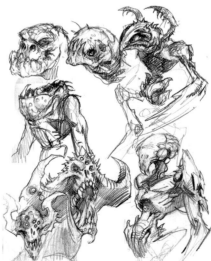 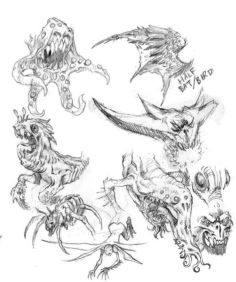

The riders needed horses, so I did one sketch that seemed to capture a nice group pose for the mounts, complete with rough figures to give an idea of how the riders might sit. Conquest leads the charge with his white horse, flanked by War on his fiery steed, and Famine on his black mare. I sketched Famine reaching his arms down either side of his horse's head, which I'd not planned, so I felt I had to justify this posture somehow. Naturally, the only explanation was that his hands were fused to his ride's skull. This was a pleasingly monstrous concept.

Death sits slightly apart from the first three characters, his raised arm holding a cloak, from which pour the host of Hades. I liked this, it all seemed to work,

so I scanned the pages into Photoshop and, using selections from the sketches I'd produced, I constructed a layout to match the dimensions of the artboard I would use to render the final drawing.

As the image is quite complicated, with a lot of characters and elements to balance and think about, this stage took me about a day to complete, but often a painting might only need a very basic sketch or thumbnail, taking a half hour or less—it all depends on the content of the piece.

With a finished sketch, and a good start on character and monster design, I was ready to begin the finished drawing, which is where the fun really begins.

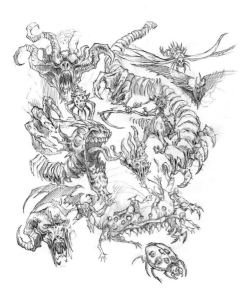

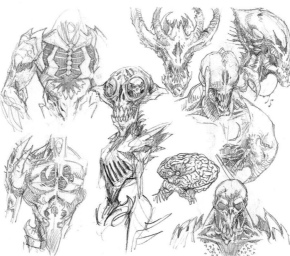

Opposite Left:
The first thumbnail sketch.

Opposite Middle:
Demon sketches.

Opposite Right:
Yet more demon sketches.

Far Left: Even more demon sketches.

Left: A more detailed sketch of the Horsemen.

Top: Sketch ideas for the Horsemen heads.

Above: Digitally composited thumbnail for the painting.

Detailed Drawing versus Rough Drawing

If you have a sketched composition you want to develop further, the next step is to produce a more finished version of the sketch to solidify design aspects and cement the elements into a composition that works. There are a number of ways to achieve this, however, and which one you choose will depend on your personal preference of working methods, and what you plan to do following the finished drawing.

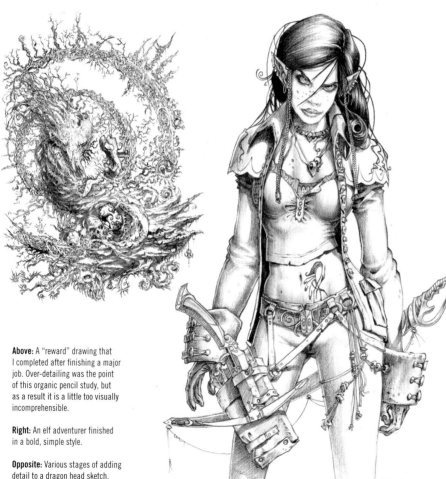

Above: A "reward" drawing that I completed after finishing a major job. Over-detailing was the point of this organic pencil study, but as a result it is a little too visually incomprehensible.

Right: An elf adventurer finished in a bold, simple style.

Opposite: Various stages of adding detail to a dragon head sketch, and the final colored version.

TIP 018

When to Produce a Detailed Drawing

One of the greatest joys as an artist is to crack open a new box of pencils and get stuck into a really detailed bit of drawing. It's so easy to get lost in such a task that I sometimes have to reign myself in, and one of the hardest lessons I ever had to learn was to recognize when detail is required and when it isn't.

Here (opposite left) is a fairly detailed drawing of a dragon head. I used an HB pencil to draw most of it, but a B pencil helped to darken some lines and enhance the shaded areas. Studies of lizard and snake skin helped influence how the scales and convoluted skin folds should look, and I enhanced this with exaggerated, overlapping armored plates, spines, and extrusions, plus lots of little textural touches. The result is a brawler of a beast. It's a fun piece that stands alone as a pencil drawing without needing any further work. I've included several stages to illustrate how the scales were developed, which is a subject covered in a tip later in the book.

If I wanted to paint over this drawing with a robust medium such as acrylics or oils, much of the detail could be lost beneath the thick paint, which would mean all the time and effort expended to create it would be wasted. Therefore, it's probably best to not spend this much time on the drawing if you intend to paint with such media.

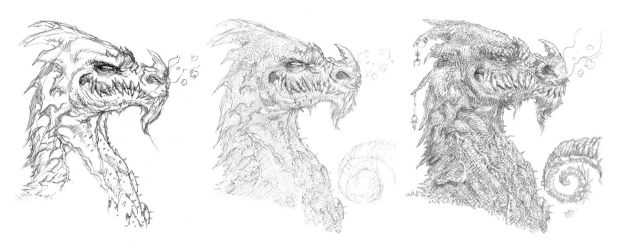

However, because the pencil is fairly dark, it could withstand watercolor washes, thinned, translucent acrylics, or colored inks. Alternatively, I've sometimes spent hours on a pencil drawing, then gone over the entire thing with ink line before applying color. The ink is far more visible beneath the color.

As an example, I've chosen to add some digital color to a scanned version of the pencil drawing. I opened the image in Photoshop, then created a new layer above the pencil with Blending Mode set to Multiply. Into this layer I used the brush tool to add dabs of color. Green and yellowish-green ocher were predominant, but blue and red were also added to enhance shadows, or to add tonal complexity to areas such as the eyes, tooth roots, or spine tips. Because this color layer is set to Multiply, the pencil remained visible through the paint and none of the rich detail was lost. To finish, I painted lighter colors into a few of the scales to make them "pop," which is a technical term meaning "to stand out." This approach can be a very efficient and fast way to deliver a colored concept, and can even be used to create quick color studies for future, more detailed, paintings.

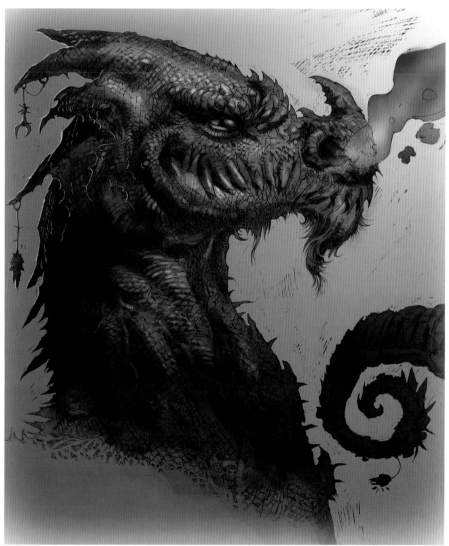

SKETCHING AND DRAWING:
DETAILED DRAWING VERSUS ROUGH DRAWING

TIP 019

When to Produce a Rough Drawing

I learned the hard way that, sometimes, it's best not to get carried away with the detail in a drawing if you then intend to paint it in acrylics afterward. I ruined a number of drawings this way when I was learning how to paint using acrylics until, one day, I discovered a book called *Warlords and Warriors* by the late great Angus McBride. Alongside all the brilliant artwork in the book was a spread which showed his pencil study of a battle scene alongside the finished piece, and I was amazed. There was so little detail in the drawing compared to the painted version. I was baffled at first. I had always assumed a detailed underdrawing was an essential guide for where to apply the paint. The mistake I was making was simple. I was so fixated on my favorite act of pencil drawing, I was blind to the fact that paint is more than capable of holding its own as a detail-building medium.

So I carried out a few experiments, which all began with quite rough and, to my mind, unfinished-looking drawings. At first, it felt completely unnatural to work this way. Starting a painting without the safety net of an extensive underdrawing was like jumping in at the deep end of the pool, or taking the stabilizers off your skateboard for the first time. It felt very much like a leap of faith, but after a while I got used to it and, in doing so, saved myself a bit of effort by not spending unnecessary time on pencil work.

These principles are true whether you work traditionally or digitally, so I produced a very loose digital drawing of a zombie-hound creature in about ten minutes using Photoshop, then printed it out onto Bristol Board and glued that onto thicker backing board. It still felt a little unnatural to work from something with so little detail, but I pressed on with my acrylics in the faith that my imagination would fill the image with all the detail it needed. After all, I never have a guide to dictate where to add the detail when I do my normal pencil drawings.

After a few hours' painting, my initial fears were again proved unfounded. I managed to find my monster without the need for much pencil detail. The paint and brushes were all it needed.

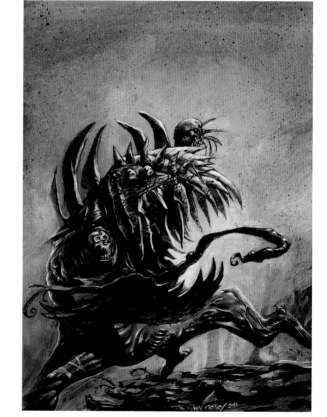

Above Right: A quick digital sketch of an undead dog-beast sort of thing.

Right: The final painting built from the sketch, in which the detail was defined by painting.

TIP 020

Loosen Up to Digital Sketching

Even though I began drawing long before computer software developed enough to offer an alternative to the humble Staedtler HB pencil, I wasn't averse to using the digital option when it finally came along. It might not have been quite the same as the real thing, but it offered a quick way to explore ideas, with the added value of being able to make instantaneous changes, particularly when using software such as the incredibly useful Photoshop.

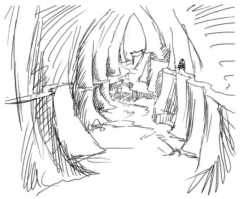

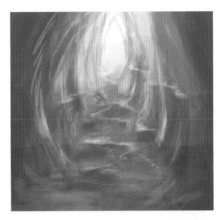

Here (top left) is a rough sketch of a cave interior, completed using the Brush Tool in Photoshop. I then very quickly painted the scene in using a range of blues and grays with a brush opacity of 40%. I now had a good idea of where the sketch was going, but I wanted to enhance the feeling of scale, so I stretched the image along the vertical axis. I also used the Pinch Filter to shrink the center of the image, which had the effect of pushing the background parts further into the distance.

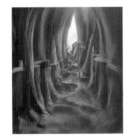

Top Left: A digital sketch of a cave.

Top Right: Color is quickly washed over the sketch.

Above and Right: The final stages of the painting.

The last stages simply involved working details into the image; breaking up the cracked, rocky ground, adjusting the light and shadow effects, and enhancing or adding features such as walkways, flying buttresses, fungal growths, and arched alcoves into the cave walls. Finishing details, highlights, and sweeps of color overlays brought the sketch to some kind of conclusion and the concept is complete.

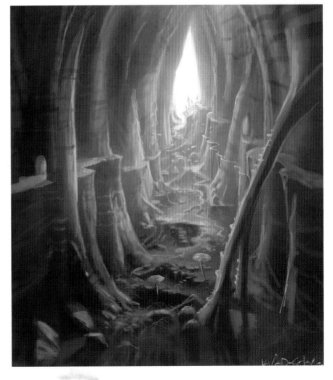

SKETCHING AND DRAWING:
DESCRIPTIVE DRAWING

Descriptive Drawing

Being possessed of good drawing skills is all well and good, but if you lack the ability to tell a story or capture dramatic tension within an image, then there may well be a serious gap in your abilities. In a similar manner to the way descriptive writing relies on astute use of adjectives, metaphor, and superlatives to paint images within the mind of the reader, descriptive drawing must do the same but in a far more literal, and immediate, way. You must put across your understanding of the subject covered, plus convince the viewer of the validity of the characters that inhabit the image. This must all be under-pinned with solid anatomical and topographical draftsmanship, alongside an ability to keep all elements well balanced so as not to create a cluttered composition. If all that sounds a little complicated, then don't worry. Like any large problem it can be broken down into smaller, more manageable chunks and tackled that way.

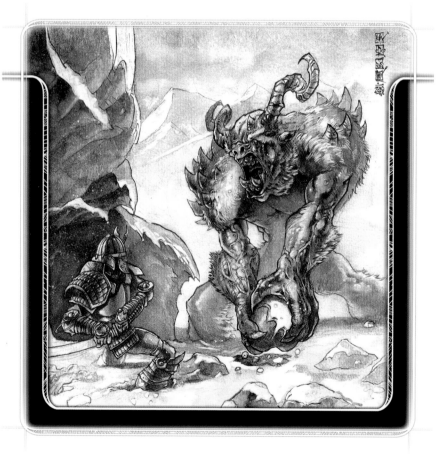

TIP 021

Setting the Scene

Opposite right is a splash-page image from a graphic novel I'm writing and illustrating. In it a strange forest environment is revealed to the viewer, who is introduced to it at the same time as the character who is waking up from her fungal bed. I wanted to achieve a number of things with this image. As I was always a fan of exciting full-page illustrations in comics, I wanted to give the reader a real surprise when they turned the page and saw this for the first time. The idea was to almost stop the reader dead in their tracks by offering them a feast for the eyes, something they could spend a long time exploring before continuing with the story. Closer scrutiny is rewarded when it becomes clear this is no ordinary forest, but one largely populated by fungi of all sizes, gigantic toadstools taking the place of trees, with smaller fungi parasitizing the larger fruiting bodies. Further questions are prompted when noticing the child awakening before the giant dragonfly creature. Just what is happening in this scene? Where is this place? Who is the girl? What happens next?

I also intended the image to function in isolation from the rest of the graphic novel, so the questions raised become all the more enigmatic and the image more immersive because the promise of answers is removed. It's an example of visual scene setting, where layers of detail build into an untold story, and inspire in the viewer an interest to learn more.

Left: A good example of a picture painting a thousand words.

Opposite Left: An *Iron Heel* sketch by David Millgate.

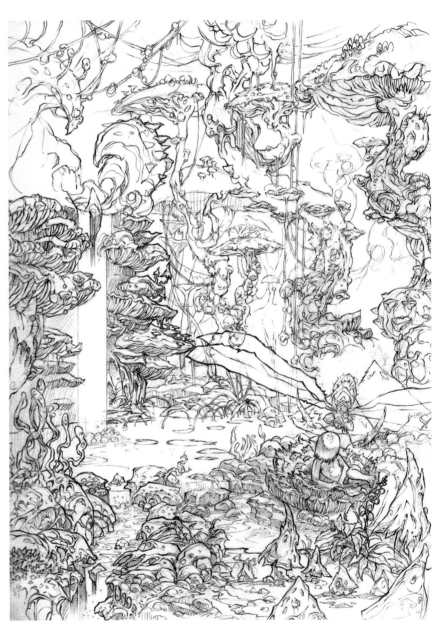

This image (above) by David Millgate tells a different kind of story. A strange, stilt-limbed creature creates a striking presence with its alien physiology and menacing demeanor. It is clearly aggressive and seems to be attacking what appears to be a watchtower. The scale of the thing adds an extra dimension of horrific wonder to the image. The drawing is executed with poise and compositional balance, facilitating a plethora of questions: Who is in the watchtower? What are they watching? Why is the creature attacking them? What IS the creature?

The ability to tell a story without words is one of the greatest skills a fantasy artist can master, and is the quintessential character of the communication between artist and viewer.

Above: A pencil drawing depicting how the dragonfly character wakes into her fantasy world.

SKETCHING AND DRAWING:
DESCRIPTIVE DRAWING

TIP 022

Selling the Drama

If you want to make art that grabs attention, then you have to inject drama into it, give it a punchy visual content that suggests action before the scene and hints at events that might follow.

Shown here are some stages of a cover painting depicting a scene from Karl Richardson's *2000 AD* story *Grey Area*. Karl produced a composition featuring a character who appears to be in quite a tricky spot. Although there is no obvious dramatic perspective or movement evident in the picture, the implication of confrontation is enough to create a sense or threat of dramatic tension. It is clear that the center character is the focal

point of attention not just for the viewer, but also for the various monsters that surround her, which begs the question of what might happen next. The sheer variety of monstrous creatures surrounding the human generates an atmosphere of exotic, other-worldly intrigue that isn't dependant on visceral action or violence. This edgy aspect is enhanced by the wonderfully sketchy initial layout, which was digitally painted in a similarly loose fashion to ensure the static energy was retained throughout the painting process.

If you look for the dramatic potential in sedate scenes, you'll find the resulting

drawings have a special dynamic that would seem at odds with the stillness within the composition.

Shown opposite right is an entirely different kind of image, this time an

Below Left: The initial sketch for Richardson's *Grey Area* page.

Below Middle: Digital color is loosely added.

Below: More detail painted in.

Opposite Left: The finished page.

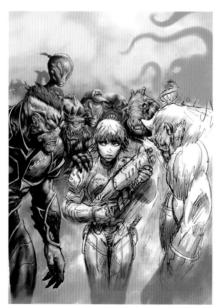

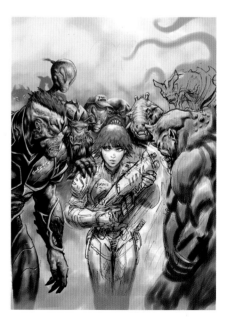

Right: A Zombie Viking Elvis
interpretation in pencil.

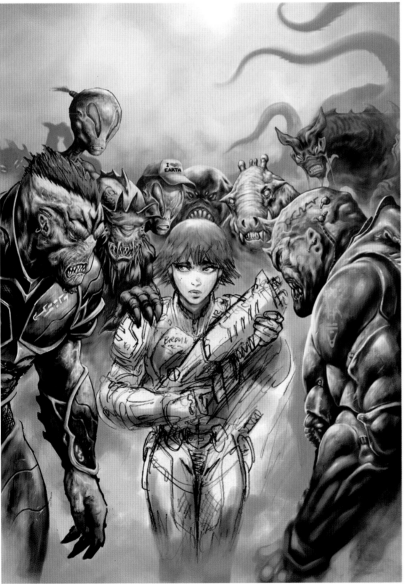

endpaper image of a zombified Elvis
impersonator! To make things even more
interesting, during his resurrection he was
imbued with the spirit of an ancient Viking
warrior, which gave me a good excuse to
work a lot of Celtic doodling into the design.

The drama in this image exists wholly within
the detail of the graphic border elements,
and within the character itself. As with the
Dragonfly page (p. 47), I wanted to offer the
eye a journey to search out within the static
image. The curved blades of knotted pattern
create a flowing framing device around the
zombie who lurks at the center, but the Celtic
knot work is inconsistent, organically mutating
as it travels around the image, dragging the gaze
of the hapless viewer behind it. The journey
always comes back to the baleful gaze of the
grinning corpse, but the tumult of pencil work
is forever moving, and soon the eye is drawn
away once again to seek out yet more detail
and different paths through the image.

Drama need not be consigned to physical
action or narrative content. It can exist in
utterly static pin-up art that lacks any kind
of explicit story whatsoever.

SKETCHING AND DRAWING:
DESCRIPTIVE DRAWING

TIP 023

Visualizing the Narrative

Fantasy art is filled with dramatic action captured in a moment. It is a visual snapshot from a story or "narrative." The greatest exponents of the genre are those who succeed in creating paintings that all but come alive, jumping off the canvas with such alacrity, they incite reciprocal responses in the viewer! After all, a good story is invigorating and mentally stimulating. When your mind is presented with a story in stasis, it responds by calculating what comes next; where will the separate elements within the frozen tableaux fall? A great static image invites a response that is anything but static, but it can be a tricky feat to pull off.

In one of my (really) old sketchbooks I found a drawing featuring a crazed warrior I created when I should have been studying. I did a lot of drawings of this character, usually dispatching evil-doers or dragons, but I left him behind long ago. In the image, although my avenging character was mostly hidden in shadows, I always liked the implied story behind it, even though I had no idea what it was. So I produced a new version,

loosely sketched out in 2H and HB pencils. The inclusion of the barely visible body, hanging upside down as something dark trickles from his inert fingers offers a chilling hint that his end was not a pleasant one. Then there are the two villains sharing out the spoils of some robbery or other; is this their designated meeting place? Were they meant to meet their third friend here, the man who now hangs above them unseen? And what of the grinning warrior who lurks beside their departed erstwhile accomplice? What, exactly, is his story, and more importantly, what is he going to do to the villains below?

If you can fill an image with such questions, then you're on the way to producing art that is much more than just a pretty picture.

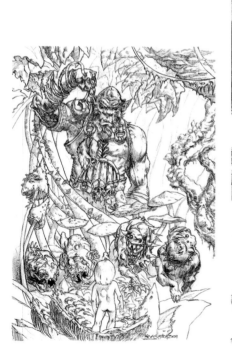

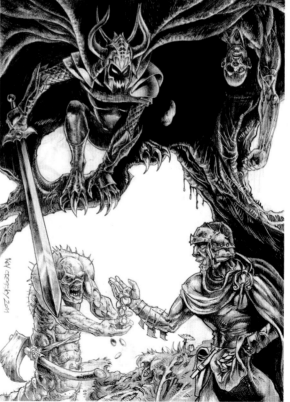

Far Left: A page from *Dragonfly*, when a Troll out pig hunting with his dogs discovers the infant Dragonfly.

Left: The new version of an old sketch.

TIP 024

Movement in Still Life

Artwork produced with pencils or paint is a static thing. It hangs on the wall or sits between the pages of a book or magazine and doesn't change. It lacks the ability to move. And yet so much great art seems to literally jump off the page or out of the canvas. The ability on the part of the artist to create the illusion of movement within a static image is surely one of the greatest feats of skill found in any of the arts, and it certainly isn't easy to master.

As a young kid I grew up reading UK children's comics such as *The Beano*, *The Dandy*, and the wonderful *Asterix* books drawn by Uderzo. The art in these stories was full of stylized cartoon characters and lots of action. The anarchic movement and motion within the stories was described using visual mechanisms such as "movement" lines that might describe the path of a footstep, for example, or the movement of an arm through the air. "Wobble" effects were also created by the use of short lines positioned around a figure or object. These movement lines were not intrinsic elements of the story—indeed, the characters were not aware of them, they were there purely for the benefit of the viewer. They acted as prompts for the eye to suggest movement and make the images more exciting to look at.

The cartoon strips here (top right) illustrate how these simple devices function. These swooping lines compliment and echo the line art, making it look more action-packed.

So, we've seen how the addition of movement lines can help sell the idea of action or motion within a comic, but such devices can't really be employed in more advanced or "serious" art, so you might wonder how movement can be created without the use of visual prompts like movement lines. The simple answer is to become fantastic at drawing anatomy in action-packed motion, a skill that is particularly evident in the superhero comics aimed at older kids (and younger adults—or any adult, actually!). However, this is a skill that requires a serious amount of study and practice to become proficient at and, indeed, there are shelves of books devoted to the subject.

As I progressed from childish doodles to producing art as an adolescent, I realized that I couldn't rely on using these visual crutches any longer, but a trick I developed soon stepped in to do the same job. I realized that I could use actual objects or elements within the artwork to describe movement. So, objects like scarves or necklaces, straps, blood drips, tentacles, hair, and the like were ideal to press into service as "movement-descriptive" devices.

This drawing (right) illustrates how these elements can be used to add flow and motion to a still image. Here are three characters, none of whom are striking particularly action-packed poses. Yet the windswept beard of the ogre and the swooping, extended "pony-tail" hair of the female warrior give the eye paths

Right: Cartoon strip.

Below: A page for *Dragonfly*, relying on "movement-descriptive" devices.

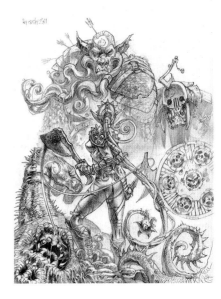

to follow around the image. These aspects are augmented by blood lines and elaborate, flowing ribbons as well as numerous spirals and circles, all of which conspire to create ripples in an otherwise-placid picture. The eye of the viewer is coerced around the image as one swooping line passes another, and the illusion of movement is achieved.

Anatomy: Reality versus Fantasy

Just as fantasy art presents us with worlds of the unreal to lose ourselves in, the physical forms of the creatures that inhabit it are subject to the same unreal considerations. While it may seem like a simple and obvious task to make up all manner of outrageous creatures and characters to populate a fantasy image, there is, in fact, a lot more to it than that. To draw from the imagination might seem obvious, but if that imagination isn't first filled with information to draw upon, the act of creation becomes very difficult. Therefore, it should be assumed that the best fantasy is informed by reality, so knowing how to draw what is real should be the natural starting point for any fantasy artist.

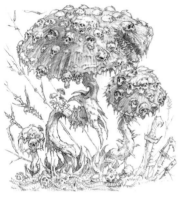

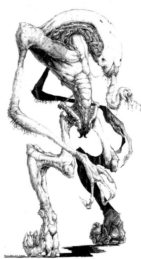

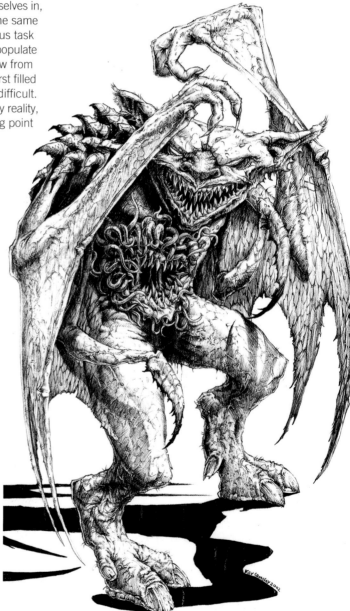

Above Left: A bizarre pencil drawing marrying fungi with fantasy horror, two of my favorite subjects.

Above and Right: Although utterly divorced from reality, these two monsters were nevertheless inspired by real-world creatures.

Know Your Anatomy 1: The Human Head

The head is a complex anatomical region that deserves to be focused on in isolation from the rest of the body. It is the home to the array of sensory organs that collectively make up the face, a region not only finely balanced and arranged, but also capable of great expression through movement and plasticity. It can take years to master this deceptively straightforward-looking set of features.

As with the rest of the body, describing the anatomy of the head could easily take up a significant portion of this book, but dry anatomy isn't the goal of *101 Tips*. However, it will be useful to have a short section devoted to it, so what follows is a simple breakdown of how to figure out where all the facial components fit in relation to one another. You will see this basic lesson repeated in a similar fashion (and in far greater depth) in all sorts of artistic manuals, books, and guides, but it won't hurt to have such knowledge included here for ease of reference.

An oval is a good place to start when drawing a head, which is simple enough. Deciding precisely where the features should be drawn in can seem trickier than it actually is, for there is a simple set of rules to help get it all perfect. First, draw a faint guide line horizontally through the center of the oval. This is where the eyes are positioned. As a rule, the eyes have a gap between them that's equal to the width of a single eye. Next, draw another guide line halfway between the eye line and the base of the oval (the chin). This line is where the bottom

of the nose is located. Then, another line halfway between the nose line and the chin is where the mouth is drawn. Easy!

The ears are no less simple. The bottoms of the ears are roughly level with the bottom of the nose, and the tops of the ears are at eye level, or thereabouts. It really is quite stunningly beautiful the way the features are all balanced in this way, and by using these guides, you just can't go wrong.

So that's a basic guide to drawing the head and face, but I can't stress enough the importance of studying this subject further, as there are, of course, lots of other little aspects to take into account. The more you learn, the more you'll practice, and the easier it will become to draw.

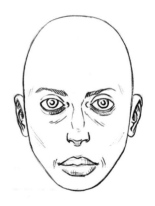

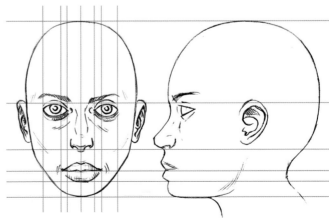

Right: How a human head is proportioned, and the drawing stages involved.

SKETCHING AND DRAWING:
ANATOMY: REALITY VERSUS FANTASY

TIP 026

Know Your Anatomy 2: The Human Body

Fantasy art may well be partly about exaggeration of reality, with particular emphasis on the body, but a solid understanding of real anatomy is essential as a starting point. You can only break anatomy convincingly if you possess a firm knowledge of the subject to start with. To that end, it will pay dividends to study how bodies go together, and how the bones and muscles relate to one another. As a brief taste of what is, in fact, a huge subject in its own right, here are several studies focusing on the proportions of the human skeleton and muscle structure, with particular focus on the limbs, along with a few drawings of the human body in motion.

There is a balance to the human body and face and discovering the basic rules of how it all fits together will, of course, make the task of drawing them in action poses much simpler.

As a starting point, practice drawing people from the front, side-on, or back, and work on the proportions until it becomes second nature.

Another great way of learning how to draw real people is to freeze-frame movies or videos of athletes or gymnasts in action, then take drawings from them. This is useful for studying walking and running cycles, as well as scrutinizing how the body actually deforms during motion, both slightly and in extreme.

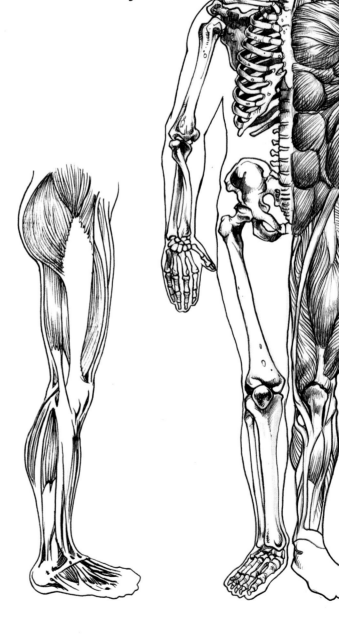

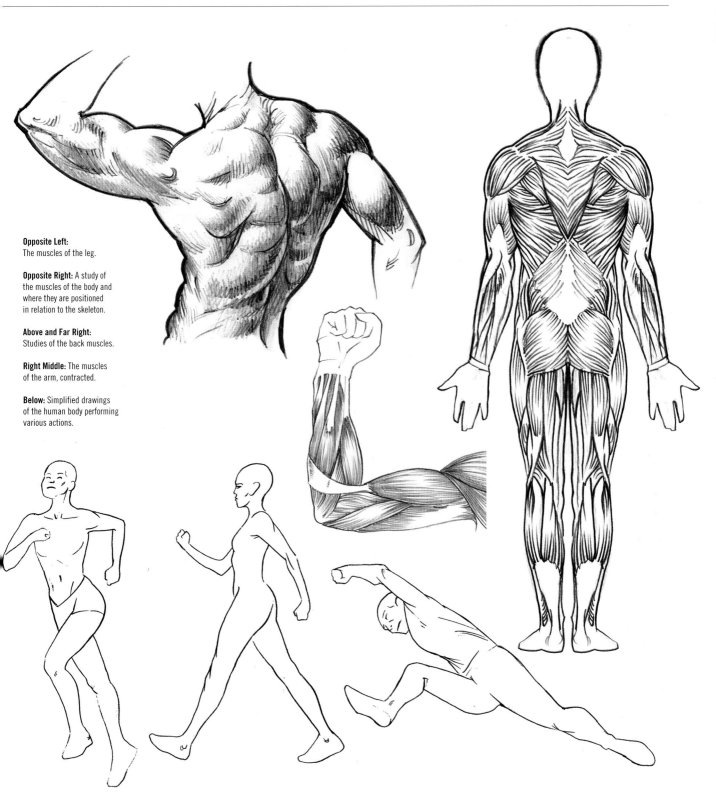

Opposite Left:
The muscles of the leg.

Opposite Right: A study of
the muscles of the body and
where they are positioned
in relation to the skeleton.

Above and Far Right:
Studies of the back muscles.

Right Middle: The muscles
of the arm, contracted.

Below: Simplified drawings
of the human body performing
various actions.

SKETCHING AND DRAWING:
ANATOMY: REALITY VERSUS FANTASY

TIP 027

Exaggerate Your Anatomy

Superhero comic art is a very particular branch of fantasy and perhaps the best place to see anatomical exaggeration at work. Shown here (right) are a team of heroes specially commissioned to strike a pose to illustrate this point. Using the drawings in the previous tip as comparisons, you'll notice the legs in particular are far longer than they should be. Furthermore, the lower leg is longer than the upper leg when, in fact, it should be the other way around. This is clearly incorrect, and yet it somehow works within the context of the illustration. There are a few reasons why this might be the case. Clearly, it is a stylized pictorial representation of reality (hence, cartoon!) and, as such, any anatomical inaccuracies tend to become less noticeable. Also there is the probability that because our generation has been exposed to graphic representations of this sort throughout our lives, we have come to accept it as truth.

There is another benefit, though, of elongating limbs in such a way—it can help to reinforce drama within the illustration by creating the illusion of forced perspective without having to resort to *actually* working out a shot in proper forced perspective, where the point of view (POV) is placed at an extreme angle, accentuating the scale of objects (or limbs) close to the POV while making elements further away far smaller.

(Incidentally, this limb exaggeration is also utilized in cosmetic and fashion photography, sometimes with hilarious results. I found an advert for expensive jewelry in a French magazine in which the model had her lower legs extended so far, they were longer than the upper legs and body combined! How it ever got approved I'll never know.)

Anatomical exaggeration is also about positioning limbs in completely unlikely extremes to enhance the drama or action within a scene, as shown in the second image. However, it is the female body that is distorted the most in fictive art. As well as the stretched legs and accentuated posture, women tend to be portrayed with waists that are much narrower than any real woman could achieve without the aid of corsetry or surgically removed ribs. Within fantasy art, such stylized representations have become commonplace, but can only be carried out with conviction if you have a solid understanding of correct anatomy in the first instance.

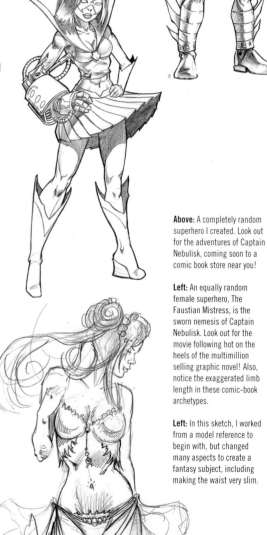

Above: A completely random superhero I created. Look out for the adventures of Captain Nebulisk, coming soon to a comic book store near you!

Left: An equally random female superhero, The Faustian Mistress, is the sworn nemesis of Captain Nebulisk. Look out for the movie following hot on the heels of the multimillion selling graphic novel! Also, notice the exaggerated limb length in these comic-book archetypes.

Left: In this sketch, I worked from a model reference to begin with, but changed many aspects to create a fantasy subject, including making the waist very slim.

TIP 028

Completely Breaking Your Anatomy

Of course, after a hard day studying anatomy and learning how not to break it, what better way is there to unwind than "making some stuff up?" Here are some examples of creatures created with a base concept of reality, but new coding on top to allow limbs, muscles, and skeletal structure to be deformed in crazy, unlikely ways, yet which retain physical conviction and balance. The zombie ogre might look totally unnatural, but is quite ape-like underneath all the bones and bolted-on bits of metal. The elf creature is simply a stretched human body, albeit with a few modifications, and the last image is, well, a complete fiction! Even so, it still obeys certain laws of how a body would fit together, which gives it a feeling of authenticity.

Bottom Left: This zombie ogre has ape-like proportions, which complements a host of monstrous features.

Left: Elf-like creatures with bodies that are far too long.

Below: A totally deformed creature with shoulderblades pushed forwards and too many joints in the limbs.

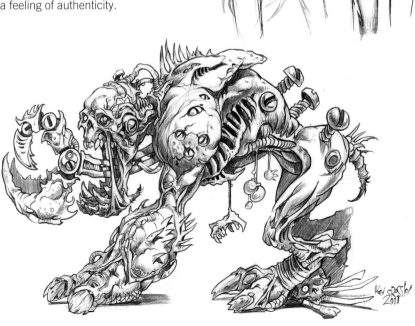

Composition and Concepts

Composition, or how the various elements within a painting are positioned in relation to one another, is one of the most vitally important aspects of an image. It is the foundation that underpins the visual cohesion and balance of a painting, and no matter how accomplished at painting an artist may be, if the composition is flawed, it will always show in the finished work. It is also important to note that major compositional changes late in the development of a painting are never easy to execute and can throw the balance of the whole piece completely out.

Creating a painting is, of course, exciting and inspiring, and part of what makes a great painting is the passion and creatively liberating techniques that go into it, which might seem at odds with the technical, sometimes clinical, processes involved in working out the layout of the image in the first instance. While there is no denying that developing a sturdy composition demands a unique type of focus as well as a good eye for balance and aesthetics, once all the elements of an image are in place, it makes

the process of adding paint to it all the more fulfilling, and can, in fact, make the process easier, allowing the artist to explore ideas and techniques unfettered by worries about compositional inconsistencies.

This section of the book also happens to be the largest, containing 19 tips in total that cover everything from The Golden Ratio to characters, vehicles, landscape, and architecture. This was quite unintended, but as I began breaking the chapter down it became clear I would need far more than ten tips to cover everything that was required. In the same way that a complex painting needs each of the elements therein to be balanced carefully within the whole, each of those individual elements must also have compositional considerations, as well as a good deal of thought put into their conception. And so the initial ten tips became 19 in no time at all, and could easily have stretched to more. The overall result is a section that goes on quite a journey, but not, I hope, one without some fun art and thought provocation along the way.

Right: Fantasy meets sci-fi in Gary Tonge's futuristic cityscape. The strong composition leads the eye around the image.

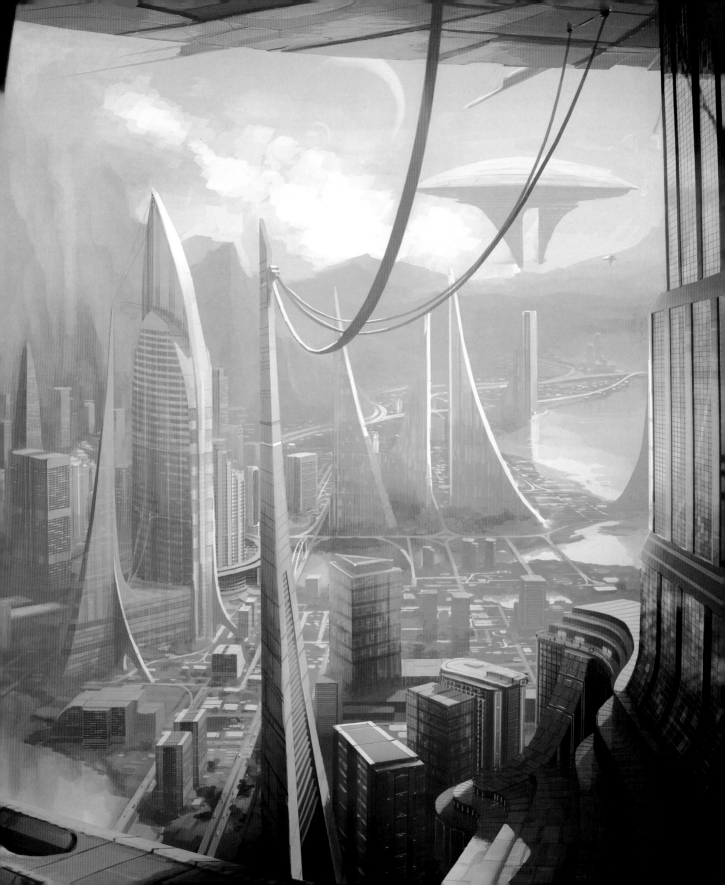

Principles of Composition

TIP 029

Composition: Where to Start?

The best way to begin thinking about the composition of a painting is to simply start sketching. If you have an idea in your head about what it is you want to do, you really have to try to get it out on paper. Only then will you be able to visualize the concept and push it toward a final composition. This might sound like an obvious thing to say, but a common mistake made by inexperienced artists is to start drawing something without first having produced any sketches to work out exactly what's happening in the image. Obviously, this is particularly applicable the more complicated an image is, but without that safety net of a few work-out sketches, there can be problems down the line. (I speak from experience—when I was starting out there were quite a few times that I began drawing a Spider-Man or Judge Dredd picture, only to run out of space for their head, arm, or foot. Rather than start again, I usually tried to alter their posture in such a way as to allow me to fit everything in, and although I got away with it occasionally, most of the time I was left with a distinctly deformed-looking drawing!)

This zombie cyborg (below) began life as a nondescript doodle in my sketchbook. I then filled the page with variations until I had a sheet of sketches, some of which were starting to look interesting. One in particular seemed like a good basis for a more developed drawing, so on a new page I began a new version. I still didn't really know what the character was or who he might be, but as I worked on this new rendition it soon began to dawn on me that it was, of course, a zombie. Naturally. So, I began to flesh out the face, or rather I began to UN-flesh out the face until I had drawn a cool-looking skull, with a little connective skin

stretched between the protruding cheekbone and the jaw. Then, I noticed a random pencil mark on the forehead that seemed to suggest there was some kind of metal hatch there. Hmmm, clearly this wasn't just a zombie, it was a CYBORG zombie. So, armed with a new addition to the concept I doodled in some cybernetic features, sketched a gun on the back, added some background elements, and worked out where best to frame it. Happy with the overall balance of the composition I then began work on the final pencil render on a sheet of 350gsm textured watercolor paper, using blue and red Col-Erase pencils to complement a

Right: A series of sketches to flesh out a good composition.

Far Right: A worked up version of one of the sketches.

regular HB grade. When the drawing was complete I painted it in acrylics. The texture on the foreground rocks was created with acrylic texture medium, a thick, paste-like substance that has sand mixed into it. This was applied with a palette knife, and shaped into an interesting rough surface. Paint was then dry-brushed over the top in layered applications to create lighting effects. This technique was pure experimentation, but it worked out quite well.

Above Once the composition is in place the sketch is worked up further.

Right: The final artwork, painted in acylics.

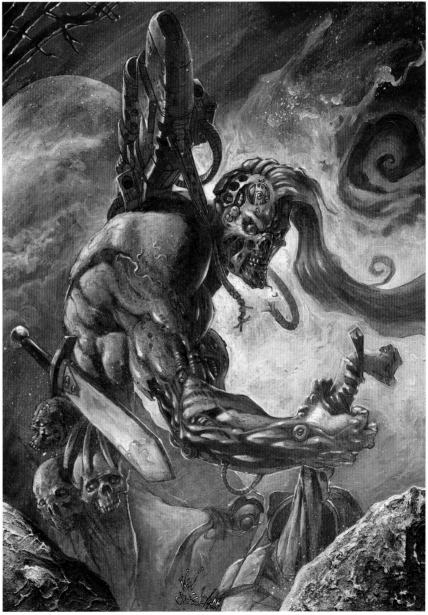

COMPOSITION AND CONCEPTS:
PRINCIPLES OF COMPOSITION

TIP 030

Working to a Brief 3: Shaping Up

This next visit to the Four Horsemen of the Apocalypse brief covers quite a few subjects, and so monopolizes the next few tips. Let's start by looking at the use of shapes as a compositional tool.

One very useful method to use when working out a composition is to rely on a series of basic shapes. Squares, rectangles, triangles, and circles are all great devices for breaking down a canvas into compositional regions, and for deciding where all the different elements will be placed. These elements, too, can be portrayed by shapes; people or monsters can be represented by rectangles, buildings by larger shapes such as squares or triangles, and horizons or vanishing points defined by using lines or small circles.

One particular technical consideration might be, for example, where to leave space in an image for text or logos, if the image is to be used as a cover for a book, game, or other such publication. In this case, a thumbnail can be quickly sketched using these basic squares and triangles to denote where gaps should be left within the composition, and hence where the focus of the image should be.

These shapes can also be used to enclose groups of characters or objects, and those groups can then be subdivided within these constraints using yet more shapes. As you can see, compositional considerations can get quite complex, which is where using simple shapes can make it a far easier job if you have a lot of elements to keep track of.

My Four Horsemen of the Apocalypse was just such a complex image, and although I felt I had a good thumbnail sketch, when I began to think about turning it into a finished drawing, I found it was still not quite right. So I opened the sketch in Photoshop and began to work with some basic shapes (below right) to refine it a little.

I began by tweaking the spiral of Hades, removing the small spirals that were leading the eye into dead space (outside the canvas), and adding them instead to the main spiral body in a much more attuned arrangement. Next, I enlarged the leading Rider and adjusted the scale and position of the others to create a vague triangular configuration for them all to occupy within the image.

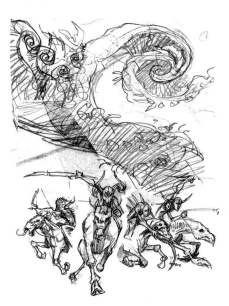
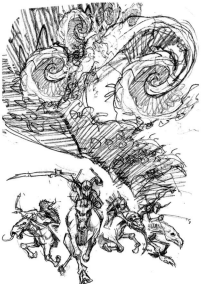
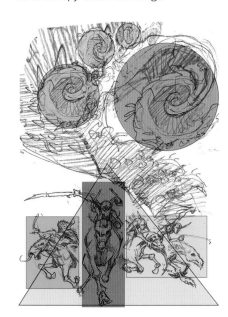

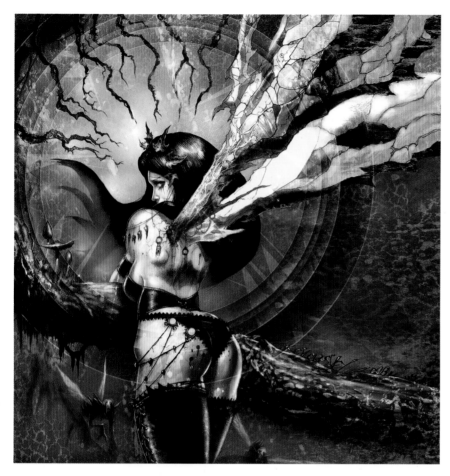

The finished image was only subtly different from the initial sketch but, by using a few shapes as guides, I was able to make the small changes necessary to create a much better balance within the composition.

Opposite Left: Initial thumbnail sketch.

Opposite Middle: Revised composition.

Opposite Right & Left: Dividing key elements of the artwork into shapes helps to set the composition.

Above & Above Right: Circles are powerful visual devices that persuade the eye to follow the boundary lines.

Another aspect of shapes is the inherent visual power they have, which is, in turn, transcribed into a finished painting. Squares and rectangles make strong, bold statements within a composition, but perhaps the most interesting is the circle. Circles can be used to lead the eye toward a focal point within a picture and, during compositional planning, can be used to make a visual note about where something might go. They respond very well indeed to being positioned over one another to create strings of circles, cascades, or concentric rings—all very powerful visual devices. I utilized this effect within the spiral of my apocalypse image, using spirals within spirals to create a proto-fractal effect. However, in a way quite different to shapes with straight edges, the curving boundary of the circle is very difficult for the eye to resist following, and using circles like this is a great way to control where the viewer's eye will move around a painting. So, overlapping circles will allow the eye to flow around an image in unbroken swoops and turns, creating an impression of a composition that is literally "hard to look away from." It is the visual equivalent of a "page turner," and will ensure an audience keeps coming back for more.

COMPOSITION AND CONCEPTS:
PRINCIPLES OF COMPOSITION

TIP 031

Working to a Brief 4: Rule of Thirds

There is another compositional guide, used mainly by photographers, but which is also useful in art composition, called the Rule of Thirds. The principle is to avoid arranging elements within an image around a center line—for example a horizon line that is positioned halfway between the top and bottom of the canvas. Instead, the horizon could be moved up or down, positioned a third of the canvas from the top or bottom edges. This makes for a more interesting layout, and can make counterbalancing foreground and background elements much easier, too.

Mixed with asymmetry, it will result in varied and exciting compositions. I used this method when reworking my apocalypse sketch, ensuring the riders occupied the lower third of the canvas while the upper third contained most of the Hades spiral. These two opposing areas are still connected through the center third of the canvas by the curve of the spiral body, which can be seen to create a fluid S shape. This is a naturally strong visual guide for the eye, linking the different elements of the image, while creating flowing movement at the same time.

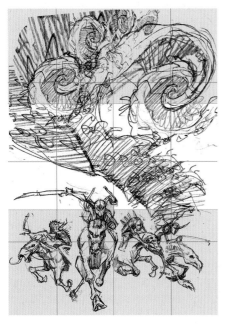

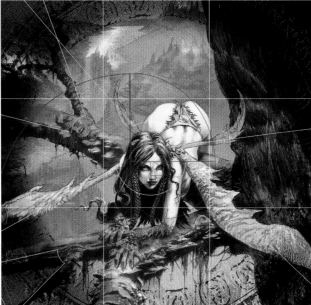

Above: The elements occupying the top and bottom thirds of the page are connected by the curve of an S shape.

Far Left: The Rule of Thirds applied to the Four Horsemen of the Apocalypse sketch.

Left: The Rule of Thirds applied to a sketch of a tree faerie.

$$A = B + C$$

TIP 032

Working to a Brief 5: The Golden Ratio

As we've seen, the circle can also be adapted into another sort of structure that is potentially even more visually alluring; the spiral. This is perhaps the most recognizable application of the Golden Ratio. This incredibly important and influential concept not only explains and describes the inherent beauty and balance in many natural shapes and forms, but it has also been utilized for thousands of years by architects and artists to design great cathedrals and magnificent artworks.

It is based on a mathematical formula that utilizes a ratio or proportion defined by a number called Phi (1.618 . . .) This number is found within a series of geometric executions, each of which splits a line segment (A) at a certain point, resulting in two new segments, one slightly larger than the other (B and C). The relationship between these segments is constant; so the ratio between A and B is equal to the ratio between B and C. Simply put, A is to B as B is to C. A is 1.618 times larger than B, and B is 1.618 times larger than C. This formula is reiterated to create the Golden Spiral, also known as the Fibonacci Spiral, which describes patterns and structures found in nature, and which can be used to create harmony and balance in a piece of art.

I realize that, to some, such a math lesson might seem a little imposing or even out of place in a book about fantasy art, and I must admit that it took me some time to grasp the concept myself. However, I felt it was appropriate to include a brief paragraph about it as it is such an important and useful concept. The beauty of it is that you don't have to understand how it works to exploit it, but once you do grasp it, the extra depth of understanding it represents makes the act of creating art so much more satisfying. It's a wonderful example of science and art coming together to the benefit of all, so I hope you will forgive this little extra-curricular excursion.

Above Right: The formula in the Golden Ratio reiterated creates a Fibonacci spiral.

Right: The Fibonacci spiral applied to a dragon sketch.

Middle Right: The Fibonacci spiral can help compose sketches where the perspective is distorted.

Far Right: The Fibonacci spiral applied to the Four Horsemen of the Apocalypse.

COMPOSITION AND CONCEPTS:
PRINCIPLES OF COMPOSITION

TIP 033

Don't Lose Sight of the Bigger Picture

This tip is concerned with detail—when to show restraint with it and when to just let it rip.

A mistake I often made as a younger artist (and sometimes still do) was to spend so much time absorbed in the intricacies of one area of a picture that I lost track of the overall balance of the whole. A common mistake is to focus too soon on working out things such as muscle tone or clothing on a character, or architectural detail on one building, without first working out the anatomical or topographical balance of the complete picture. I once spent an entire evening drawing a beautifully detailed arm holding a sword, only to realize the arm was at a completely incorrect angle and scale compared to the rest of the body. All that work was wasted and I had to start again.

However, although you should always be mindful of the "bigger picture" when working on a painting or drawing, sometimes you just have to allow yourself to get lost in the detailed parts. Personally, I treat these excursions into indulgent detail as rewards after spending time doing the less fun parts of art creation; compositional layouts for example. It's always a great way to let off steam. However, good balance within a composition can be maintained by having the detailed areas broken up and separated by areas that are less complex or crowded. This "visual punctuation" also acts as a "windbreak" for those times when you have to concentrate on the detailing, which means that however deeply focused you might be on

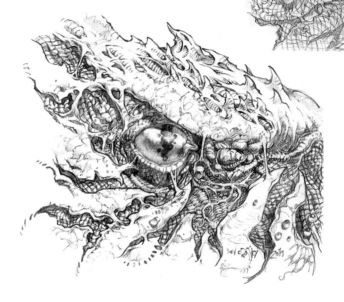

Above: The intense detail in this doodle detracts from the bigger picture.

Left: A more refined version, where areas of minimal detail break up the image, making it easier on the eye.

rendering that little grisly area around that dragon's eye, for example, there will come a point when you meet the edge of that area, bringing you back out of the picture so you can review overall progress and maintain a cohesive balance.

Here (above) are two versions of a drawing. The first (top right) was a sketch I produced almost absentmindedly late one night while relaxing in front of the TV. Although eye-catching, it is also a great example of how too much detail can damage visual legibility, resulting in a cluttered-looking picture that lacks focus and also doesn't have much tonal range. Perhaps I'm being too harsh on what was essentially only intended to be a doodle, but another aspect of being a professional is that, unfortunately, you subject everything you do to the same

level of judgemental scrutiny, whether it is a scribble or a finished painting.

While it is always fun to lose yourself in the act of producing a good, detailed work, you must keep in mind that the broader picture might suffer because of it. This isn't always an easy balance to strike.

The second image shows another version of the same picture, but this time executed with a little restraint to produce a more balanced-looking picture. The detail has been applied in more interesting, visually contained configurations, with areas broken into less detailed armored plates to create areas of calm amidst the visual noise in the picture. Now the eye can more easily discern what is actually going on in the image. In effect, it has the room to breathe.

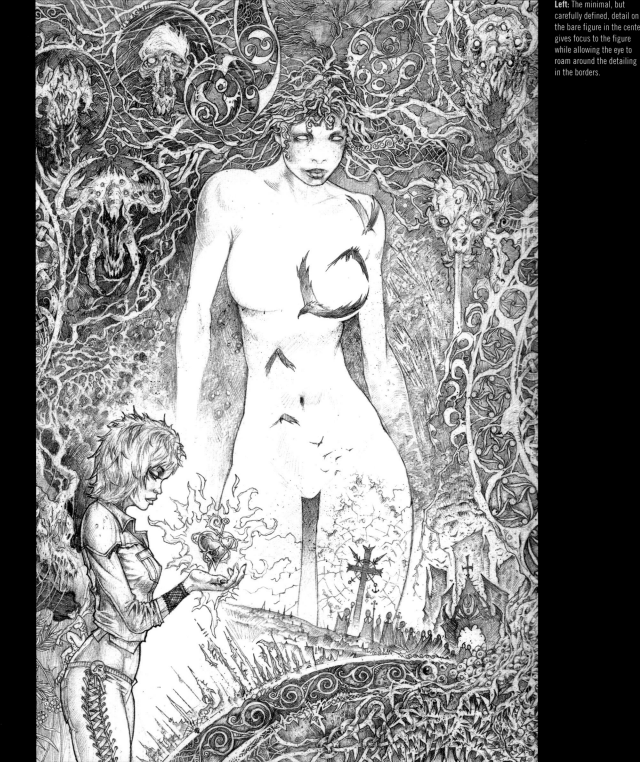

COMPOSITION AND CONCEPTS:
PRINCIPLES OF COMPOSITION

TIP 034

Working to a Brief 6: How Content Influences Layout

When I began thinking about the layout for the Four Horsemen of the Apocalypse, I was initially concerned solely with the riders themselves, so I produced a number of sketches featuring the four close up, so I could put lots of detail into them. This meant the orientation of the picture was naturally landscape. I produced a fairly detailed sketch featuring the riders filling the frame.

I was settled on this as the layout until I began doing a little more research about the subject, and discovered the mention of Hades following in the wake of the Death rider. This changed everything, as I knew I had to include this vision of hell incarnate as part of the composition. No matter how many new thumbnail sketches I produced using the landscape template, I just couldn't find a way to balance the riders with this vision of Hades. It was a good example of how difficult it is to make changes to an established composition, and I knew I had to scrap it and start again. (This is another great tip: never be too proud or scared to abandon a concept, picture,

or painting if it isn't working, no matter how long you've been working on it.)

This time, I changed the orientation to portrait. I repositioned my basic rider layout at the bottom of the image, which of course made them appear smaller in the finished composition, but it meant I now had an entire empty area of canvas in which to place Hades. Quite apart from the compositional considerations, this change of orientation inspired me to double the size of the canvas so, in fact, I would still be drawing and painting the riders at the same physical size as I'd originally intended. So far, then, so good! Next I simply had to sketch in lots and lots of monsters to represent Hades. Simple? Not at all.

While it would have been okay to simply fill the sky with these creatures, it soon became clear that such an approach looked too messy. It would still have been fun to lose myself in creating the monsters themselves, but viewed from a distance of just a few feet, the effect would have been indistinct, or even offensive.

My response to this first layout idea was the realization that it had to be clear they were following in the wake of Death. This mass of creatures needed some kind of structure, a visual constraint that would also serve to focus attention and draw the eye around the image.

My next approach was to adopt one of my favorite visual devices—the circle. This seemed a natural direction to move in, as I could create a focal point in the sky out of which the horde of monsters would come. It's a very strong visual device, and the next sketch I produced was already a vast improvement. I opted to draw the creatures emanating in concentric circles from a black sun in the center of the sky. It looked pretty good, and the tone thumbnail looked quite striking, too. However, it still lacked a logical narrative with the riders, as it was just a separate element above them, more a background than something that was connected to them, so I had to rethink. The circle was still working on a fundamental level, so it just needed a little tweak. It was obvious really; I broke

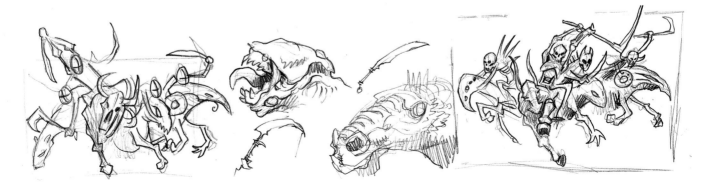

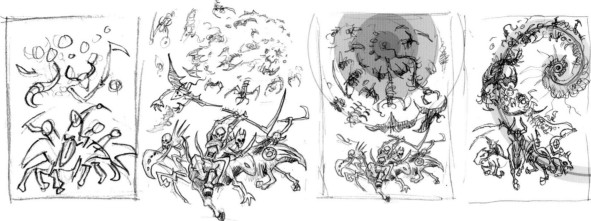

Opposite: Landscape
sketch versions of the
Four Horsemen.

Right: The finished
pencil composition.

Above: Portrait layouts
with Hades in the sky,
including one utilizing
the Golden Ratio.

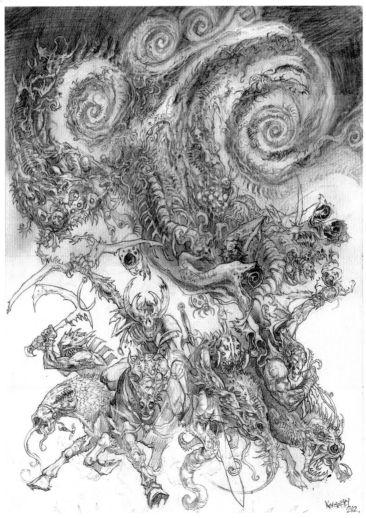

the circle down and turned it into a spiral.
This new line began in the center of the
black sun and spiraled out, getting larger
and larger, but it also solved the problem
of connectivity with the riders, as this
ever-widening line flowed smoothly
toward the Death character. A quick
adjustment to his posture resulted in a
raised arm holding a billowing cloak, out
of which came Hades, and the host of
hell fell back into the sky. Perfect.

So, I had my layout. It was balanced,
and offered some promising opportunities
for striking lighting and grisly, arresting
detail. To finish up, I wanted to disguise
the spiral device a little, and so I broke
it down into secondary swirls and loops,
although all were ultimately still aligned
with the overall structure.

COMPOSITION AND CONCEPTS:
PROCESSING SKETCHES

Processing Sketches

TIP 035

Tidying Up Scanned Sketches and Paintings

Although a lot of fantasy illustration these days is created digitally using a variety of software tools, many digital artists still start traditionally. Of the many uses Photoshop can be put to, one of the most basic and useful is its ability to tidy up rough scans or scruffy drawings, and this is a strength that makes life so much easier. It can save a lot of time, too.

Most digital paintings I create start out as sketches or more finished renders created using pencils or, sometimes, ink, which are scanned into Photoshop ready for "processing" to prepare them for digital development. The beauty of painting, whether digital or traditional, is that it can cover up a multitude of sins in a slightly dodgy drawing, but sometimes a little tidying up doesn't hurt, either. Here (above right) I scanned in a couple of rough sketches from my sketchbook, but the scans were rather dark and slightly yellowish. What I wanted were clean, dark lines against a bright background, so I needed to brighten the scanned art without making the linework fade or disappear.

To do this, I started by opening the Levels dialogue (Image > Adjustments > Levels or Ctrl+L). Adjusting the sliders alters the light and dark balance of the image, so I experimented until the background was lighter but the linework was still dark. Next, I duplicated the background layer

(Ctrl+J) and set its Blending Mode to Multiply, which allowed the background to show through, strengthening the weight of the drawing. This also darkened the background a little, so I made further alterations using the Brightness/Contrast dialogue box (Image > Adjustments > Brightness/Contrast). Reducing the saturation turned it into a grayscale drawing, and to finish, the Lasso tool was used to select any imperfections and delete them.

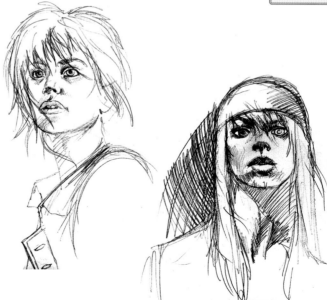

Top: These scans of pencil sketches show how the quality of some scanners can result in images that require tidying up.

Above: The Levels function in Photoshop is a useful tool for adjusting the contrast and tonal balance of an image.

Left: The tidied up scans.

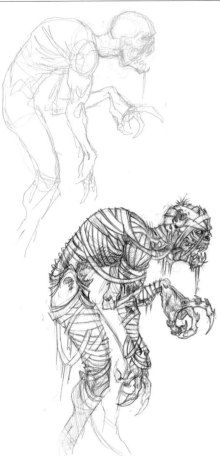

Similar techniques can be applied to scanned paintings, and they are particularly useful if you happen to be using an old scanner that might produce scans that are a little too dark. This sketched pose (left) was colored orange in Photoshop, then printed onto Bristol Board as a base for a detailed pencil drawing of a decrepit, mummified zombie. Gouache was then used to paint the creature, producing a nice, ragged look. I then scanned this back into Photoshop, but the resulting scan was quite dark and rather desaturated. This made the image look flat and lifeless, but by increasing the saturation, adjusting the brightness and contrast, and tweaking the colors just a smidgeon, I produced a much crisper version of the painting.

All: After adjustment, the sketches are well defined against a clean background.

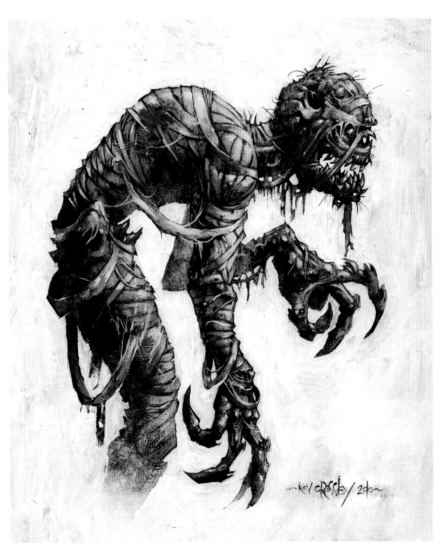

COMPOSITION AND CONCEPTS:
PROCESSING SKETCHES

TIP 036

Creating a Layout Using Multiple Sketches

Another great attribute of Photoshop is the ease with which you can construct an image template or design using numerous sketches or source images. To illustrate this, I collected a selection of sketches from different sketchbooks and scanned them into Photoshop. Each one was drawn as a doodle, without any thought of their use beyond being simply a sketch. I tidied up each image using the technique described in the previous tip before pasting them all into a new file with the orientation set to landscape. I ensured the Blending Mode of each image layer was set to Multiply, which allowed me to move each sketch around without obscuring or being obscured by any of the other layers.

Next, I simply moved each character around until I found a group pose that looked good. I flipped one horizontally, and used the Scale and Rotate tools to fine-tune the arrangement. I was left with a drawing that never physically existed, but which I can use as the basis of a new design. I might make a new pencil drawing based on this concept, or I could simply begin a digital painting directly over it. This technique is a great example of traditional and digital media complementing one another beautifully.

Above: Here, a collection of doodles are scanned into Photoshop.

Left: The doodles are combined and composed into a new sketch that can be developed further.

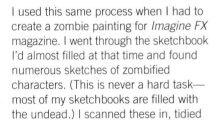

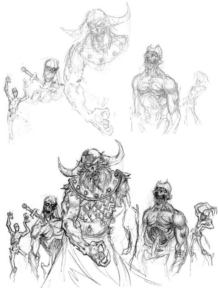

over this sketch, expanding on the scant detail until I had something I could take to the next level. This meant adding paint, of course.

I began to paint using acrylics, which I first applied in dark washes over the entire drawing, picking out shadows and enhancing the physiques of the cadaverous creatures. Next, I used light tones—ocher, bluish, and gray—to finish the detailing, adding a moon to complete the picture.

The final stage involved scanning the painting back into Photoshop, where I adjusted the color balance, then finished with a touch of digital overpainting. From beginning to end, this was a painting created using both traditional and digital techniques, and this hybrid style of working is one of the reasons I love being an artist.

I used this same process when I had to create a zombie painting for *Imagine FX* magazine. I went through the sketchbook I'd almost filled at that time and found numerous sketches of zombified characters. (This is never a hard task—most of my sketchbooks are filled with the undead.) I scanned these in, tidied them up, then began to paste them all into a new multilayered PSD file. With a bit of judicious scale adjustment, I ended up with a very rough composition that looked promising, so I flattened the layers, turned the color to a light orange, then printed this out onto Bristol Board. I then produced a new pencil drawing

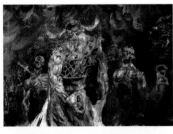

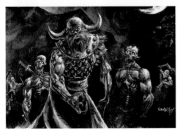

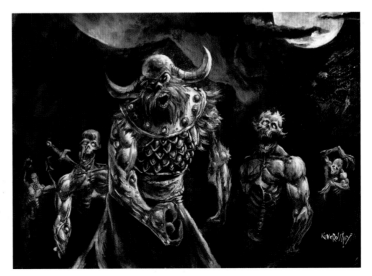

Above Left: Here, five sketches were gathered together from disparate sources.

Above: Each sketch was arranged in such a way to produce a brand new design.

Left: The design was printed out, tidied up in pencil, and painted using acrylics, before being scanned back into Photoshop for digital overpainting.

COMPOSITION AND CONCEPTS:
CREATURE DESIGN

Creature Design

Fantasy is reality skewed. It is a universe populated by exotic locations, peoples, and creatures, as wild and varied as our imaginations are capable of making them. However, although it may well have been born out of a compulsion to escape the drudgery, boredom, or trauma of reality, the most convincing of the unreal creations that abound throughout fantasy art retain something in their DNA that relates to the real world. For example, dragons are perhaps the iconic fantasy creation, with esthetic and mythological variations that permeate the folklore of almost every civilization throughout

history. Whether it is a ribbon-like dragon from Chinese legend, or a brutish, fire-breathing demon from a fantasy card game, all dragons are creatures of fantasy. Even so, it seems likely that their creation was a reaction to the unearthing of gigantic bones, frightening relics hinting at the existence of monstrous animals in our prehistory. It is surely no coincidence, then, that dragons more than superficially resemble dinosaurs.

The same principle can be seen at work within much of fantasy art. If you look hard enough at a monster or megalithic

Right: Dragons are perhaps the most widely recognized fantasy creature.

space cruiser you will usually find some aspects that hark back to the real world. If you design a creature that looks like a cow's head on top of a writhing mass of octopus legs, it becomes a fantasy, but you can recognize the genesis of it.

TIP 037

Real to Unreal

I set myself the task of creating a dragon-type creature, but using an everyday animal as a starting point. Although it might have been easier to use a lizard, I chose a horse instead—partly for the challenge, but also to illustrate how anything is adaptable. Additionally, the horse has a stocky, broad head that will impart a particular character into my creature design.

I started with a quick Photoshop sketch of a white stallion head, then created a new layer over the top and began drawing using a soft brush with opacity set to 70%. As I sketched, I added loose strokes to indicate scales and other reptilian features that followed the contours of the horse's skull shape. The eyes remained largely similar,

except for the addition of scaled ridges and eyelids. As I progressed, I began to think about the skull of the horse, which has a large gaping orifice behind the nostrils. It seemed like a pleasingly gruesome concept, so I worked it into the design. This influenced the area around the mouth, and the beast began to take on a life apart from its equine heritage. The ears suggested horns or spikes, but I extended that concept to a mane of spines flowing back from the skull.

I resized the image a little, elongating the skull. Then I began roughly daubing color over the drawing, and further enhanced the scaled aspect of the creature. So, from humble beginnings, a monster was born.

TIP 038

Find the Unreal in the Real World

Following on from tip 007 (Study the Natural World), here are some more examples of how real animals and plants can inspire absolutely crazy creatures. The earth is simply swarming with entities that might seem utterly alien to anyone lacking in-depth botanical or natural-history knowledge. Many of these organisms could be used in a fantasy picture and they would look completely at home, but it's far more fun to take real creatures as starting points, then veer your designs off into wilder directions.

Far Left: A monstrous centipede-type beast, as large as a tree.

Left: An insectoid lizard-type creature, part animal, part plant.

Below: I have no EYEdea what this monster is, but it has bits of all sorts of animals in its genes.

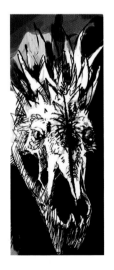

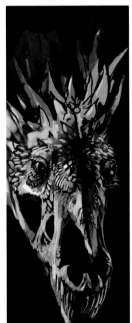

Opposite Far Left: This sketch of a horse seems like an unlikely starting point for a monster design.

Opposite Left: A new drawing was made on top of the horse, incorporating aspects of the skull into the design.

Far Left: The drawing was resized, and blocks of color helped to add definition.

Left: The details were gradually worked in with quick daubs of color.

COMPOSITION AND CONCEPTS:
CREATURE DESIGN

TIP 039

What If?: Creating a Natural History

The reason vertebrates look the way they do, why mammals and reptiles are all built to the same basic pattern with a head, four limbs, and a spine, is due to unfathomably long chains of evolutionary processes that stretch back millions of years. All physical attributes of every creature living today, or of any creature that has ever lived on this planet, have developed as a response to changing environmental conditions. Evolutionary life is a reactive, adaptive, responsive thing, extremely sensitive to environmental changes that might adversely affect the survival likelihood of a species.

There is, of course, a lot more to it than that, but this broadly explains the idea that is often given the title Survival of the Fittest, in which body shape is defined by an evolutionary history that stretches back in time. It is also an intriguing exercise we can explore to create brand new animals.

Imagine if land vertebrates evolved from a fish with more pairs of fins than the creature that was responsible for our four limbs? What would reptiles and mammals look like then? What if we started with a different creature entirely? Let's imagine that some kind of multi-segmented, armored invertebrate had crawled from the primordial ooze before evolving into a completely bizarre alternate bestiary of prehistoric animals. In order for such a creature to attain the size of dinosaurs or even the smaller animals of the present day, we must assume their internal organs evolved to mimic those of vertebrates, which would mean they would have lungs and a windpipe terminating in a head or some other orifice. Although this basic, multi-segmented and limbed body design would go on to influence every land vertebrate that followed, there is no reason why you should not vary the numbers of limbs, and we can imagine a whole world of creatures, each of which evolved in the best way to exploit and survive within its environment.

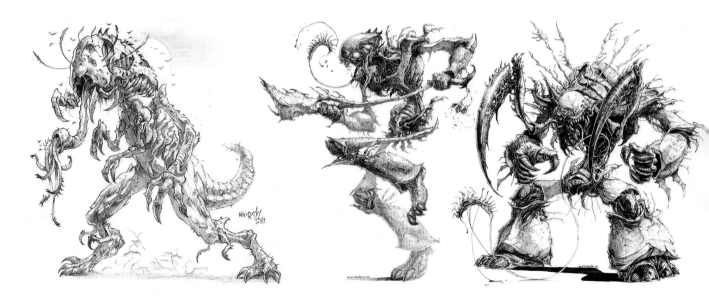

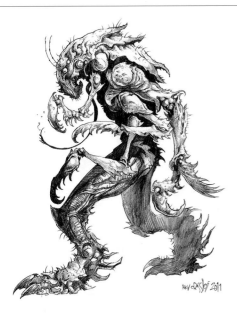

To finish, what about imagining totally outlandish body configurations? Creatures with double spines, or strange animals possessing circular spines with limbs attached like spokes, for example. What if corals evolved into higher animals that extruded their stomach in order to fight or eat? The possibilities provide a literally endless and increasingly bizarre resource for fantasy creature design.

Opposite Top: An ancient multi-finned fish evolved into this eight-legged armored lizard.

Opposite Far Left: What a Tyrannosaur might have looked like if it had evolved from invertibrates instead of fish.

Opposite Left and Above: Examples of humanoids that evolved from insects.

Right: What humans might look like had they evolved from a frog-like creature.

COMPOSITION AND CONCEPTS:
CREATURE DESIGN

TIP 040

Have Fun with Creature Design

Clearly, if you are serious about wanting to become a professional fantasy painter, then you must spend a lot of time practicing, make a few sacrifices along the way, and remain focused on your goal. It's a serious endeavor that should be treated seriously. However, if you try to achieve your ambitions and goals with rather too much zeal, you might actually stop enjoying what you do and, in doing so, some of the energy and life will be lost from it. So how do you combat this? Simple. Just remember to have some fun once in a while.

For example, let's have some fun at the expense of our favorite Mesozoic monster, T-Rex. Tyrannosaurus Rex was a giant, megapredator dinosaur who dominated the world during the late Cretaceous era, between 85 million to 65 million years ago. Everyone knows this, of course. What isn't quite so well known is the fact that there were many different species of T-Rex, some even possessing feathers . . . crazy! However, there was one Tyrannosaur who was much smaller than the norm, but far deadlier than any of its contemporaries, for it possessed a weapon seen in no other dinosaur. It had machine guns in its eye sockets.

Okay, so the fossil record might be a little inconclusive on that point, but during a trip to a museum I saw a dinosaur with strange objects in its eye sockets that I imagined were some kind of device designed for weaponry to be attached. (Such is the blessing/curse of having an imagination.)

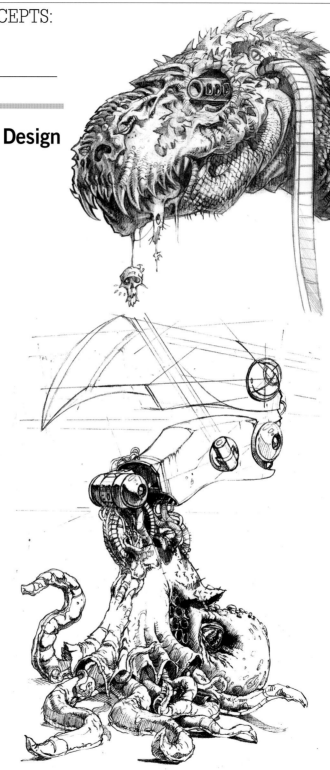

Above: A species of Tyrannosaurus Rex with machine guns for eyes.

Left: A cyborg squid.

Opposite: Various *Iron Heel* character concepts by artist David Millgate.

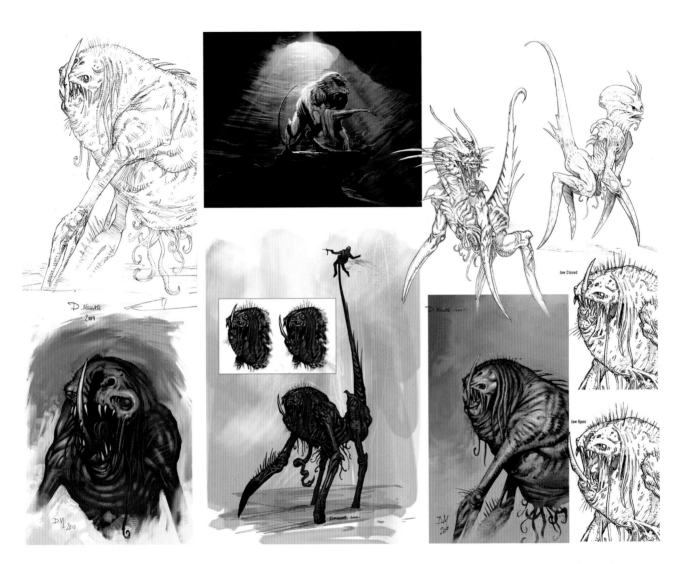

Exercises such as this are, of course, a bit silly, but they do stretch the imagination, allowing it "off the leash," if you like, which is always good to do, as you never know what rich seam of crazy-cool ideas it will unearth. And, of course, a wide-ranging imagination will always come in useful down the line, such as when you need to invent . . . a cephalopod with a giant cyborg pincer, for example.

When David Millgate was developing creatures for his *Iron Heel* story, he took inspiration from a number of existing creatures, but married the elements together in such a way that the final monster looked like nothing from this earth. The design evolved from early sketches, which featured heavy, bestial physiques, to more slender variants that drew resonantly from reptilian physiology, but the blade-like, mantis forelimbs

persisted for some time, becoming longer, even stilt-like. The gruesome glee the artist took in the development of the creature is particularly evident in the freakishly extended lower tusk which, over the course of the animal's life, has carved through its upper jaw to split the face in two. It's a unique creation that nevertheless began life as the bits and pieces of real things, demonstrating an artist's license to experiment!

COMPOSITION AND CONCEPTS:
CREATURE DESIGN

TIP 041

Learn to See Monsters Everywhere

Most people have probably played the game in which clouds are imagined to resemble all sorts of random things. This is a tip about expanding that sort of imagination game. Learning to see interesting creature shapes, monsters, or faces within everyday things is a great way of getting your imagination working. (And one possibly born of a serious psychological problem, as I've been seeing monstrous faces in all kinds of everyday objects ever since I can remember!) Far from being a problem, though, this ability to form faces out of nowhere was a constant fascination for me. I would sometimes just let my gaze relax into a scene and, very soon, my mind would ascribe facial features to objects, shapes, or textures within the scene until a dragon or some strange ogre took up residence before my eyes. I would later draw these things with my trusty Crayola crayons, and years of having fun in this way certainly helped to lay the foundations for my later monster drawing.

Here (right and opposite) are a few examples of where monsters might pop up. It's a splendid way of relaxing after a hard day at the drawing board or graphics tablet, and a fabulous workout for that all-important imagination. And it probably ensures sanity remains intact for another 24 hours.

I discovered something fun to do that is related to this exercise. I've always found children's drawings quite charming, as they remind me of my own humble beginnings. I'm a particular fan of the weird and wonderful creations created by my own little boy, so I thought I might take one of his doodles and use it as inspiration for a new monster sketch. There simply are no words to describe this kind of fun, although he might have to wait a few years before I show him what I did to his drawing . . .

Below: Child's play—digital render of Aidan's nursery monster doodle; plus seeing monsters in the clouds.

Right: A series of objects subjected to "monsterfication."

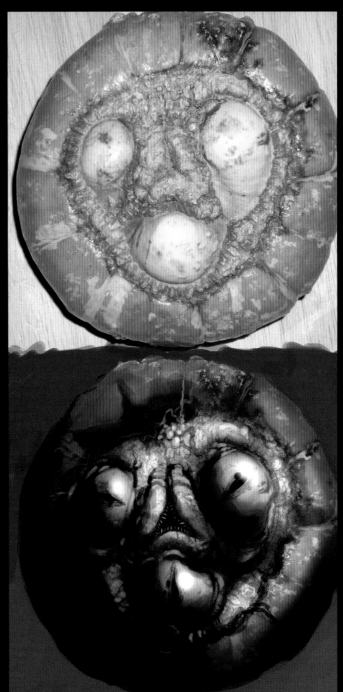

COMPOSITION AND CONCEPTS:
CREATURE DESIGN

TIP 042

How to Create a Krike Dragon

What better way to conclude this section about monsters and creatures than with a blow-by-blow account of how a dragon is created. In this case, it's a "Krike" dragon.

This fellow began life as a handful of doodles in a sketchbook. I had the idea of a circular shape formed by the wings of a hideous dragon, so I did a few sketches to explore how to tackle the layout.

I wasn't sure what sort of a head to give it. I didn't want a head that looked like you'd expect. Instead, I wanted something truly horrific. For inspiration I jumped onto the Internet and looked for images of deep-sea fish, and the monsters I found were perfect, with suitably gruesome names to match: Snaggletooth, Gulper Eel, Fangtooth, Bathysaurus, Viperfish. I set about producing a few studies based on these magnificently ugly beasts and soon settled on a head composition that looked interesting. I liked the large mouths filled with thin, needle-like teeth, but the feature that made these creatures look so otherworldly and nightmarish were the eyes set near the end of the snout while the mouth stretched far back. It was just the look I wanted and, along with an impossibly skinny neck, I had soon settled on a design I was satisfied with.

I scanned a sketch into Photoshop, then quickly augmented it digitally while producing a quick painting in blue-gray to set the tone. It was looking good, but I wasn't sure about the blue, so I changed the hue to a reddish brown, and overlaid some photographs of rust and moss, tinted to complement the image, with the Blending Mode set to Multiply. I flattened the image and was ready to start painting.

I began by adding a red ocher hue to the wing skin, and a touch of greenish ocher to the spike of rock the dragon was perched on. Next, I added detail to the head, using pale gray tones to create an almost rotten, fish-corpse look to the crown of the skull. This set the mood I was looking for, and I continued to add swathes of color to the dragon and rock spur, gradually building tone and detail. I wasn't too worried about staying inside the lines, as any errant coloring would be soon rectified. I began to sketch in crosshatched grids over areas of the dragon's skin, which would form the basis for scales.

When the dragon had the basic colors blocked in, I painted the background around it in a lighter tone. A pale, grayish-beige ocher gave the creature and the rock structure something to help it really stand out in the foreground and already the image was starting to sing. At this same time, I started to paint a little of the background color over the areas of the dragon that were a little further into the background. This simple technique offers a fantastic way of creating crucial depth and atmosphere.

Next, I concentrated on the rocky spur, which had some interesting shapes and skull objects that benefited from dark reddish-brown shadows and a selection of yellowish tones for the lighter areas. I also painted some reflected light into the shadows using lighter red tones, and the overall balance between the green and red hues in this area began to look quite striking, yet always complementary.

I also redesigned the torso of the dragon, which I had sketched to resemble the underbelly of a serpent. It just lacked flair, so I opted for an open ribcage, something more in tune with the zombie theme of the creature. The tail was also developed, and I liked the happy accident of the connective lines of color that made it look part of the rock. As the tail wrapped around the column, it swept behind these foreground elements, so I painted over it with the background color. At the same time, I used a diffuse brush to add a fuzzy cloud inspired by the rough digital suggestions made earlier in the process. This cloud would partially obscure the bottom areas of the image and help maintain focus on the center.

And so back to the dragon—I added more detail to the head, paying attention to the curved teeth, horns, and folds of skin beneath the eye. I added scales to the area around the mouth and created definition in the lower, shadowed jaw with some rich, bloody reds and ocher shades. These were carefully applied to form odd, bulbous protrusions clustered behind the head, as well as to help define the sharply jutting spikes positioned above. Connective filaments of tissue or veins were enhanced or added to break up the texture.

Gradually, scales were worked into the scrawny neck, each individual scale being refined to build up an overall skin texture that looked organic, yet distinctly unhealthy. I also used more photographs

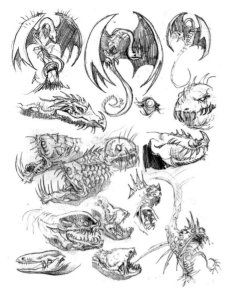

The Rest: This image was completed in Photoshop 7, an ancient version of the software, which goes to prove that it doesn't matter what you use to do a painting—what does matter is how you get the best out of that software or equipment.

for texture—just a touch of moss here, a patch of lichen there, overlaid using the Multiply Blending Mode—that I carefully erased and positioned.

Now almost complete, a few areas required finishing, and so the strange tendril that hung over the leg was given weight and substance, the leathery wings were made to look lined and weathered, and final flourishes of detail were added wherever there was room. Although it was tempting to continue adding detail, I decided to call it a day. Overall, the painting took 45 hours over a week.

COMPOSITION AND CONCEPTS:
CHARACTER DESIGN

Character Design

TIP 043

Giving a Character Different Treatments

This is a tip that crosses boundaries a little. Being able to produce numerous treatments of a character is a useful skill, not only when you're designing people to populate a painting, but it's also handy if you happen to be producing concept art for a video game, film, or TV show.

First, produce a drawing of a character. This will be the starting point for all the variations to follow. A great tip, when you have to do a number of variations like this, is to do every subsequent drawing over the top of the same original image. This is especially easy if you work digitally, but if you like to start your designs traditionally, as I do, then you can always print out numerous copies of a basic body layout. I usually print these in a light blue or yellow color, which can be easily removed from the finished art when it's scanned back in.

Then, using either of the methods described above, decide what kinds of treatments you want to give the character and simply make a series of drawings exploring these variants. In the examples shown here I began with a standard fantasy female character. I then produced a selection of quite different variations, including a ninja, vampire, ogre, and even a steampunk lady, complete with robotic arm! I finished with a completely wild-card version, presenting her in a manga variation to show there really is no limit to the styles and themes you can explore.

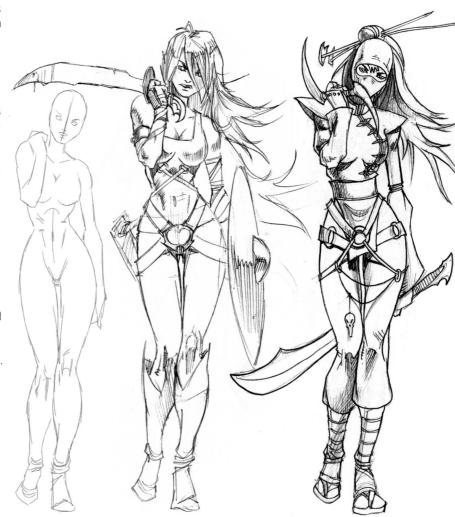

All: The characters were drawn over the basic, blue-line body shape template. The various versions of the character template are: classic fantasy, ninja, vampire, ogre, steampunk, and even manga.

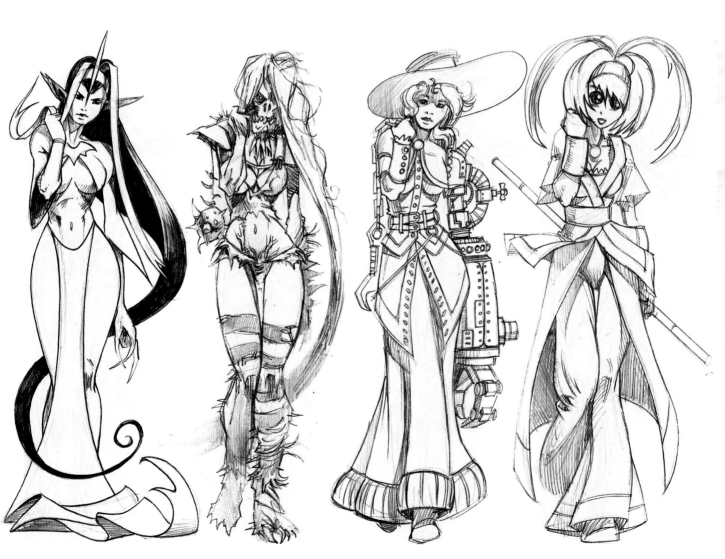

COMPOSITION AND CONCEPTS:
CHARACTER DESIGN

TIP 044

Armor and Weaponry

Although not all fantasy art involves armored warriors wielding all manner of incredible weapons, quite a lot of it does, so including a tip to talk about the subject seems perfectly reasonable. This tip expands one of the themes covered in the previous tip. Armor is one of my favorite subjects to play with in an image. It is very useful in creating and enhancing personalities for the warriors who wear it, and it can be helpful for identifying different sorts of people or tribes within a composition. It also lends itself to endless variations within themed parameters, so you'll always be able to fill an image with lots of unique content.

Inspiration can be found in historical examples and there are some wonderfully crazy armors employed by various armies across the ages. Opposite, bottom right, is a small selection of designs based on different kinds of armor worn by warriors from various ages in the past.

Something to keep in mind when designing armor and weaponry is to think about where the soldier or warrior comes from. What sort of society are they a member of? How technologically advanced are they? Such considerations will inevitably influence how a fighter would be equipped for battle.

Many soldiers throughout history would have been poor, pressed into service by their local lord or sheriff. Such men would have to equip themselves as best they could, and might actually go into battle with nothing but a leather skull cap and pitchfork. However, if such soldiers managed to survive their battles, they would have the opportunity to scavenge for better armor and weaponry so, over time, you would see such soldiery evolving into a mishmash troop with mismatched armor, helmets, and weaponry. This was realized to great effect in Peter Jackson's *Lord of the Rings* trilogy, in which the various clans of orcs can be seen equipped in just such a fashion.

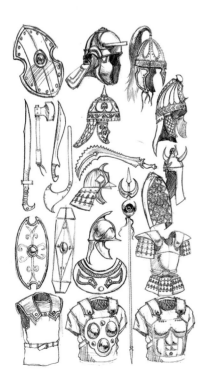

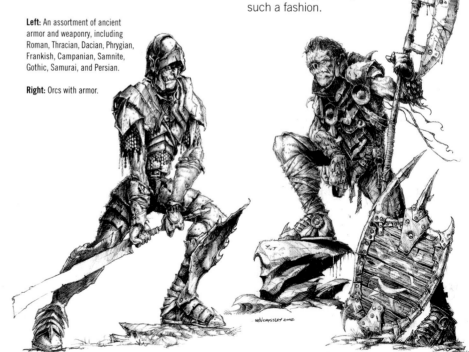

Left: An assortment of ancient armor and weaponry, including Roman, Thracian, Dacian, Phrygian, Frankish, Campanian, Samnite, Gothic, Samurai, and Persian.

Right: Orcs with armor.

Professional soldiers or armies conscripted by a wealthy state are quite different. In these circumstances, armor and weaponry is mass produced in designs that are practical and effective, using the best materials available. The legendary longevity and success of the Roman war machine was due in no small part to how well equipped Roman soldiers were. Clad in steel, they were often far better protected than their enemies. At its height, Rome equipped its legionaries with armor and weaponry that was technologically the most advanced in the world at that time, and they backed it up with military strategy beyond that of most other armies.

The soldiery of the similarly legendary Samurai armies of feudal Japan were also very well equipped. Ordinary warriors were issued with robust, segmented helmets that folded flat (excellent for mass transportation and storage), and similarly segmented lacquered armor. This practical approach to mass production resulted in armor that looked unique on the stage of military history, and similar considerations could easily be utilized when designing fantasy armor.

Isolated peoples would generally have no option but to clad themselves in armor constructed from whatever materials they had access to, so civilizations with limited access to metals might clad their soldiers in leather hide with animal bones stitched in, while other tribes might wear skulls and bones purely to terrify their enemies. Some armies would wear bamboo-type armor, or perhaps armor made from dragon scale or hides from other fantastic creatures. (How you would get a dragon to part with its scales is another matter!)

The sorts of weapons a character might carry can denote their status within a military hierarchy, or their function within a particular unit. It could simply indicate their personal preference, of course, but should always be in some way practical. If you equip a soldier or warrior in your picture with a particular weapon, think about what that weapon is used for. Is it practical in the situation your characters are in? In the same way that an adventurer wouldn't raid a dungeon while carrying a 20-ft (6-m) spear (it just wouldn't be practical), bear such details in mind when designing weaponry.

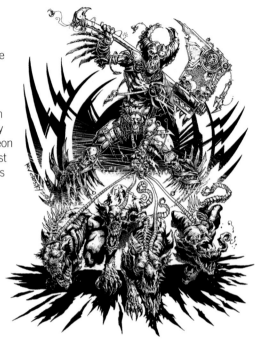

Right: Invented armor for a zombie dog master.

Below: Knight, samauri, Viking, Ninja.

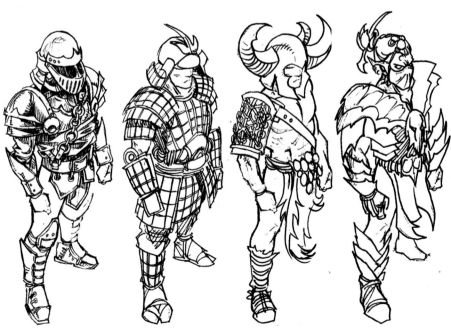

COMPOSITION AND CONCEPTS:
SPACECRAFT

Spacecraft

TIP 045

How to Develop Vehicle Concepts Quickly

When I think of the term fantasy art, I must admit I think predominantly about sword and sorcery themes rather than science fiction, and although this book is mostly concerned with the former, I thought it would be fun to have a little look at that staple of science fiction—cool vehicles, and spacecraft in particular. This little tip is, of course, a bit of a wild card slotted in with all these monsters and warriors, but I make no apology because this is such a fantastic trick to use when creating spaceships, and it is also easily adapted to tackle many other fantasy design problems.

I started with a simple brief—design a high-altitude fighter. I wanted to leave it quite open so I was free to explore any number of styles and concepts. The first stage involved filling a page with scribbles. Literally scribbles—the less form or thought behind them, the better. They were smallish, between 3/8 in (1 cm) and 1 in (2.5 cm) or so. When I had filled a page with them I scanned them into Photoshop and began the next stage. This part was fun, as it involved chopping up the scribbles and rearranging them into new configurations with other bits of scribbles until they started to take on form and shape. I continued this process until I had essentially remade the page of scribbles, turning it into a page of slightly more functionally formed scribbles. I then

trimmed each new shape vertically, creating an axis from which I created symmetrical adaptations of each one. The result was a whole set of interesting shapes that looked like they could be top-down silhouettes of spacecraft, vehicles, fighters, and the like.

Next, I took four or five of the shapes I liked best and produced new sketches based on these, exploring configurations of engines, wheels, cockpits, wings, and weaponry. I even adjusted the symmetry on a few, creating something a little more original. I also started to think about them in three dimensions, producing side-on studies and isometric drawings to experiment with how they might look in a finished drawing. When I had a good selection of these drawings I chose the one I liked best to develop further into a finished rendering.

For the finished drawing I started by producing a quick block version in Photoshop, laid out in dynamic perspective. This helped ensure the parts of the spaceship fit together okay, as well as injecting a bit of drama into the finished drawing. I then printed this guide version onto Bristol Board and used a 2H pencil to begin drawing the actual spacecraft. The first stage involved producing a light overview of the entire craft, before strengthening the lines and

gradually building up the detail. I then used an HB pencil to add weight to the outline and shadows.

This is one of my favorite working methods for creating vehicles of all kinds, and during my tenure on an *AVP* video game, I produced over 50 different spacecraft quite quickly using this technique. I can't encourage you enough to give it a try, and see what other things this technique could be used to design.

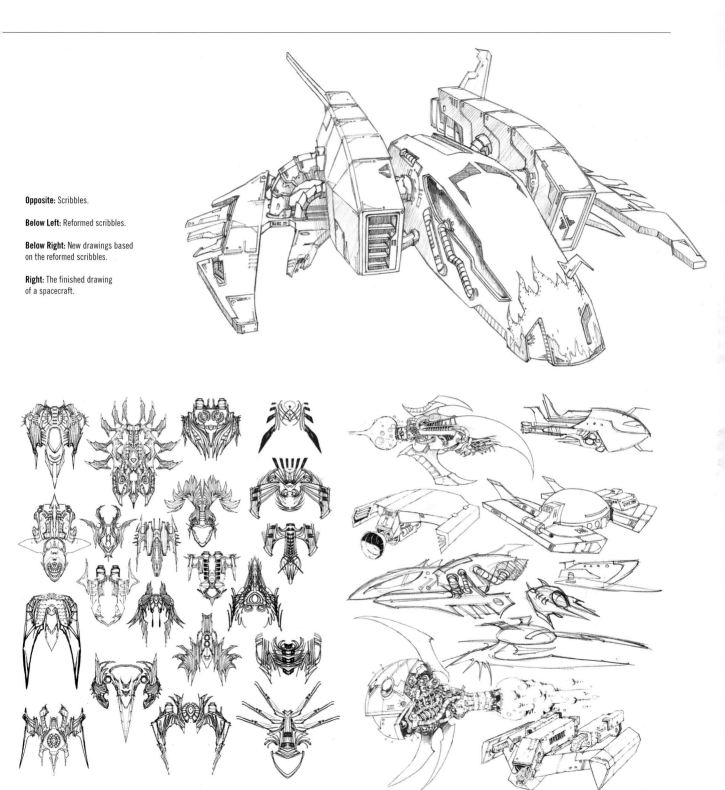

Opposite: Scribbles.

Below Left: Reformed scribbles.

Below Right: New drawings based on the reformed scribbles.

Right: The finished drawing of a spacecraft.

COMPOSITION AND CONCEPTS:
LANDSCAPE

Landscape

If function defines form, this maxim is especially true for landscapes! Dealing with such a vast compositional subject would require a volume of its own, and indeed there are many out there, so out of necessity the following pages offer an overview of the subject. When thinking about landscape, it must always be placed into some kind of context; does it serve as a background for an image focused on character dramatics, or is landscape the primary focus in its own right? Landscape can provide many functions, from setting a scene to creating empathic resonance with other themes present in an image; the environment in which a scene is constructed can be used to convey so much more than just a pretty view.

TIP 046

Landscape Perspective

Landscape design and painting is in itself a vast subject, but I've included a few tips to get you thinking about it. Landscape is possibly the largest canvas against which a fantasy subject or scene can be played (except for cosmic or spacescapes, which are subjects for an altogether different volume). As such, their specific attributes can be exploited to great effect, none more so than perspective. It is a key element, which can be used in a straightforward manner, or twisted and warped to create even more striking imagery.

In this watercolor and gouache painting (right), a ravine opens out into a snow-swept, precarious wilderness. The point of view is high above, but moves from looking straight down at the bottom of the image to looking out into the horizontal distance near the top. It's an effect that can be captured with certain camera lenses (such as fisheye), but is well suited to being exploited in fantasy art.

In Eventide by Gary Tonge, the artist employs what can best be described as epic perspective to create a vast, flowing landscape that carries the eye toward the spire in the middle distance and beyond into the luminous, unseen sunrise. It can seem like an imposing task to create such depth and flow but, as seen in the layout diagram, the layout skeleton beneath the image is disarmingly simple. A fan of curving lines curl out in ever increasing scale from an imaginary horizontal line, and these lines are reflected along the horizontal axis. All the major features and elements, both obvious and subtle, are aligned to this framework, and this solidity underpins everything in the final painting. Simple, yet astonishingly elegant in execution.

Right: Die a Hero employs a fisheye perspective.

Oppposite Top: Eventide by Gary Tonge.

Opposite Bottom: Elements in the landscape sit along imaginary curved axes.

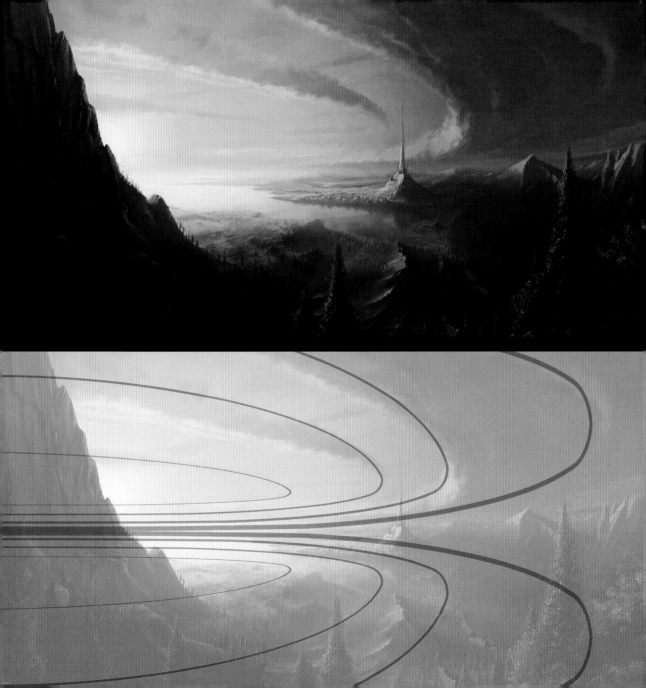

COMPOSITION AND CONCEPTS:
LANDSCAPE

TIP 047

Landscape Inspiration

Inspiration for landscapes can come from anywhere and, sometimes, quite without warning! This became the theme of one of my favorite *Imagine FX* articles, for which I produced a painting of a fantasy landscape inspired by preparations for Christmas dinner. I was preparing the carrots, and as they were a dwarf variety, I was simply chopping the tops off to cook them whole. I stood each one on the work surface, flat-top down, and when I finished the last one I was struck by how interesting they looked: It was like looking at a weird, alien forest. It was slightly absurd, but the more I studied them, the more it struck me that I could turn the scene into something fun. So, I fired up my digital camera and took a few snaps before consigning the orange, carroty forest to their doom on the hob. (They were delicious.)

Christmas came and went and I gave the carrots no more thought until I uploaded all the photos onto my computer and rediscovered the images. The upturned carroty landscape had lost none of its intrigue, and I resolved to pursue the matter further at the first opportunity. This came when *Imagine FX* asked me to do a Q&A about finding inspiration for landscapes. It was a sign, a sign to resurrect the carrots! I dug out the photos, picked one, and got to work.

I loaded the photograph into Photoshop and desaturated the image. I was sad to lose the orange, but I needed to knock all the colors back before adding a bluish tint. This was going to be a landscape, viewed from high above, so the blue

tint would be a good starting hue as it suggests distance. Next, I removed the kitchen background by painting more pale blue around the carrots. Now they were removed from their ordinary reality it became that much easier to visualize what they could be instead of a bunch of diminutive, crunchy carrots. The first idea that came to mind was that they were lofty pinnacles of rock, a strange outcrop of weathered peaks standing high above the plains of some imagined past or forgotten future. Perhaps they were the fossilized plugs of some kind of multi-caldera volcano, whose softer outer rock had eroded long ago.

That sounded feasible, so I started to think about how best to achieve such a landscape. It seemed that a winding river might break the image up nicely, so I carefully teased the pinnacles apart to facilitate the addition of a waterway. I painted this in orange as a nod to the carroty genesis of the image. I then sketched in a distant mountain line toward which the river meandered, and added a small disc of light blue as a placeholder sun. So far so good.

The next stages involved the hard graft of painting over everything. I began by enlarging the sun and importing a few

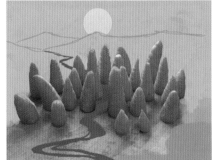

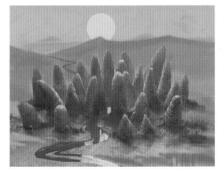

photographic textures, one of which was of moss. (The methods I use for applying photographic textures are covered in a later tip.) These textures began the process of breaking up the tones, and the moss, in particular, was very useful for adding what looked like small clumps of trees and other types of foliage to the bases of the carrot columns and the areas surrounding them. This same texture created faint dustings of slightly luminescent clouds caught among the cage created by the root vegetable rocks. Some adjusted parts of a rust photograph created some wonderful atmospheric effects in the sky and ate nicely into the disc of the sun.

Using a soft brush with opacity set to about 30%, I used a darker greenish hue to define the shadowed areas of the columns and add some reflection

to the river. Using the same color I then started to break up a region in the bottom right of the canvas, imagining it to be the start of a canyon whose crumbling sides had fallen away. I extended this as a series of fissures and cracks spreading toward the river and carrot peaks. Lighter shades of greenish gray were used to enhance the lighter areas of this landscape feature.

Next, I began to paint over the carrots themselves. The best way to envisage these objects was to imagine that when the volcano had been active, these lava plugs had been added to gradually over thousands of years, each successive surge of lava pushing the previous plug up before settling back. This would mean they would be made up of discs of material, which the weathering process would expose. It would also bear a happy

similarity to the slightly ribbed texture of the carrots. So, I started the long process of painting ridges around each of the vegetable-based pinnacles, adding vertical striations to further divorce the image from its beginnings. I also added a few fragile structures linking some of the peaks. These might have been curious natural formations, or perhaps they were an indication of an ancient civilization that lived among the peaks long ago. It added to the story that was unfolding around this landscape. Reflections were then added to the river, bringing the metamorphosis of small carrots into megalithic rock formations that much closer.

The landscape in which the lava plugs stood was then worked into; the waterways were extended into the distance while mountains were suggested with flicks of lighter tones throwing back the pale light of the sun. The features of the hills and rocks were continually enhanced and refined; luminous sheets of low mist were added here and there, the distant river line silvered, and more and more detail added to the pinnacles. As the painting drew to a conclusion, I added one final detail: a flying animal of some kind, colored orange to balance with the river and provide a further reminder of the carrots.

Everything about this painting makes me smile. It is, of course, very silly, but it just goes to show how a landscape can indeed be made out of anything.

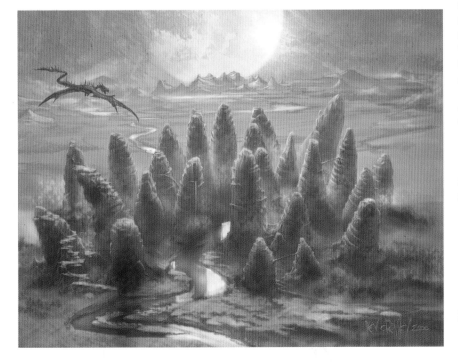

All: Inspiration can be found in unlikely places . . . Christmas dinner becomes a vast fantasy landscape.

Black-and-White Art

When I was planning this book, I knew I wanted to devote a chapter to black-and-white art. It might not be a very long chapter, especially compared to the previous one and, indeed, could easily have been covered as part of another section, but there are important and useful principles involved in understanding monochromatic art that should be explored in isolation from other painting principles.

Right: A "befouled pool," where gross monster meets HB pencil.

BLACK-AND-WHITE ART:
THE IMPORTANCE OF BLACK AND WHITE

The Importance of Black and White

TIP 048

Using Black and White to Simplify a Composition

In the Composition and Concepts chapter we discussed the importance of creating breathing space within an image by not allowing too much detail to blur the line between extremes of tone. A fantastic way to achieve this is by producing small thumbnail studies of a piece before committing to any preliminary drawing. Like the thumbnails you would produce for other compositional purposes, these studies need only be small—1 in (2.5 cm) or so wide—as it is the small size that forces you to boil an idea down to the important elements without the distraction of finer details.

Here (below) are a handful of thumbnail sketches I produced when I was trying to work out a composition. I knew I wanted to portray a stark contrast between dark and light, and it took 30 minutes of sketching to settle on a concept that

looked promising. I then scaled this up to the final version, making sure I echoed the balance between black and white and resisting any temptation to apply too much detail anywhere it wasn't required.

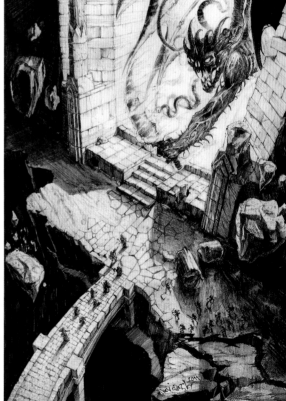

Right: The final drawing was underpinned by a carefully plotted perspective grid, and then rendered in HB and 2B pencils.

Right: The initial thumbnails were inch-high abstractions of the intended image.

TIP 049

Capturing an Evocative Atmosphere

A black-and-white illustration by definition lacks color, but this shouldn't be mistaken as being somehow less than a finished color painting. The virtue of being grayscale presents a unique approach to creating an interesting or arresting image, as you can't rely on color to elicit or control responses in the viewer. Instead, the artist must fall back on exploiting the contrast between black, white, and the shades of gray in between, and because the difference between two shades of gray must rely on tone alone rather than hue, there will always be a marked difference between them. The same cannot be said of colors, which can be the same tone even though they are from different sides of the color wheel. This natural "built-in" attribute of black and white makes it easy to create images that are evocative and striking.

A great example of how effective a monochromatic palette can be in creating striking ambience and electrifying atmospheric effects is the old tradition of black-and-white movies, Film Noir in particular. Back then, directors didn't have the option of working with color film, and so had to work within the limitations of grayscale. As a result, skilled lighting technicians became the arbiters of thrilling scenes, defined by shrewd exploitation of the contrast between light and dark. Shadows were darkened to enhance key focal elements such as actor's faces, and

bright lights shone starkly against gloomy backdrops. Actors themselves had their features enhanced by the application of dark makeup applied around the eyes and under the cheeks. The net result was, in effect, a fantasy rendition of reality, and this understanding of dramatic lighting has arguably declined since the advent of color filmmaking.

The same techniques carry over well into two dimensions and have been exploited in one particular medium to great effect for decades: the sequential art found in comics and their evolved siblings, graphic novels, has been the best place to see fine black-and-white art, although, because most comics these days are produced in full color, it is becoming a rather rarefied art form. Artists to watch out for include Mike Mignola and his exceptional *Hellboy* series, as well as *Judge Dredd* luminaries Mick McMahon and Brian Bolland, but there are many, many more . . .

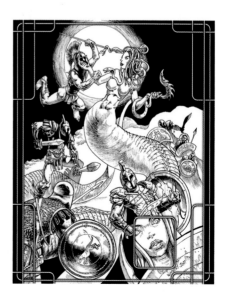

Top Right: Pages from *Wages of Sin* inked in an experimental Noir-esque style.

Right: Pages from a differently styled comic featuring Medusa.

BLACK-AND-WHITE ART:
EQUIPMENT AND APPLICATIONS

Equipment and Applications

TIP 050

Black and White Texture Techniques

When it comes to working in black and white, obviously the best place to start is with the humble pencil. There are many grades available; H grades are hard, producing light tones, while B grades are softer and broader, producing darker tones that smudge easily. Personally, I use 2H to sketch out an image and lay down shading, then progress to HB to strengthen lines and give depth to some shadows. B or 2B are useful for producing very dark planes of tone, but as they smudge so easily, you can make a mess on the paper with them, so my preference is to avoid using them.

Black ink is another great choice, which can be applied with a brush or dip pen. There is a bewildering range of pens available. Also, look out for graphite sticks, pastels, paints, automatic pencils, Letratone, and the digital option, of course.

Then there are the ways media can be applied. Pencil is highly versatile, and can be used with a sharp point for tight linework, or turned on to the side for broad strokes of tone. Mix these with a number of idiosyncratic, artistic flourishes and flicks of the wrist and you can end up with an astonishing range of effects and textures.

Each of the images that accompany this tip was produced using a different technique. The Green Woman began

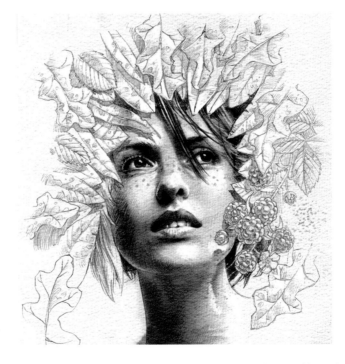

Left: This drawing of The Green Woman began as a black-and-white digital sketch based on photo reference, which I printed onto watercolor paper and finished with HB pencil.

as a black-and-white digital painting based on photo reference, which I then printed onto textured watercolor paper and finished using HB and B pencils to add the leaves and redefine the shading.

The Vampire is a fairly old, slightly cartoonish take on the bloodsucker of legend, rendered using a sharp HB pencil, with 2B used to apply the darks. My knowledge of anatomy was still a little shaky back then, but I was beginning to

experiment with mark-making and texture work, and this seemed to me of greater interest than worrying about avoiding lopsided faces or getting the arm muscles right. (I did a lot of rectification in these areas in the years following.) This experimentation is still something I indulge in, with constant discoveries of new tricks being the reward.

Next, I've included what was a departure for me at the time; a selection of sequential

Finally, here is a digital black-and-white tone painting for The Siren image that appears in the next chapter (see tip 58 on page 111). I produced this in Photoshop, creating a Multiply layer above the scanned pencil and filling it with mid-gray. I then used the Eraser tool to carve the gray away until I had defined the lighter values, then used the Burn tool to deepen the darker tones.

Far Left: A detailed, slightly comic take on the vampire rendered in HB and 2B pencils.

Left: *Wages of Sin* was inked traditionally using various drawing pens, and India ink was applied with a brush.

Below: A black-and-white digital tone painting for Siren.

pages produced in stark black-and-white ink. At the time, I was rather unpracticed with ink work, but I used various pens and brushes to build a series of pages that eschewed my natural proclivity for detail and swathes of tone for stark, bold delineation between black and white. Although it was not my natural way to work (I had to fight the urge to revert to my comfort zone throughout the nine-page story), I liked the end result, and learned a lot during the process.

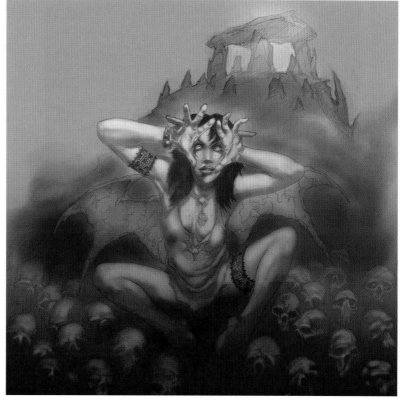

BLACK-AND-WHITE ART:
SEEING BACK TO FRONT

Seeing Back to Front

TIP 051

Practice Painting Negative Space

Begin by painting what isn't there by simply painting the whole canvas black, then use white paint to uncover the details of the image. If you've never come across this idea before, I guess it might sound a bit odd. I certainly thought so when my university drawing instructor first introduced us to the concept of drawing negative space. "What a baffling prospect," I thought. "What are the benefits?" Back then, we were encouraged to go out and about and scrutinize the features of the streets, towns, cities, and countryside, but instead of focusing on the elements that define a place, such as buildings, lamp posts, trees, or people, we were encouraged to look at the empty space between these elements. The sky, the empty air. Although such an alien concept took a little while to come to grips with, I was soon filling sketchbooks with abstract images where the only thing I drew was the shape of the sky between objects. It seemed like the most radical thing I'd ever been introduced to at the time, and it turned the way I looked at the world completely upside down.

Here (opposite) is an image I created using this method. I used a character concept sketch as reference, and gradually "uncovered" the details by painting white over a black canvas. This is an interesting exercise as it forces you to work in a counterintuitive way, painting details from the wrong side, as it were.

But there is something special about working this way—it gives boundary lines a different quality, and makes you start to see forms and shapes in reverse. Learning to look at a scene "backwards" like this helps to sharpen your perception of how tone works to balance an image, as it takes a lot more thought and effort to force light tone to pop out of a black canvas.

It is also supremely useful for developing your ability to create details from nothing within a painting (that you hadn't envisaged in the underdrawing), or for times when the paint goes on a little too thick and obliterates your guide sketch. Ultimately, this is an exercise for the imagination, the engine that drives the creative impulse, so it's a great way to keep yourself on your toes.

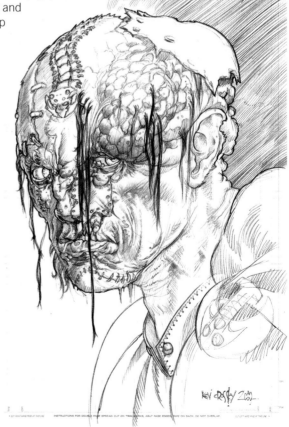

Below: Character concept sketch.

Right: The finished artwork, making use of negative space.

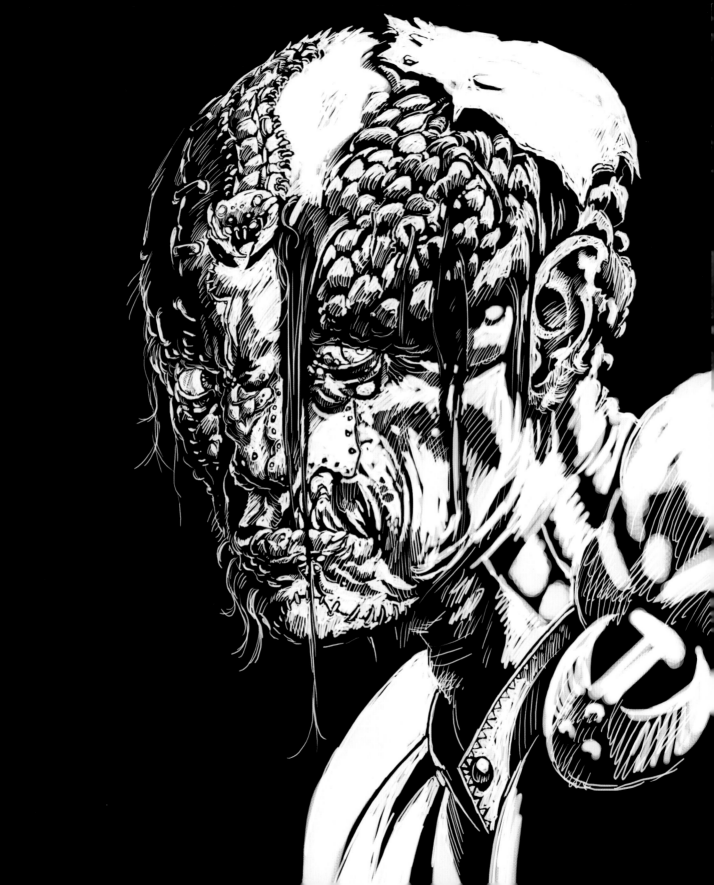

BLACK-AND-WHITE ART:
CREATING A GRAYSCALE TONE PAINTING

Creating a Grayscale Tone Painting

TIP 052

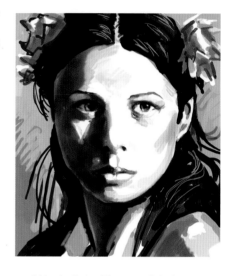

Defining Light Using Grayscale

This tip carries on from the issues discussed in tip 49. Definition of the light and dark areas of a painting is sometimes quite difficult to achieve when working in color. If you happen to choose different colors that are tonally similar, it can make the painting look flat, and it isn't always an easy problem to avoid. This is due to the fact that although different colors may be chosen to identify separate areas within a painting, if these colors were to be desaturated and turned to gray, they might turn out to be very similar shades of gray, which are, of course, difficult to tell apart. It is this tonal similarity that, although invisible in the color picture, is responsible for flatness of tone.

A simple solution to this is to start a painting in grayscale. Painting in shades of white, gray, and black affords a simple way of breaking up an image into its constituent tonal shades, which will inspire the correct shades of color to use over the top, and will result in a finished painting that has richness and depth.

This first example (below) shows a quick Photoshop sketch painting that has been desaturated to reveal how great the contrasts are between the different tonal areas. This grayscale variance is what defines the dramatic tone character of an image, and makes color sing!

Before Greg Staples began adding color to his amazing cover painting for *2000 AD* Prog. 1750, he began by producing a fairly refined grayscale painting. Areas of black were blocked in, including Judge Dredd's uniform, to create a base value from which the rest of the tonal range

could be built up. The rest of the image was then shaded to define how the various light sources might work on the characters and objects.

In a similar way, Matt Dixon produced a grayscale tone underpainting to work out the values of his Saber-tooth Squid Girl. In Matt's words, "Values control the

Above Right: A monochrome painting helps to show tonal variations.

Right: The initial sketch and the grayscale tone painting produced by Greg before the finished rendering of *2000 AD* Prog. 1750.

Opposite Top: Matt Dixon's grayscale tone painting for Saber-tooth Squid Girl.

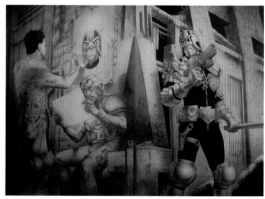

contrast and, therefore, the focal areas of the image in addition to defining form and separating shapes and planes." In addition, producing a monotone version of an image is a good way to experiment with how the shading will work. Without color to distract the eye, such attributes become easier to work out. Matt continues, "Placing the values independently of color allows for more deliberate control over these important elements."

As an aside, it's also worth noting that, if a detailed pencil drawing is scanned into Photoshop, a good tone "painting" can be achieved by simply importing a grayscale photographic texture into a Multiply layer above the pencil. The detail of the pencil will show through the photo, and you will instantly have interesting tone values coupled with texture, ready to develop into a color painting.

Working to a Brief 7: Defined in Black and White

With the apocalypse pencil drawing complete, I set to work to produce a grayscale underpainting to define the overall tones. First a light, transparent wash of medium gray acrylic was brushed over the entire image. I used my water spray to ensure it didn't dry too quickly. This way I could assess where the paint was too thick or too obscuring. In these areas the wash was lifted away using a tissue to ensure important details in the drawing were not lost. When the gray wash was dry I strengthened any lines that needed it, then used a smaller brush to paint another gray wash into the shadows and darker areas, gradually building up the tone values and balance of the entire image. Particular detail was put into the Four Horsemen, and the image was ready for color.

Below: The initial gray wash.

Right: In areas too obscured by the gray wash, the paint was lifted, while other areas were strengthened with a second gray wash, gradually building up tonal contrasts.

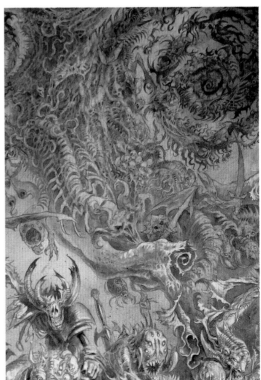

Developing a Painting

One of the best ways to advance your technique and create a deeper understanding of art is to study the art of others. As a young painter I knew little about formal technique, and hadn't actually been taught much about how to paint with the different mediums available. This left me with no choice but to make it up as I went; learning how to develop images without much experience to draw on felt like laying the tracks in front of a moving train, but in the process I tried very hard to glean some knowledge from the great artists who continued to inspire me. Slowly I built up a store of knowledge and tricks—a little composition lore from here, a bit of visual narrative creation from there, and so on . . . I learned one of the greatest lessons of my life: the more you learn the more it seems you have yet to learn. Wider eyes simply reveal more of what you don't yet know.

What follows is a selection of developmental criteria, taking in composition, story, character, using reference, and more, which should keep any improvement-hungry artist busy for a while!

Right: Although solid knowledge of anatomy and figure drawing is important, photographic body reference can be invaluable help when devising a composition.

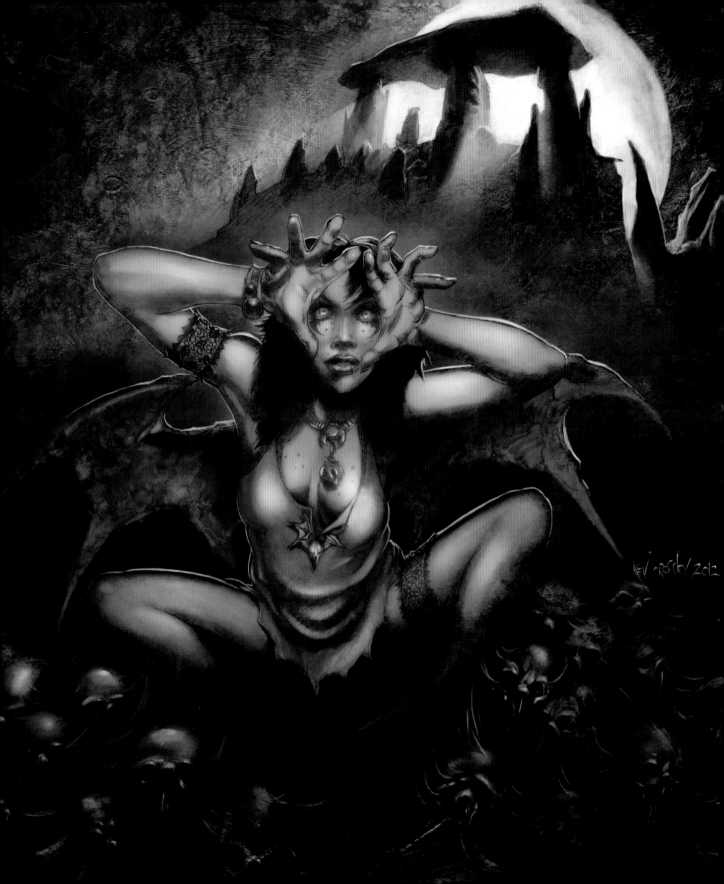

DEVELOPING A PAINTING:
TACKLING A COMPLEX COMPOSITION

Tackling a Complex Composition

TIP 054

Color Roughs

Sometimes it helps to visualize how a painting will turn out by doing a rough color sketch as a progression from any preliminary sketches you may have produced. Contemporary fantasy painters such as Frank Frazetta, who painted in oils, would often produce test studies using watercolors to work out how the colors might balance with one another. It's a useful technique, and the easy-to-manipulate and quick-drying attributes of watercolors makes them perfect for this.

If you don't own any watercolors, you needn't break the bank by buying an expensive set of paints you might not use that much. As these test paintings are purely intended to offer practical color guidance to the artist alone, you only have to buy a set of children's watercolor paints for less than the price of a cappuccino. They're cheap, they

function just like high grade watercolors, and, although inferior in quality, the color pigment is enough to experiment with how you might want the colors in the final painting to look.

I decided to produce a rough color study of the *ABC Warriors* painting before adding any final colors. To do this I printed a simplified copy of the pencil drawing onto Bristol Board, then taped it down onto an art board. I thought I might see how it would work if I inked the drawing first so, using drawing pens and markers, I quickly blocked in the ink before splashing the watercolor over. It was quick, and rough around the edges, but it was sufficient for the purpose and gave me a few ideas of how I might approach the final painting.

Right: This set of watercolors cost less than a cup of coffee and comes with a handy snap-shut case and brushes.

Far Right: A simplified inked version of the *ABC Warriors* image quickly painted using my son's watercolors.

Above Right: Matt Dixon's color rough of Saber-tooth Squid Girl.

Breaking a Big Job Down

When faced with a large painting like the Four Horsemen of the Apocalypse, the sheer number of elements within such a composition can be quite imposing, making it difficult to figure out where to begin. The simple solution is to break the job down into smaller tasks.

The composition could be broken down into three main parts: background, riders, and Hades. Each of these could then be split into separate tasks, too. Background: would this be cloudy? Would there be breaks in the clouds? Would there be any landscape features such as mountains within it? How extensive is it? Riders: the main characters could be divided into four separate jobs, each one of those being split into rider and horse. Also, the lighting can be worked out during this breaking down stage. Hades: although this feature was complex and detailed, it actually only needed to be broken into color saturation bands. Because the horde of monsters was retreating into a point in the sky, identified by the black sun, it would be important to create a convincing impression of great distance among the more faraway creatures, and you do this by desaturating colors. So, I split the spiral of creatures into a number of bands, each of which describes a level of saturation appropriate to its distance from the central rider characters.

Right: Here, the background elements are shown isolated from the riders and monsters of Hades.

Below: The spirals of Hades are shown broken into saturation bands.

Bottom: This diagram shows how the riders will be illuminated by two light sources; one from the front and a secondary one from the sky behind.

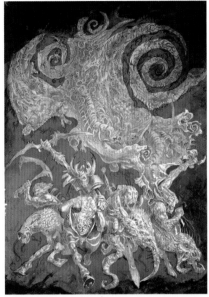

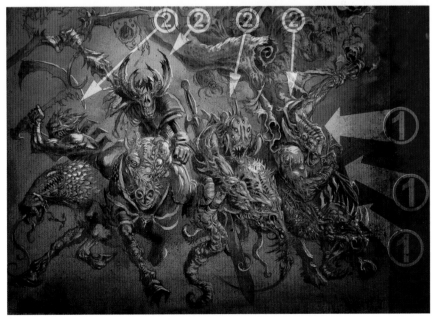

DEVELOPING A PAINTING:
TACKLING A COMPLEX COMPOSITION

TIP 056

Underpainting

An underpainting can perform a similar function to a grayscale tone painting. But where a tone painting sets the groundwork for the light-and-dark balance of a picture, an underpainting creates a color background or base coat, too. This "first-pass" painting can be rough and ready, or fairly detailed—there really is no right or wrong way of doing it. Although such an underpainting is usually laid down in a single color range (for example reds and browns), it could be applied in full color, too. What you do depends on what sort of effect you want to achieve.

I didn't know anything about underpainting until I became friends with some of the professional artists I'd been inspired by as a kid. Previously, I'd simply painted my early attempts in the colors I wanted, and that was that. Although it didn't really matter with my watercolor and ink painting (we'll come to the reason why shortly), my discovery of the underpainting technique added a depth and atmosphere to my gouache and acrylic paintings that, almost overnight, lifted my game to another level.

One of the great attributes of an underpainting is that it can be allowed to show through the finished colors. My favorite method is to brush a blend of dark reddish browns over a pencil drawing, using translucent acrylics thinned with plenty of water. The reason I use red to create underpaintings is due to a lesson I learned from my old art teacher at school. Graham Carver taught me that when you paint shadows, black should never be used by itself, as it is void of

color and, hence, will divorce itself from the rest of the colors within the painting. A little burnt sienna or red ocher mixed into the black eliminates this "tone vacuum," the warmth of the red hues creating more depth within dark shadows. I'm not sure I understood the principle at the time, but it was one of those rules you don't need to understand in order to benefit from it. I never used virgin black again in my painting, and the results vindicated the teaching. (Thanks, Mr C!)

Just like a tone painting, darker hues are applied into the shaded parts, and soon a very basic color and tonal study of the painting is completed. If I'm working traditionally I might then strengthen the pencil lines using black ink or simply the humble ballpoint pen, which is a great tool for laying down over acrylic, as the pressure required creates useful texture and scoring. I sometimes cover larger dark areas with fine crosshatching, and the image is then ready to have the final colors applied.

Underpainting is a technique restricted to opaque media such as oils, acrylics, or gouache, and doesn't work in quite the same way with translucent media such as watercolors or inks that rely on very different application techniques (which will be covered in later tips). When painting digitally, color can, of course, be applied in both a transparent or opaque technique, and so the underpainting technique can be used. The picture *Blue Jasmin*, shown opposite top left, began as a pencil drawing that I scanned into

Photoshop. I then created a new layer above the pencil with Blending Mode set to Multiply, and quickly blocked in color and tone using exactly the same technique as I would in a traditional painting. The only difference is that I didn't have to wait for it to dry, and there was no chance of accidentally washing my brushes in the cup of tea I just made for myself (just one of many pitfalls that await the unwary in the arena of Doing-It-The-Old-Fashioned-Way). This *ABC Warriors* picture (opposite top right) is a comparison example of what a traditionally painted version looks like.

Here (opposite bottom row) are three stages showing how David Millgate started his *Iron Heel* painting by producing an underpainting. The artist explains his approach as follows:

"I dislike painting any real detail onto a pure white board, so I like to throw a bit of color onto it first. I started this painting by roughly laying down a loose wash of Payne's gray over the inked art. This was applied very fast with a large, semi-damp, hard bristle brush. Most of the paint is on the creature as it's obviously the main element. Next, I added a second overall wash with a greenish blue tone, then spattered some paint over the whole thing using an old toothbrush—some green, red, burnt sienna, and Payne's gray. This added texture would help when it came to the actual detail and acrylic painting. I then used a small brush (size 1) to quickly define skin tone in the creature. Things were now moving

in the right direction. The spattering of colors applied with the toothbrush started to suggest various textures on the creature's skin, so instead of applying large swathes of color all over the creature, I could begin to pick out highlights in these areas and leave other parts in shadow. The net result was a painting that was starting to look very interesting in a very short amount of time!"

Above: A digital underpainting for Blue Jasmin.

Right: The *ABC Warriors* underpainting in gouache.

Below: David Millgate's underpainting stages.

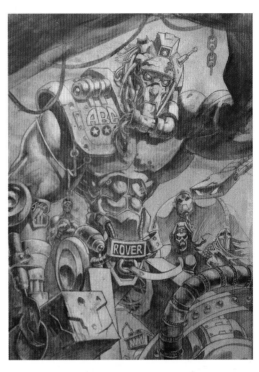

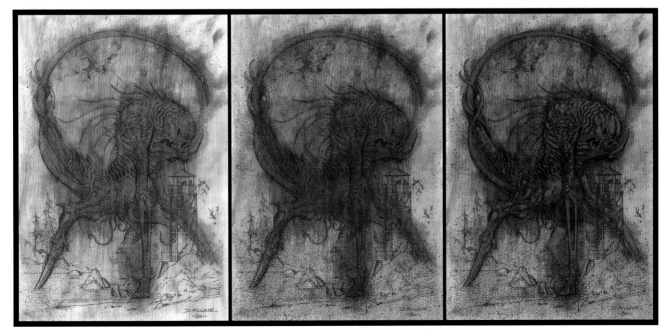

DEVELOPING A PAINTING:
CHARACTERS

Characters

TIP 057

Brief 9: The Four Riders

With complex projects, we've already established that it helps to break the whole down into separate elements while at the development stage. So, this is a tip focusing on the riders themselves. They have shape and form, and each has a color scheme suggested by the horse on which he rides; white, red, black, and sickly green for the pale rider. The tone has been painted in grayscale, which forms the foundation for applying the final colors.

I began by mixing a translucent acrylic glaze of reddish brown to wash over the grayscale tones. Color can define a character, and is particularly important with the Four Horsemen, but I still wanted to have a ruddy tint as a base color so I could allow it to bleed through the final painting to create texture. So, I gradually created the underpainting, building on the work laid down by the tone painting, until I had a basic shaded version of the riders completed.

Next, I used a black pen and a dark brown brush pen to work the details back over the dried underpainting. I started to add the final colors to the riders, keeping in mind the primary lighting is in front of them, while the lightning in the tumult behind will cast dramatic highlights onto their shadowed backs. Then, each "horse" is similarly painted. When a job is split up, it's easier to work out an approach.

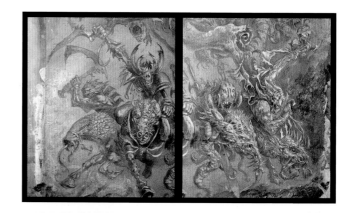

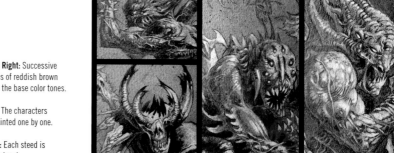

Above Right: Successive washes of reddish brown define the base color tones.

Right: The characters are painted one by one.

Below: Each steed is then colored.

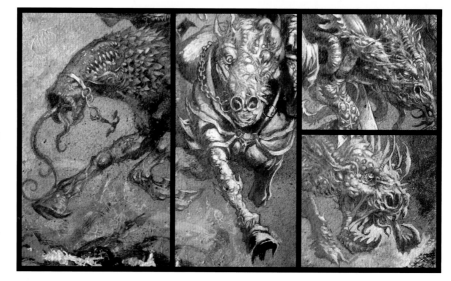

TIP 058

Character Building 1: Working from Reference

An artist who has to draw people on a regular basis must spend a lot of time studying human anatomy and practicing drawing the body from all angles. It also helps to use model or photographic reference from time to time. I usually use it as a starting point, taking a pencil sketch of the model or pose, then altering aspects of it, such as posture of the limbs and head. I'll almost always alter the features of the face, and sometimes I even mix elements from one photograph with those from another to create a new pose to build from. What I never take from the reference is lighting cues, as I'll work out how I want the character lit as I develop the drawing.

I have folders filled with cuttings from magazines—fashion supplements, hair photos, movie stills, that sort of thing—but there are also sketches I took from reference years and years ago. I found one such doodle of a woman striking an eye-catching pose. I always liked the way the hands framed the face, drawing attention to the piercing eyes with the spread fingers acting like radiating spokes functioning to both pull focus into the face and encourage the viewer to look out into the wider image. Clearly, I supposed I might rediscover it one day and develop it into a painting, so who am I to disappoint myself?

I liked it so much I decided to do a new pencil drawing that was almost completely faithful to the pose, adjusting the hip twist to accentuate the asymmetry of the posture. When the initial sketch was done, I then had to invent a reason for the drawing to exist! A sketch is fine, but to become finished fantasy art it must

have some definition of purpose, a narrative. I decided to flirt with cliché and give her wings, turning her into some kind of angelic siren, a notion inspired by those summoning hands and hypnotic eyes. I then adorned her with a loose but slim-fitting vest to emphasize her figure, finished with two lace garters on opposing limbs to keep the asymmetrical balance. A pile of skulls seemed like a good addition, along with a dolmen on a hill behind. The pencil drawing was then scanned into Photoshop and adjusted before a transparent layer of gray was added. A selection from a photograph of white lichen patches on stone was pasted into another layer with Blending set to Overlay. This would be used a later to create a pleasant atmospheric base from which to build the rest of the painting.

I turned the visibility of the lichen layer off while I created a tone painting out of the gray layer. When this was complete, I turned the lichen layer back on and mixed it with another photograph of weathered rock before flattening the image. More grayscale painting ensued, with the addition of a moon to make the dolmen a dramatic secondary point of focus.

Because the image was so dramatic, there was a danger that too bold a color scheme might become a bit reductive, so I created a limited palette by putting splodges of earthy color into a new layer. The colors were applied in sketchy, thin strokes to complement the tone values rather than dominate the image. Finally, highlights were added in relation to the light sources—backlighting from the moon, and primary light responsible for the illumination of the face and eyes.

Above Right: Initial sketch based on the original drawing.

Right: The addition of texture from a photo of lichen.

Below: Tone painting more texture added from a photo of weathered rock.

Bottom: The final painting with a limited color palette.

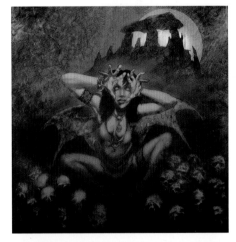

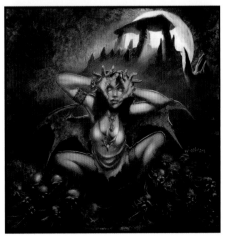

DEVELOPING A PAINTING:
CHARACTERS

TIP 059

Character Building 2: Design By Committee

When I was thinking of other artists who I thought could contribute to this book, a relatively new friend in the form of Matt Dixon immediately came to mind. I thought his unique take on sexy fantasy females would look superb, so I approached him, and the dude agreed! There then followed an exchange over Facebook as we thrashed out the details of what he could do. This process in itself struck me as actually quite important—it echoed the sort of process professional artists go through with clients and art editors all the time, so I thought it might be fun to include the transcript of that conversation to illustrate how a brief is sometimes developed.

Matt Dixon: I'm up for it, Kev, but does it have to be a dinosaur? I think we'd get a better end result if we start with something with just a touch more grace—something feline, aquatic, or amphibian perhaps? It could still be scary like a saber-toothed tiger, giant squid, or poisonous frog. Just improvising there though—T-Rex is totally cool. Cheers!

Kev Crossley: Tell you what, I've decided to do a dumb T-Rex hybrid anyway, so I'd love you to take one of those suggestions as a starting point and run with it! Cheers Matt! Looking forward to it!

Matt Dixon: Cool beans. I'll probably go saber-tooth or squid. Do you need to know before I get cracking or can I just go for it and see which feels best on the day?

Kev Crossley: Saber-tooth or squid, eh? I have to ask this; could you incorporate aspects of both? I think I can see what you could do with the saber-tooth, and that I would love to see! But my interest is piqued by this squid idea. I just can't imagine where you'd take that. It would be a real standout if you could mix the two!

Kev Crossley: Hey Matt, I'm just working on my *101 Tips* book, I have a wild idea for you, if you're up for it: could you do me one of your lovely ladies, but using a T-Rex as a starting point? I'm doing a spread about "perverting nature," i.e. taking inspiration from the natural world to feed into artistic fantasy visions. I was going to do a sort of T-Rex-octopus-bat hybrid monster, but I looked at your work and thought, "hey, if anyone could pull off a lovely, green scaly lady with a massive tail, T-Rex jointed legs, and spines all over her back, it'd be Matt!" So, what do you think?

Matt Dixon: Mix the two?! You looney! Let me chew that over. I'd want to try and keep at least a little allure in the final thing, but I'm not sure how easily that will come off with fur, fangs, tentacles, and suckers all vying for attention against the boobies. I'm game, but I reserve the right to bail out if it starts to look like something that would frighten Cthulhu away!

Kev Crossley: Ha ha! Fair enough! How about the coloring and fangs of the Saber-tooth with the other squid stuff?

Matt Dixon: Well, I'm thinking of a standard cat woman thing, with the fur color fading to white across the belly. Fur will be kept to a minimum, popping up mostly on the extremities. The prehistoric tiger pattern will be shared across the body and the tentacles.

Matt then adopted radio silence while he worked his magic and, after a few sketch updates to let me know which direction he was headed in, the final art stages showed up, and I replied as follows:

Kev Crossley: Matt, she's fantastic!!! You really stepped up to the challenge!! I love the movement in the tentacles, and is that a tentacle tail? Awesome. It's obvious thinking about it now, but that wouldn't have occurred to me. It's really great, mate! Cheers!

Matt Dixon: Heh! This is something I would never have conceived on my own, Kev. Good fun to work on!

Perhaps not all jobs are quite that easy-going, but it shows how good relationships between open-minded creative sorts can result in really rewarding working experiences and, of course, killer concepts.

Opposite Left: Matt's first digital concept sketch.

Opposite Right: Matt then simplified the drawing, ready for painting.

Below Left: After producing a grayscale tone painting, Matt began adding color in distinct blocks, with modeling and finished rendering applied along the way.

Below Middle: Next, the tiger stripes and tentacle suckers were added, and detailing painting onto the face and other areas.

Below: To finish, a little color adjustment was implemented, and a spot of background color added to complete the presentation.

DEVELOPING A PAINTING:
CHARACTERS

TIP 060

Photoshop Technique 1: Photo Texture

Painting in Photoshop affords the use of certain techniques carried over from traditional methods, but it also offers so much more that is unique to it. One feature in particular is very useful, and the clue is in the name. Photoshop is, after all, first and foremost a photo-manipulation tool, so I always like to utilize the features that exploit this.

The Elf Adventurer pencil drawing became the basis for a digital painting, and after the character had been mostly resolved I began to think about the background. I experimented with a graphic overlay I'd created, and mingled this with various photographs of dry grass and winter trees. Although it looked interesting, it wasn't quite working. Using a small, hard-edged brush, I scratched a

new background color over the photograph layers, purposefully blocking areas of color in with crosshatched brushstrokes, then applying broader swathes of color here and there with a larger fuzzy brush. To this color I then applied the Texturizer filter a number of times, using various photographs to create a layered melange of varied textural effects.

It seemed to be working better than the last effect, and the addition of a redesigned graphic seemed to look okay, too. Next, I resolved to add some more photographic texture, but this time, less directly than the previous attempt with the grass. I chose six images I'd taken with my digital camera, including: bubbles in washing-up water, lichen

on a rock, sun reflected in the Irish Sea, various tracks in sand, a strange vase surface, and my old favorite, speckled banana skin. From each of these photographs I used Color Range to isolate a specific tonal area, sometimes repeating this if the photo was particularly interesting. Each of these selections were imported over the elf image, and each one was then altered or applied in a number of ways. I used a variety of Blending Modes, including Multiply and Overlay, and the transparency of each texture was varied, too. Sometimes, I reduced the color of a layer to a flat tone, other times, I left it as it was. It really was a process without direction or intent. The idea was to adjust each photographic layer without any preconceptions of what I was trying to achieve.

In effect, it was an exercise in emptying the mind to leave plenty of room for free-form idea generation. After a few hours of playing around, each layer had found its place within the mix and, when I took stock, it seemed to me that I had progressed the painting nicely. This is an image I've been picking away at for about five years, and I have no idea when it will be complete. The intention is to dip into it every once in a while, applying any new tricks I've gathered, which may include printing it onto art board to be worked over traditionally before rescanning for more photographic overlays. Long-term projects like this one might not be everyone's natural way of working, but I like the feeling that it transcends the moments-in-time captured by an image completed over a few days.

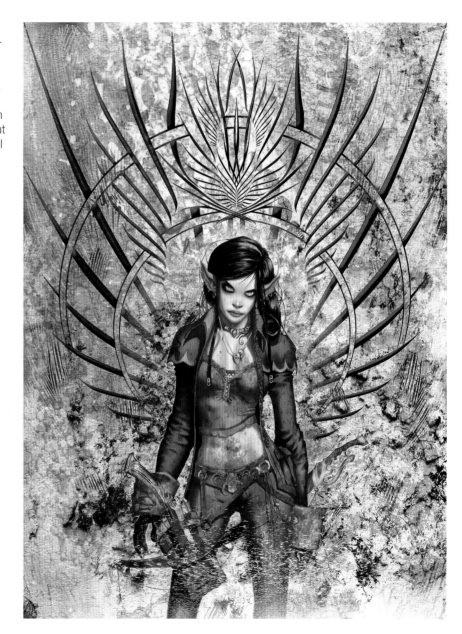

Opposite Left and Middle: Initial stages of the Elf Adventurer digital painting.

Opposite Right: A selection of photographs from which elements will be isolated for use in the painting.

Right: How the painting looks after different parts of each photograph are layered using various filters and blending modes.

DEVELOPING A PAINTING:
MONSTERS

Monsters

TIP 061

Brief 10: Demonology

As revealed in tip 55 (see page 107), the monster part of the apocalypse painting was broken into a number of saturation bands to help guide the painting process. This would essentially be carried out in the same way as that described for the riders in tip 57 (see page 110). However, the monsters would differ in a specific way from the riders, as I didn't want too much color to feature. Instead, I wanted to have them very similar in tone to the sky, which would set them nicely apart from the riders in the foreground.

So, as with the riders, I set about producing a tone underpainting, which began with a wash of thin color, into which I added darker tones to work out the shadows. At this stage I wasn't thinking too much about the saturation bands, as I would develop those later. Instead, I wanted to work out the shading and light balance, which would allow me to see what I would have to do next.

When the tones were all marked in, I then worked on the sky itself, adding more depth and drama, being bold with darker tones where required. This would allow me to desaturate the right areas to the correct degree, as I now had something to work back to. And so the process continued; tweaking the shadows, working out highlights, and adding details here and there until the main body of the work was complete.

Above: A color tone painting is produced.

Right: Light and dark areas are defined.

Below: Thin washes of slightly opaque color are used to push the most distant elements into the deep background.

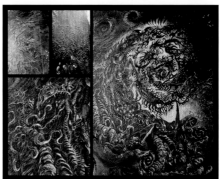

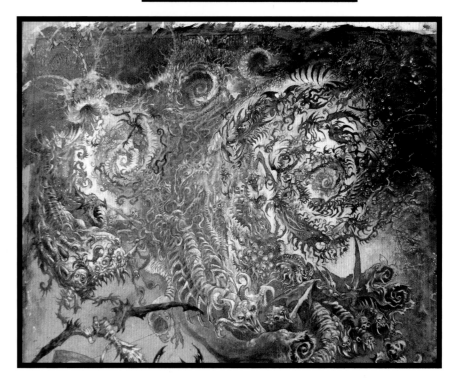

Photoshop Technique 2: Beast Revisited

To create the digital beast painting featured in tip 11, I scanned the penciled version into Photoshop, then duplicated the background into another layer. I then used a filter trick I learned from Liam Sharp. Filters for Photoshop are more numerous than the stars, it seems, so it can be a bit tedious having to sift through them trying to find a few that produce the effects you want. However, Photoshop has an extensive but manageable selection of useful filters built in, and Liam introduced me to the excellent Bas Relief filter, which is found under the "Sketch" list in the Filter menu. As with most Photoshop filters, learning how to get the best out of Bas Relief is a matter of trial and error but, if used subtly, it can create wonderful effects and provide the groundwork for further creative experimentation.

With the duplicate layer selected, I ensured the foreground color was light gray, with the background color set to dark blue-gray, before running the Bas Relief filter. The effect is a stunning abstraction that colors the entire image in shades of blue-gray, picking out the pencil lines and any other marks on the paper with sharp but subtle contrasting tones. I then reduced the opacity of this layer to 70% to allow the original pencil marks to show through. By itself the filter is too much, so I used the Eraser tool with an opacity of 50% to carefully erase parts of the filter layer, mostly on the lighter areas and the fleshy parts. This created the start of a tone painting, and I then flattened the layers.

As this image was actually a new version of a digital painting I did some years ago,

I used the original as a color guide. I imported the old version onto a new layer with Color Blending and resized it to match the new linework. I could then use the color scheme as a basis for painting the beast himself, but before that I built the background using parts of a dozen photographs, as well as elements from the original. These were layered, manipulated, recolored, blended, and arranged until I had a rough facsimile of that old version. Next came the slog of boosting the colors in the character using the Dodge and Burn tools to enhance the hand-painting. I used both the digital original and the traditionally painted version as reference. The lighting was the final painting stage, but I thought it would be interesting to see what it would look like with a border to finish off.

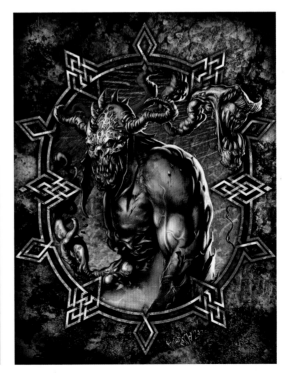

Left: Finding the Bas Relief filter.

Below left and Below: The Bas Relief filter is applied and the filter layer is adjusted and selectively erased.

Right: The final image, presented in a framed border.

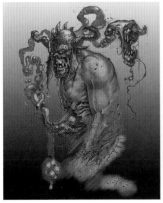

DEVELOPING A PAINTING:
MONSTERS

TIP 063

Photoshop Technique 3: Blending Modes

Blending Modes are another of Photoshop's powerful tools that can be utilized using duplicate layers to create exceptional effects. For the painted version of Zombie Viking Elvis, I chose to do it digitally, and in the execution, Blending Modes featured heavily, producing subtle but resonant results.

After importing the pencil drawing into Photoshop I pasted a photograph of scuffed metal over the background layer with Blending set to Multiply. I then used the Hue/Saturation dialog to alter the color of this layer to a nice blue-green to create a cool base for the zombie. I then duplicated the blue metal layer, changed the color to a warmer hue, and used the Eraser tool to remove the parts of the

layer covering the linework. This formed the basis for the background. I then brightened the background around the head of the character using the Dodge tool and a bit of hand painting. After creating a duplicate of this edited layer (to be used later as a mask), it was then merged with the original blue version, ensuring the Blending was still set to Multiply. The image was then flattened.

Next a focused bout of painting gave the character some definition and color. A few touches of crimson and vermillion around the eyes and gums contrasted nicely with the green-blue base color, but on the whole the palette used was monochromatic in the base hue, resulting in a sick, putrid, rotten skin tone and

overall feel to the creature. The colors used in the Celtic knot work were similarly limited. A little of the background color was brushed over the far shoulder and flaring collar to add depth to the image, and focus attention on the face.

Next, a photograph of clouds was imported, but this time the Blending was set to Overlay, ensuring the brighter areas of cloud were visible. A selection was created using the duplicated background layer, then inverted. With the cloud layer active, the selection was used to delete the area covering the linework, ensuring the clouds only covered the background. Further erasing and use of the Dodge tool and Paintbrush was required to whittle the clouds down to a focal point around the head of the zombie, before this layer too was merged with the zombie layer. At this stage a touch of the Texturizer filter was required. Set to Canvas, the filter was applied, mostly as an experiment, but it added a hint of texture to the piece.

More photographic textures were then overlaid, including paint splats recolored to reds, whites, and other hues, depending where on the image they appeared. A photograph of toothbrush-spattered paint was also scanned in and adjusted so it looked like white stars against a black background, then pasted over the image with Overlay Blending. This layer was blurred slightly using Gaussian Blur, then a duplicate was created. This layer was again blurred, but this time, using the Radial Blur set to Zoom to really create dramatic focus on the figure. These photographic layers were edited using the Eraser tool before being merged with the zombie layer.

A duplicate of the art layer was created and the Texturizer filter was used again, this time importing a photo of deeply scarred leather to provide some interesting texture over the duplicate layer. The Eraser tool was once more used to judiciously delete areas of the duplicate layer until the leather texture was mostly relegated to the background, before the layers were merged once again. A photograph of cracked, dry mud was then imported to add a final flourish of broken veins to the image.

Although hand painting was a great feature of the image, a large amount of the visual dynamic was due to the unique properties presented by Photoshop.

Opposite Left to Right: The first stages of digital painting for Zombie Viking Elvis.

Below Left: Texturizer filter is applied.

Below: The King lives again! Zombie Viking Elvis completed.

DEVELOPING A PAINTING:
FACES

Faces

TIP 064

Understanding Face Planes

This tip is concerned with the face, in particular how it is broken up into the planes that define how it should be painted and shaded. I've chosen to use a human face to illustrate this, but the principles are transferable to any kind of creature you might dream up.

I never found drawing faces easy as a kid, but I picked up a few tricks from movements like Cubism, specifically the method of interpreting objects, scenery, or human anatomy as a series of flat planes. This actually allowed me to visualize three-dimensional physical space in my head in a way I hadn't been capable of before, and I still use this Cubist approach whenever I start painting faces.

For the example shown above I used a cool face I saw on TV as inspiration for building a plane-form model, in which the features are broken down into a series of shapes that, together, create

the form of the head. The colors are chosen to mimic shaded and light areas. Half an hour of blending is all it takes to turn it into a more realistic visage.

It is a task that does require some study and practice to master, but there are some easy tricks you can apply to make instant improvements to a flat drawing and, once again, I must extend gratitude to Liam Sharp for his instruction in this matter.

Spots of light color above and below the outside edge of the eyebrow will pull that area into an authentic position in relation to the eye and brow, and careful blending will keep the effect flawless, yet striking. Similar application of highlights over the bridge of the nose, and the areas of skin around the lower, outer part of each nostril, will bolster the illusion of physical presence within the features.

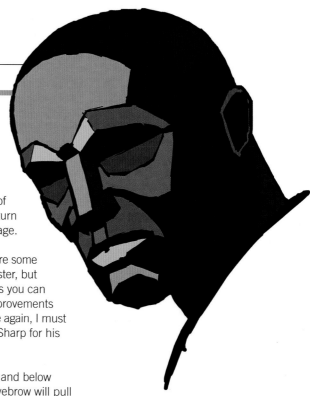

Above: A face painted as flat planes of color.

Right: The planes are rendered up to a finished painting.

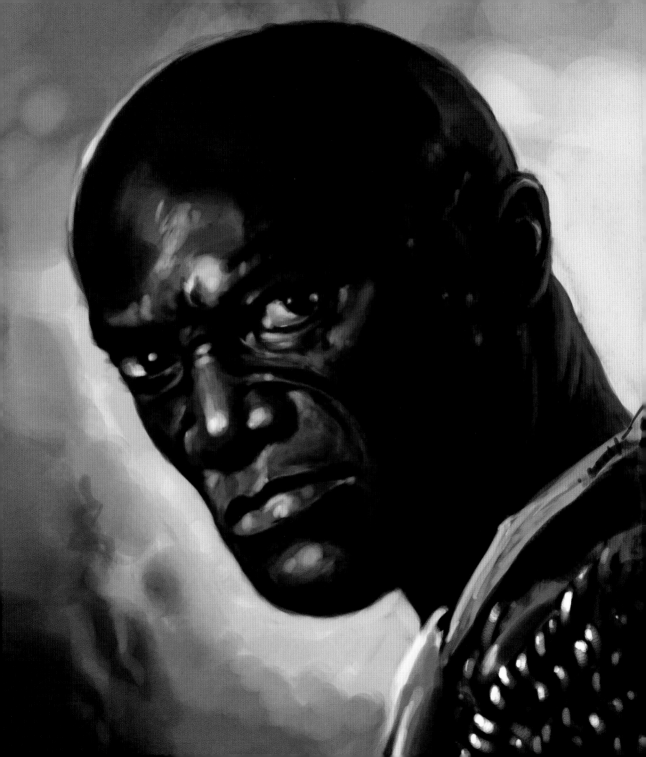

DEVELOPING A PAINTING:
LANDSCAPES

Landscapes

TIP 065

Take Lots of Photographs

This probably goes without saying, but an extensive library of photographs really does help when producing landscape concepts and paintings. In Rodney Matthews' book *In Search of Forever* there are numerous examples of how photographs were used to inspire elements in his fantasy paintings, and I've used photographs in the same way ever since. These days, of course, digital cameras make it so much easier; a photograph can be taken and utilized almost immediately, and it doesn't take long to amass a vast collection.

I searched through my photo library and randomly plucked out these images, each one with an interesting feature of some kind. I then created a new image using bits of each photograph. Although the lighting is all over the place and it clearly looks like a Hockney-gone-wrong melange, it provides a solid foundation from which to develop a new painting.

Right: A selection of landscape photos.

Below: A new mock-up composite created using parts of each photograph.

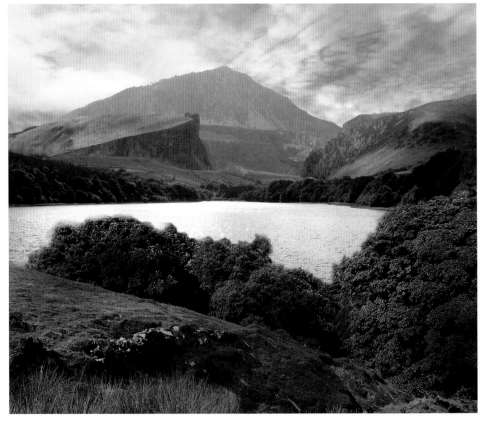

TIP 066

Painting a Landscape

Although similar in principle to painting characters or smaller objects, painting an environment is uniquely challenging. For example, although there might be many colors and hues within it, everything will be suffused with ambient lighting, whether that is golden sunshine, silver moonlight, or artificial light. There is also the problem of scale. If your landscape is expansive, how can you convey a feeling of distance? Even if your environment is small, atmospheric conditions might conspire to complicate aspects of depth and tone—but such issues are, after all, what make environments interesting to paint.

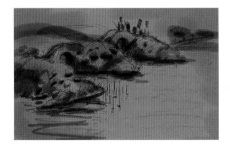

Having found a sketch stuffed down the side of my chair (!), I scanned it into Photoshop and tidied it up a little. The first stage of painting involved covering the entire piece with flat color, so I filled a new layer above the sketch with a grayish blue. I set the Blending Mode to Multiply so the sketch showed through, and flattened the layers. This hue would provide the basis for the overall ambient color of the scene, the idea being to apply paint in such a way that this blue base tone would show through in places.

With the Brush tool opacity and flow set to 60% and 30% respectively, and mode set to Multiply, I selected a slightly darker shade of the gray-blue color and began to paint over the shadows and darker areas. The image was now ready for more color. With the brush mode set back to Normal, I painted a brighter blue over the sky and a greenish ocher color was used to cover the ground. Because the opacity was set at 60% the coverage was variable in consistency, which allowed the background color to show through. I was careful not to paint too far into the shadowed areas. In the same manner

I added color to the bridges, trees, and other features until areas of flat, variable tone covered all the areas not in shadow.

I set the brush mode to Multiply and then enhanced the shaded areas with a little dark brown. At this point all the disparate colors and hues needed to be brought together. First, I made the sky a little brighter behind the tree, and darkened it at the other edge of the painting, then a little of the sky color was painted over the more distant hills and features using a soft brush with opacity set to 20%. I used this color to separate the distant hills from nearer ones, which suggested distance and scale. I painted darker tones of the ground color into the shadowed areas, and repeated the process for other features. Pale yellow was then brushed over the painting for soft highlights, and a mixture of pale blue and yellow was used for highlights in the murky swamp water. The whole process took less than an hour, resulting in a very rough color study, but what used to be an indistinct sketch is now a well defined painting, with a balanced tonal range and enough detail to suggest form and function within the image.

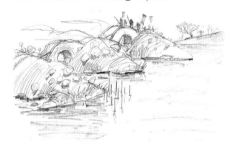

Top: Even the scruffiest sketches can be used as a basis for a painting.

Above: A blue-gray base color is applied to the image, and shadows are enhanced.

Right: Flat planes of color are painted using medium opacity. The finished painting, with adjusted tone and shading.

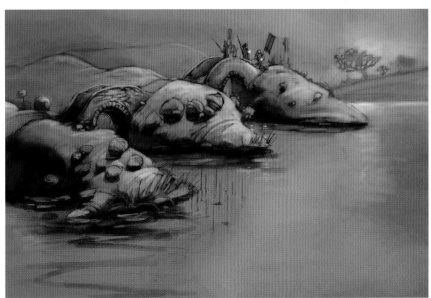

Using Color

I struggled with color when I was younger. I had a tendency to use colors that seemed to clash, and sometimes my mixed tones would become dull or muddy. I also found it hard to grasp how light worked within an image, resulting in many early paintings in which every element was lit identically, as if in isolation rather than as member elements of a collective composition. Such problems are common, of course. We all must start somewhere, after all. As I progressed in my studies, I discovered a few principles about how colors work together, how some complement and others repel, and how both instances can be exploited within an image. Light plays a huge part in this color theory, of course. Darker colors absorb light and lighter colors reflect it, and any other surfaces that face these reflective surfaces will, in turn, absorb or reflect the "bounced" light. Then there are materials to consider; hard plastics or metals will collect and reflect light in sharp areas of contrast, while softer materials such as fabric or weathered stone will interact with light in a much more diffuse way. It's easy to see how complex a subject it can turn into, but art is expressionism, and you need only master a few basic light and color principles to create compelling, convincing images.

Right: The pallid flesh tones mixed with earthy, bloody hues effectively portray this image of a skinless werewolf creature.

Understanding Color

TIP 067

Beast: Caught in the Light

When I set about creating the traditional version of The Beast from tip 12, I printed out a darkish, yellow ocher-colored version onto Bristol Board, which I then pasted onto a thick backing board. After the background had been painted, I created an underpainting using yellow ocher with a touch of pale lemon yellow and burnt sienna to darken the shading in appropriate areas. This began the process of building form and shape. I then mixed together Winsor blue and raw umber to add depth to the shadows, but the mix also imparted a greenish tint to the skin

when applied in a thinner wash. This formed the base from which I could build the rest of the painting.

Because the penciled art was quite well developed, I wanted to retain it as much as possible in the finished painting, so I applied the colors in translucent washes. Acrylics are very flexible in this respect.

The monster was illuminated by a main light source coming from the left, so the next task involved darkening the right side of his body to bolster the light dynamic.

It also provided a good dark contrast for the secondary light source I intended to add later. So I mixed together some ivory black, raw umber, and burnt sienna, but tempered this with a dash of Windsor blue to create a subtle resonance with the background. This was applied in a series of thin washes, gradually building up the tone.

Then something happened that is unique to the traditional method, something random, yet inspirationally exciting. After applying the dark paint I took

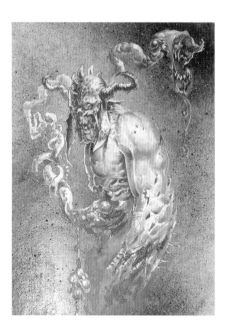

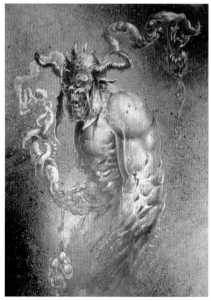

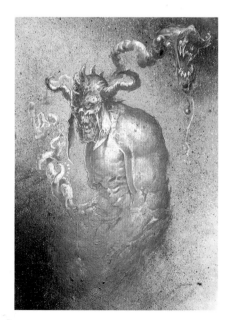

out my digital camera to take a few photographs for this book. I let the flash fire on one photo, and because I had the camera too close to the painting, the flash light illuminated some of the dark shadows around the belly area of the beast. The effect was interesting, so I decided to try to emulate it in the painting, using a light blue-gray paint mix. This resulted in greater depth around the area between the forearm and the torso, and this only occurred to me because of the serendipitous accident with the camera flash. (This sort of thing is why I will never give up traditional painting, and I include it here to illustrate one of the many ways an artist develops new working methods and techniques. There are some tricks you just can't learn from books.)

Next, I concentrated on the chest and face. I mixed a skin color using a base of Naples yellow, burnt sienna, and crimson, with titanium white, raw umber, and cobalt blue "on the side" for shade and color variation. Again, I applied the color in translucent washes, building up the tones gradually until some sort of form was taking shape. The less subtle

application of titanium white helped to boost highlights, and I frequently used a toothbrush to spatter various colors to keep the texture developing. The helmet was painted using the basic flesh tones augmented with gray. Lighter gray was used to develop a dull shine while retaining the pencil detail beneath. A variable mix of crimson and raw umber created thin veins here and there, and the same tones were applied around the mouth and helmet.

This felt like a natural end to this painting stage, so it was a good time to pause and take stock of progress. Sometimes it's difficult to see mistakes or areas that need attention in a painting when you're too close to it, so I usually spend an hour or so working on something else to help clear my mind of it. When I came back to The Beast it seemed clear that the torso and shoulder lacked definition in both shape and form, so I took out a simple black ballpoint pen to do a bit of reshaping and sculpting of the chest and upper arm. I then reinforced the skin tones, and bedded down the ballpoint pen remodeling with a touch of dark brown.

The next stage involved the creation of a secondary light source, coming from the right; a bright gray catching and illuminating details on the shaded side of the creature. This really helped the character "pop" out from the background and, after a few finishing details, including masking around the head to spray blue tones over the intestine-mouth-neck to push it into the distance, the painting was complete.

Opposite Left: The first stage of underpainting.

Opposite Middle: Shading is added to the underpainting.

Opposite Right: Shading is added to the right side.

Below Left: Lighter tones are painted into the stomach area to mimic the photographic flash effect.

Below Middle: Skin tone is added, and ballpoint pen remodeling is applied to the arm and shoulder.

Below: The secondary light source completes the image.

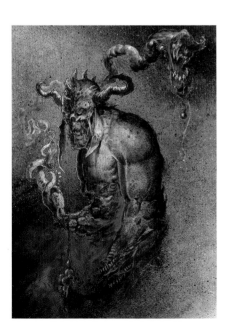

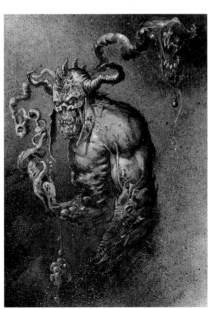

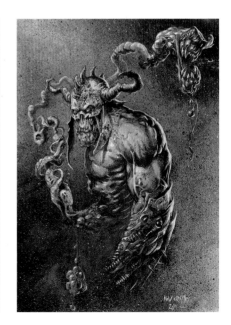

USING COLOR:
UNDERSTANDING COLOR

TIP 068

Using a Limited Palette

One of the methods I used to help me deal with my color-clash problems was to work with a limited palette. I actually picked this tip up from the children's show *Rolf's Cartoon Time* back in the late 1980s, when the show featured a cartoon from the 1930s that was colored using only four colors—something like black, green, yellow, and blue. The effect seemed limited at first, but soon gelled, and actually seemed to have much more character and atmosphere than the other gaudily colored cartoons. This approach is useful in creating a range of complementary tones from the outset that will unify an image rather than create areas of discord.

Dave Millgate set about producing a new acrylic painting of his *Iron Heel* monster concept that beautifully illustrates how a limited color palette can create atmosphere and character.

Before painting commenced, Dave turned his initial sketch into a finished pencil drawing, but flipped it before inking. Dave explains, "my reason for flipping the drawing was partly because people tend to scan over an image much as they do when they read text from left to right, so it leads you past the creature first and then onto the tiny soldiers falling from the guard tower. I think it worked better this way, both story- and composition-wise."

Dave then developed the underpainting before defining more details on the surface of the creature, adding a little more texture, highlights, and shadow areas.

Next, he blocked in the background to help define the creature's shape and edges and clarify the composition. A dramatic background was then defined by the addition of dark clouds, flak explosions, and other atmospherics. World War II elements such as the Stuka bomber and Nazi guard tower helped to define the time in which the image is set.

After applying finishing details to the principle elements of the image, a subtle glaze of color was washed over the entire piece. This was applied using a very thin, watery color with hardly any paint on the brush. Tonally, this glaze helps to tie the whole piece together, and also stops any edges from looking too sharp and harsh to help maintain the foggy and moody atmosphere of the piece.

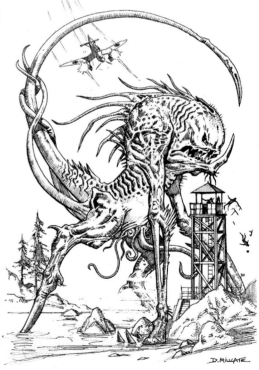

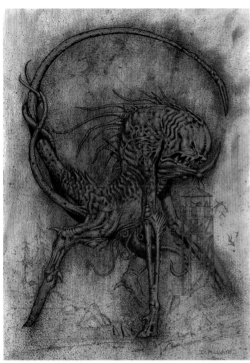

Opposite Page: The initial stages, from sketch to inked pencil.

Left: The underpainting.

Below Left: The addition of background elements helps refine and define the image.

Below: The completed image.

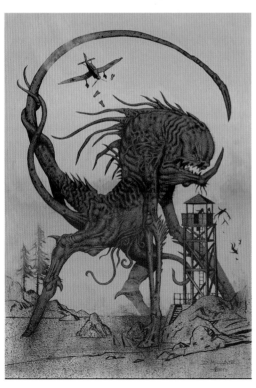

USING COLOR:
TRADITIONAL TECHNIQUES

Traditional Techniques

Throughout the years I spent developing my art skills, I would usually concentrate on getting used to one medium at a time before trying something different. Watercolors were the first thing I really got to grips with, and perhaps it's no surprise that most of the paintings I produced in those following 20 years were produced using them. I then experimented with colored inks for about a year before having a go with gouache. These water-soluble paints seemed to me to perfectly complement watercolors, with the bonus of an opaque finish. Learning how to use acrylics is my most recent exercise and, once again, I didn't use any other type of paint as I familiarized myself with the medium. Over the following tips we'll explore different traditional media, and see how the particular qualities of each can be exploited. First up is gouache.

Opposite Top Left: The pencil version of *ABC Warriors*.

Opposite Left Middle: A blue background is painted over the red underpainting.

Opposite Left Bottom: The lead character and foreground elements are painted.

Opposite Right: The background characters and final lighting details are completed.

TIP 069

Gouache

In 2006 I did an inked pinup for *2000 AD* of the *ABC Warriors*. Although I was attempting to channel the classic *Black Hole* series partly illustrated by Simon Bisley, my technique was a little roughshod, with a scribbly hatching style that grated against my eyes when I rediscovered it just prior to starting this book. I thought it would be good to have another bash at it and, after producing a new ink study, which I then used as a watercolor practice piece, I set about rendering a new pencil version.

I brought to bear all the knowledge I had acquired since I did that first shaky version, but opted to use gouache, a medium I'd not used for almost 15 years. This was on the recommendation of Greg Staples and Liam Sharp, who extolled the virtues of the paint one dark, beer-drenched evening in deepest Derby (in Derbyshire, UK). This was going to be a bit of a voyage of rediscovery for me, but I soon got used

to it again. I began by producing an underpainting in various reddish brown hues. Although this technique works best with oils and acrylics (with a water-soluble medium such as gouache, later painting could mix back into the undercoat), I wanted to experiment a little to see how far I could push the medium.

For the final colors, I began by painting in an almost flat blue background to define the negative space around the characters. I then focused on the lighter tones, as I do when using acrylic, leaving the reddish base painting visible in the shadows. However, I quickly began to rediscover some of the characteristics of the medium. Unlike acrylic, which dries into an impermeable, plastic finish, gouache has a unique granular matt finish, which can crack and crumble away from the painting if applied too thickly, so I was careful to avoid this with subsequent applications. That said,

the ability to work back into areas of dried color really impressed me, and the richness of the tones was wonderful, too. I blended the light colors into the shadows and gradually it began to feel like a cohesive whole. To represent reflected, ambient light sources I then painted some lighter shades into the shadows, sometimes using blue tints to reflect the background tone, but still allowing some of the reddish underpainting to remain uncovered. This redness permeated the entire painting, supplying a unifying tone that holds everything together.

The brushwork was boosted by all my usual painting techniques; smudging with tissues and fingers, spatter effects using the old toothbrush, with a few new texture ideas thrown into the mix. By the end I had a renewed appreciation for gouache, which I pushed further with an idea to use it with inks (see tip 76).

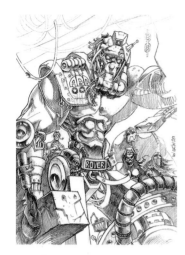

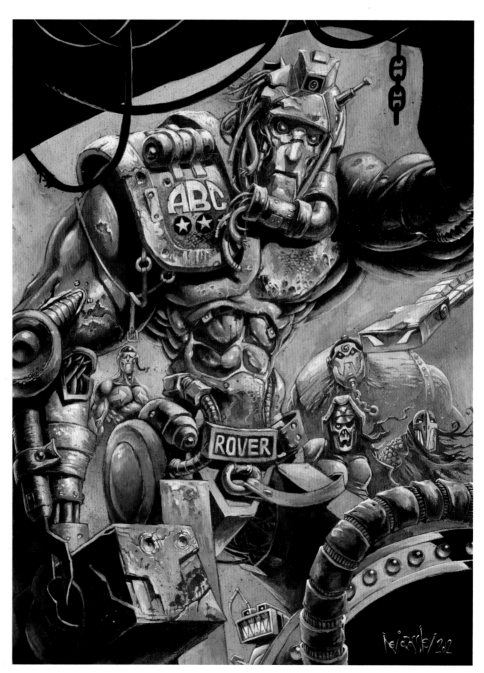

USING COLOR:
TRADITIONAL TECHNIQUES

TIP 070

Below Right: A watercolor study with the paint applied in thick daubs straight from the tube.

Watercolors

Each of the images on this page was painted using watercolors in different ways. The *Die a Hero* story (right) featured a Samurai warrior's fateful meeting with a monster, and was drawn using colored pencils with watercolor washes over the top. A lot of texture experimentation went into the art, including salt technique and mark making.

The bear (far right) was an odd one, as I ended up using very little water to dilute the paint, just enough to give it fluidity, but, for the most part, it went onto the paper in thick, opaque, expressionistic daubs. Toothbrush spatter added finishing texture. Although it's okay to use this approach, watercolors don't naturally lend themselves to it—the pigments just aren't robust enough, leading to muddy colors lacking vibrancy. Watercolor relies on the brightness of the white paper shining through washes of color, which is lost when painting in this way.

Finally, these two pages (right) from the *Dragonfly* story featured a split narrative. The primary story was drawn in ink, shaded with pencil, then finished with watercolor washes using a limited, monochrome palette. The secondary flashback story played along the bottom of each page, and was drawn in Col-Erase non-repro blue pencil with a blue watercolor wash over the top. It's a useful and versatile medium with hidden depths.

Above Left: A page from a sequential story painted using watercolors in a variety of applications.

Right & Far Right: Pages from *Dragonfly* published in *Event Horizon*, painted in watercolors.

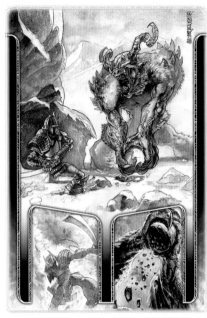

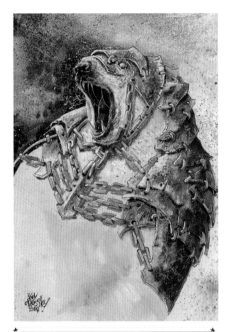

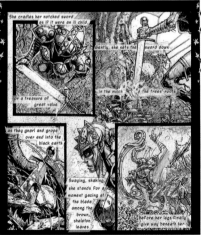

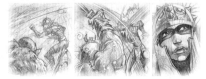

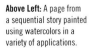

Color Pencils

Colored pencils are a useful addition to the fantasy artist's toolbox, but they are sometimes overlooked in favor of more robust methods of rendering. I must admit that after leaving school I didn't use colored pencils again for many years but this book gave me the opportunity to rediscover them all over again.

The first dragon shown here (below) is a rather strange-looking beast, drawn using a 2H pencil, after which I ran over it with pencil crayons. This was the first time I'd used them after nearly 20 years, and it was almost totally alien to me, yet interesting enough to encourage me to dig out my old watercolor pencils to use on another dragon. This time I printed a sepia-toned version of a dragon

pencil drawing onto heavy art board, and added various complementary pencil colors in a fairly sketchy way. Watercolor pencils are very useful indeed, as they lead a double life—you can use them to achieve normal pencil effects and textures, but with a brush and a little water, they can be transformed completely. Although

similar to proper watercolors, the feel and technique are distinctly different and, depending on how wet the brush is, the "paint" will do all sorts of random things on the paper. For this piece, after adding water and mixing the colors into one another, I used a little colored ink for spatter texture and highlights.

Below Left: A curious dragon-type creature colored using pencils.

Below: Colored pencil is applied in sketchy strokes.

Right: A wet brush brings the colors together.

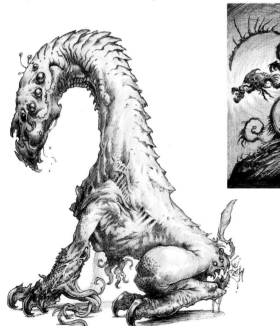

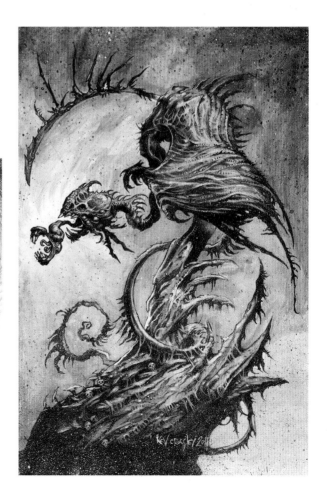

USING COLOR:
TRADITIONAL TECHNIQUES

TIP 072

Colored Inks

Colored inks are a vibrant, colorful, almost summery medium to use, and their versatility comes in handy in so many circumstances. They can be applied with brushes, dip pens, diffusers, and airbrush, all of which were used to paint this image. Color was laid down in thin washes of complementing hues, with spatters and sprays of color added to break up the tones. I then painted the background pure white, using opaque white ink, and this led the lighting of the image, implying bright highlights and ambient secondary illumination. As I had started the painting process using washes to set the tone, I needed to mix a small amount of white ink into the final colors to give them a little bit of opaque body. This was an interesting approach, and a new one for me, which felt similar to how I would use acrylics or oils but, even used like this, inks have their own qualities that set them quite apart from other media. I found that color applied in rough strokes resulted in a pleasing balance against the visible areas of background wash, which functioned as a tone unifier. Very soon, it reached a point where I could easily have overworked the colors, so more white ink tinted appropriately was used to add highlights and other details to bring the painting to a finish.

TIP 073

Brief 11: Acrylics

The opaque, quick-drying properties of acrylics mean that progress on a painting can be made quite quickly compared to oils, for example, and the ability to paint light over dark adds a depth to the tone that is simply not possible using watercolors or inks. Although the pigment content is inferior to good oil paint, acrylics do offer bright, energetic color properties that stand up well when applied as detailing over darker areas of a painting. A technique they lend themselves to is when applying a glaze, which involves mixing the smallest amount of color with a lot of water to brush over a finished painting. Because it dries so waterfast, this glaze won't cause any muddying or lifting of color, as would happen with watercolor or gouache, so it's very easy to unify the color values of a painting by adding color glazes at frequent intervals during the painting process. The first of these two images below show the painting in a well-progressed state, but the colors are lacking a cohesive quality. The second image shows the subtle change a glaze can create. I've found that it doesn't harm to apply a glaze whenever you feel it is required, not just at the end of a painting. Also, the amount of pigment mixed into the water will determine how extreme a tinting effect will be, so experiment to see what works best.

Below: Flat colors and textures are applied to the pencil drawing.

Right: Detailing is added using translucent and opaque colors.

Below: The colors lack a cohesive quality.

Right: A glaze is applied to unite the acrylics.

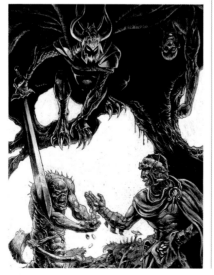

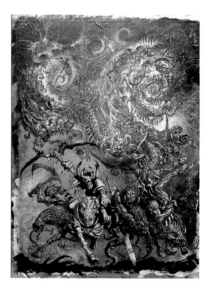

TIP 074

Oils

For this oil painting by Liam Sharp, Liam set about creating a four-armed Martian ape appearing in a doorway before a female acolyte. The approaches Liam used to define his characters were varied, and it took an amount of experimentation to capture the feel he was looking for in the image. This involved trying out numerous color variations within the characters and background—all easily facilitated by using oils.

The downside of working with oils is their drying time. Unlike acrylics, oils don't dry very fast, so you need a day after you've laid down the underpainting before you can go in and paint on top. If it's not dry, the brighter colors get muddy and you

lose the integrity of the base art. Therefore, painting in oils affords an artist time to stand back and consider how best to push the painting. Liam spent a few weeks producing this masterpiece. However, having to wait until a coat of paint dries is well worth it, because oils have a richness of color unlike any other medium, and this is particularly apparent in Liam's painting.

To start, Liam produced a quick pencil sketch, then quickly laid down an underpainting in red-brown tones. This was developed until Liam felt it was ready to leave to dry.

Liam then worked on the anatomy of the characters, adjusted the color of the background blue while having fun developing the texture of the stone wall, and already the painting was taking fine shape. However, as it was meant to be a Martian setting, Liam opted to change

the background blue to rich yellow and orange, a significant change that ultimately affected how the light worked into the other details of the image.

Next came the details and highlights, and soon the face was looking more gorilla-like. Liam added some red and cyan as a glaze to enhance the highlights and unify the skin tone before changing the background color once again. The yellow wasn't saying Mars, so a red-orange glaze fixed that, as well as adding a lot more drama and making the whole feel more coherent.

Lastly, Liam felt there needed to be a hint more architecture in the background, so he added a faint suggestion of steps, and changed the area around the girl's feet, strengthening the composition. A touch of varnish added richness to the colors and shadows, and the painting was finished.

 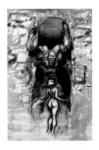 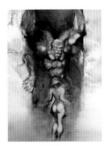 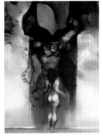 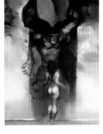

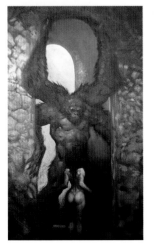 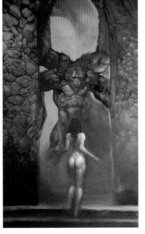 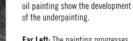

Above: The early stages of Liam's oil painting show the development of the underpainting.

Far Left: The painting progresses, as Liam experiments with color schemes while building up the detail.

Left: The background color scheme is changed to yellows and oranges more befitting of the painting's Martian setting.

Right: The final painting is full of poise and atmosphere.

USING COLOR:
TRADITIONAL TECHNIQUES

TIP 075

Using Masking Film

To begin, I imported the pencil version of The Beast, as featured in tips 11 and 12, into Photoshop, and used the Color Balance and Hue/Saturation dialogue boxes to color the linework a reddish brown. I then printed this onto Bristol Board, and used adhesive to stick this onto thick card.

I do frequently paint directly over my pencil art, but sometimes I like to retain the pencil version (as I'm such a fan of the medium). Plus, if I make a mistake, I can always start again.

Although my usual working method would involve painting the character first using loose, rough strokes before painting a background, for this I intended to use lighter, translucent washes in a much more controlled manner, so I painted the background first. I wanted the

background to be applied in broad strokes and sprays, so I used adhesive film to mask the character. Masking film is very useful, and can be used at any time in the painting process, as long as the surface it is to be placed on is dry. It comes in sheets and rolls of various sizes, and has a strong enough "tack" to adhere to the surface of your artwork without pulling the surface off the paper when removed. I used to use masking fluid, a liquid applied with a brush that dries into a rubbery film, but I almost never managed to remove it without peeling off the paper surface. It also ruined numerous brushes.

I cut a sheet of masking film to size and pressed it onto the printed art. I then used a scalpel to carefully cut around the character, and removed the excess film, leaving the background uncovered.

I have found that, sometimes, paint or ink can bleed beneath the masking film so, to prevent this, once I've cut the mask to shape, I use the back of a spoon to rub over the film. This ensures the edges are firmly pressed onto the art, and the rounded spoon won't scratch or cause any damage.

With the mask in place I painted the background in acrylics. Using a broad brush I applied a mix of various blues, with pale green, titanium white, deep red, and black to create nice gradients of tone. The brushstrokes varied from wide strokes to light dabbing and stippling to create interesting texture.

When the paint was dry, I used my airbrush to smooth the rough textures with fine sprays of liquid acrylic and ink color. Applied at an extreme angle, this

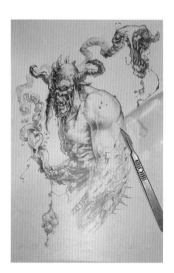

method catches the peaks and veins caused by the loose brushstrokes in places, further accentuating the texture.

To finish, I used my old toothbrush to spatter larger sprays and spots of black, white, and yellow over the background, then left it to dry. Next came the tricky task of removing the masking film. I have found that if I've used colored ink or watercolor, the film is fairly easy to peel off, but the beast here is obscured under thick acrylic, so the edges of the film are not so easy to spot. Eventually, I located the edge and, using the tip of my scalpel, I teased it up until I could peel it off the artwork, being careful just in case it happened to be stuck anywhere. (Luckily, it wasn't this time!) With the background complete, I could turn my attention to painting the beast itself.

Opposite Left: Here, the masking film is stuck down over the art, and a scalpel is used to cut around the character.

Opposite Middle: Brush, diffuser, and toothbrush are used to add a range of tones to create the background.

Opposite Right: When the paint is dry, the film is removed carefully.

Right: The beast, ready for painting.

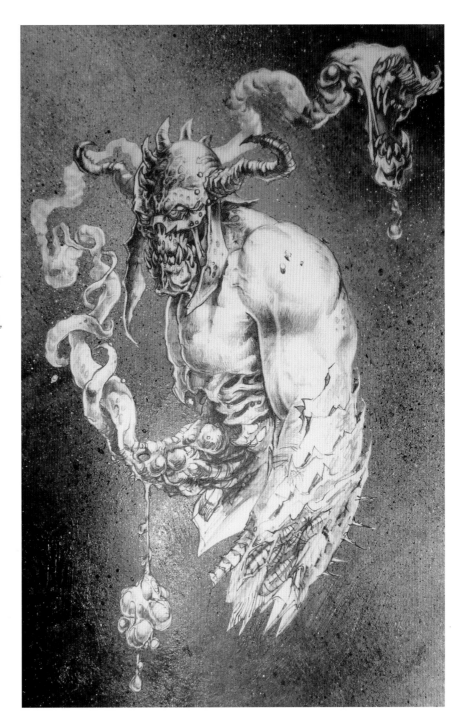

USING COLOR:
TRADITIONAL TECHNIQUES

TIP 076

Scorpion: Mixed Media

Artistry goes hand-in-hand with experimentation, and the best way to experiment simply involves mixing media. With practice and experience, most traditional artists will discover particular properties unique to various types of media, which they then perfect to suit their requirements. I have recently begun to produce mixed-media paintings and, in the following tip, I'll show how I build a painting using acrylics, inks, gouache, and watercolor pencils. I never quite know what technique or medium I'm going to use, or when, which is part of what makes it so exciting!

For the traditional version of the scorpion faerie featured in tips 11 and 12, I began by laying down a grayscale underpainting. To start, I took the pencil drawing, which was on heavy, textured watercolor paper, and stretched it onto an art board. I quickly brushed a medium gray acrylic wash over the entire image, then used splashes of water to vary the weight of color. I had a damp wad of tissue on hand to quickly remove thick areas of paint that would otherwise have obscured parts of the pencil drawing.

Once dry, I used watery washes of black acrylic to define the shading of the entire character, with a slightly stronger wash applied with a fine brush to strengthen the linework. Acrylic paint dries waterfast, and so would remain unchanging as I add layers of color over it.

To allow the shades of the tone painting to show through I used colored inks for the base color. Using a selection of reds

and brown I painted a watery wash over the wings and ribbons of the character. Darker brown was then used to add definition to the shadows. When dried, the pencil and acrylic tones were still apparent beneath the color. I repeated this process using a light brownish hue for the hair, then allowed the ink to dry.

I covered the figure with a fine misting of water (to prevent the paint from settling

too soon and obscuring the pencil), then daubed darker, ruddy hues of acrylic over the skin, particularly around the edges and into any shadows. The remaining paint mix was roughly brushed around the edge of the painting. A toothbrush was used to haphazardly spray colored ink over the image, first peat brown, then black India ink, followed by white ink. The resulting underpainting looks like a mess, but out of chaos order will come,

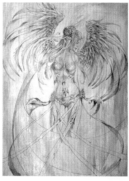

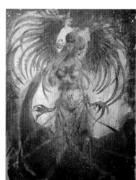

Far Left: Light gray acrylic is used to create a tone painting.

Left: The wings and ribbon colors are added using translucent colored ink, then a red and brown undertone is added using acrylics.

Below Left: The background is painted in, and gouache defines the skin tone.

Below: Gouache is painted over the colored ink to bring out the lighting and details in the wings.

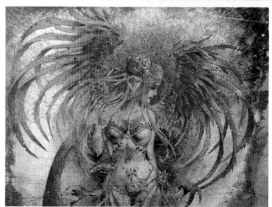

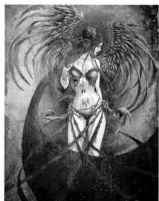

and all that lovely, speckle-textured red will add a sumptuous depth to the base notes of the painting, once the finishing coats are applied, and the edges are refined once more.

To get there, however, the background needed to be painted in, and to do this I opted to use masking film to cover the character, a process that took the better part of an entire evening to complete. The chance to go nuts with the paint made up for it, so I used acrylics, colored inks, and watercolor pencils to create a whole range of different effects. However, once I removed the film, I found the background paint had bled beneath the film in places, so I used a black pencil crayon to bolster the pencil line where required.

I then took out my gouache paints and set about blocking in the pale skin using white and grays. I also picked out the lighter areas of the wings using a pinkish range of colors before painting in the black ribbons and brown hair. Black with a little brown was used with white to create striking ribbon detail, and the traditional painting was complete.

This being a mixed-media tip, however, I decided to add a little finishing presentation technique using Photoshop to produce an interesting comparison to the fully digital version.

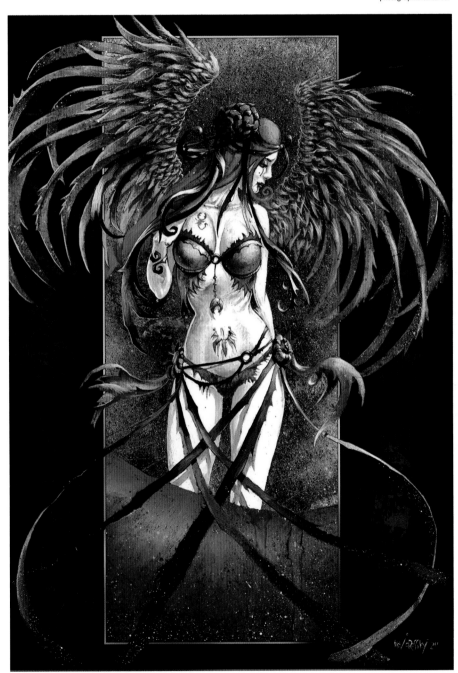

USING COLOR:
DIGITAL TECHNIQUES

Digital Techniques

TIP 077

Painting Over Inks Digitally

This image of zombie smugglers was produced as a cover for the *Lewes Bonfire Society* magazine. Once the pencil sketch had been approved, I inked it, then scanned it into Photoshop. I then added flat color for the different elements in a Multiply layer over the ink art, using the Lasso tool to create selections that I then filled with the Paint Bucket. Dodge and Burn were used to add subtle shade and light values before the image was flattened, and finishing tone and texture was added using the Brush tool. This is a useful method to use, particularly when coloring pages for graphic novels.

Right: The first sketch was amended slightly before inking.

Below Left: The inked art.

Below: The digitally colored art.

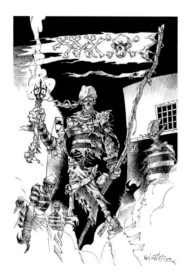

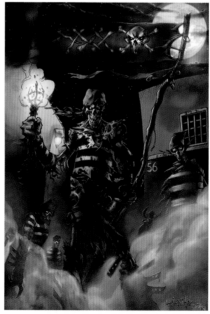

TIP 078

Scorpion Digital: Dodge & Burn

To produce the digital version of the Scorpion as featured in tips 11 and 12, I decided to go back to the very first method I ever used to digitally "paint" an image: Dodge and Burn. When I was a young Photoshop acolyte, I found the painting functionality in the early versions of Photoshop didn't quite work for me, but Dodge and Burn did. With hindsight, using these tools exclusively to paint an image didn't produce the standard or quality I would be looking for later on, but it provided me with an easy introduction to using the software as a fine-art application and, as such, I thought it was a technique that merited inclusion here.

I began with the raw pencil drawing imported into Photoshop. In a Multiply layer above the art I used the Paint Bucket tool to fill it with a gray-blue hue, which I lit with a greenish-aqua-colored Omni light, found in the Filter menu. I then selected the Dodge tool. (This is found along with Burn and Sponge in the Tool Panel.) While Burn darkens color, the Dodge function essentially lightens tones, and I used it as I would a brush to lighten the skin of the figure before adding flat red and orange-ocher into a new Multiply layer to color the wings and hair.

I can never go too long in Photoshop without experimenting with a few photographic overlays so, once I'd melded a few images of stone, lichen, and cracked mud and bedded them into the image, I continued my Dodge-Burn painting. I decided to echo the color of the wings in the clothing, and added black to the ribbons, all of which I gently defined using Dodge to create lighter

surface planes, and Burn to create darker areas.

The wings were next, and they took a long time to paint, but eventually the interplay between Dodging lighter and Burning darker areas results in a painting style that doesn't look too bad. These days, if I use Dodge and Burn, I do so sparingly, so I do touch the image up with a little overpainting. The result is a striking image created in an unorthodox way. It's a great illustration of how flexible Photoshop can be.

Below Left: The scanned pencil drawing is tinted, the skin tone is developed, and bright, flat color is added.

Below: Photographic elements are imported to add texture and the tone values are developed using Dodge and Burn.

Bottom: The completed image.

TIP 079

Digital Werewolf

Manon created this fabulous, grisly demonic wolf from scratch in Photoshop. She explains her process: "I started with a roughly textured background and a very low opacity brush, avoiding detail to build up a vague idea of the creature's face. Next, I overlaid some interesting textures around the jaw, cheeks, and eyes to create an impression of ligaments and tendons, then used a low-opacity brush with a tapered tip to paint over the textures, developing the shapes.

"After working on this for a while I flipped the image horizontally and found that I preferred it this way around. Shadows were painted on a Multiply layer before the image was flattened. For blood, the best technique I've found is to use a new layer set to Multiply, then pick a medium red and a low-opacity brush and just go to town. The process is repeated over the top of that layer and the layer opacity can also be adjusted. More and more detail can be built up in this way, including picking out spots of light in the skin to make it look shiny and wet.

"The last addition is also the most fun: adding the drool! A new layer is set to a low opacity and a gray color is used to sketch in 'action drool.' White is then painted into a final layer to give it the wet look—et, voila! It LIVES!!!"

Below: Vague details are suggested with a low opacity brush in the initial Photoshop sketch.

Below Middle: Textures are overlaid to lend authenticity to the wolf's features.

Bottom: The finished painting.

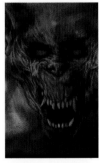

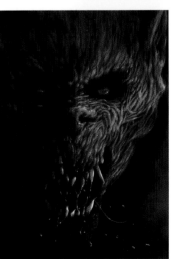

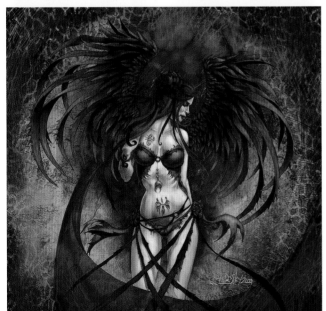

The Devil Is in the Detail

Texture is one of the great attributes of traditional painting. Over the years I've learned a lot of tricks from other artists and from many books and magazines, but there have also been many instances in which serendipity has presented me with some fabulous tricks, which I'll describe in this chapter. However, texture is not restricted to physical art; the digital medium presents a unique approach to texturing paintings. Real world examples can be applied to create stunning effects in digital paintings. It's also a lot of fun. In this chapter I'll show how photographic overlays can be used to mimic traditional painting and add depth to images.

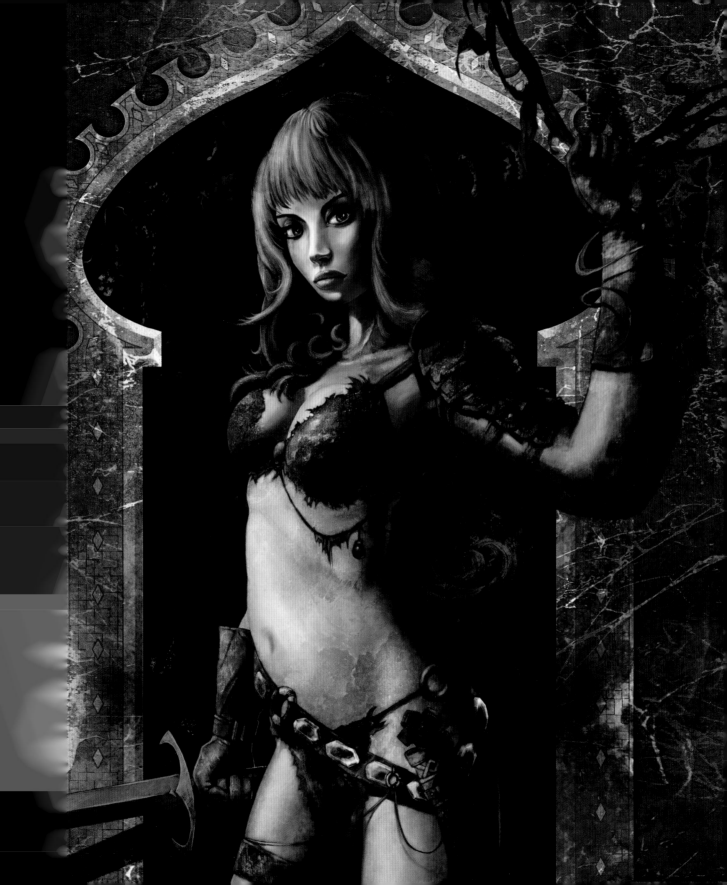

THE DEVIL IS IN THE DETAIL:
TEXTURE: PHYSICAL

Texture: Physical

TIP 080

Creating Veins

This painting certainly isn't the best I have ever done—the anatomy is too blunt and immobile—but I persisted with it because I liked the accidental texture effect I discovered when I started the underdrawing. I wanted to repaint over an old picture, and so coated it in swathes of white, mixing acrylic as a base. I applied the paint using a strip of card but, when I lifted the card from the paint, it caused the paint to lift up in veins and ridges that looked stunning! I created more of the ridges before leaving the paint to dry.

The stage photographs illustrate how to achieve the effect, by first dropping paint onto the board, then smoothing it across the surface using a strip of thick card. Pressing this card onto the paint, then lifting off, creates the various vein effects. The thicker the paint, the wider apart the veins are, becoming more like knife-edge ridges. The photograph of a faerie painting I'd just begun shows the effect of pressing a small amount of paint onto the paper. It creates numerous, fractal-esque ridges and veins that, when dry, will form a tactile base on which some interesting texture can be developed. Another cool aspect of this technique is that a painting featuring these effects will catch the light in different ways at different times of the day, although it can be a bit of a pain to scan in on your flatbed!

Right: These details reveal the extreme vein textures.

Below: The stages of how to create veins using thick paint.

Bottom: I used the making of this painting to experiment with texture.

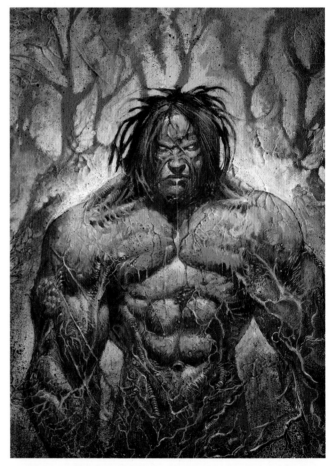

TIP 081

Using Rock Salt

Salt has been used for thousands of years as a means of preserving all sorts of meat and other foods, and it does this partly by drawing the moisture from it. This property of salt can also be great fun to use when painting in watercolors or thinned acrylics and gouache. To get the varied effects shown in these examples, I painted watery washes onto the paper, then added blobs of paint direct from the tube into the pooling water. Onto this I then piled rock salt. The effects are totally random, and can be affected by adding less or more salt or different grades of salt, as well as adding more paint on top of the salt itself. I then leave this overnight to dry (or on a radiator for expediency), then brush the salt away to see what effects I've been left with. (The last example has been photographed with a lamp positioned to one side to show the texture produced if you choose to leave a few salt crystals embedded on the surface.) As an extra tip, you can keep the salt and reuse it; sometimes, previously soaked-up color will be released back onto the paper, creating new textures. This is one of the best and most fun tricks I know.

Right: In these panels, salt creates useful textures with wet paint.

TIP 082

Various Ideas

These panels were all painted using watercolors and, in some cases, white ink, but each looks markedly different. In some, a texture medium was created by mixing sand into a basecoat of paint and white glue, allowing the paint to be molded and shaped before it dried. A scalpel was used to create rain effects in another, and a nib pen was used to apply paint in hard lines elsewhere. The best part of learning how to use a medium is the MISusing of it!

An old metal trivet was used to create subtle patterns on the armor of the ABC Warrior. Using an airbrush and toothbrush to spray paint through the warped holes of the metal grill created nice irregular patches of gridded texture, which could then be touched up by hand.

One of the best tips I took from art college was to remember everything you learned in art up to the age of 11, and forget everything learned afterwards. The drawings my three-year-old son brings home are created using objects like cut apples, fingers, hands, tongues . . . you name it! The results are charming and chaotic, but there's a vibrancy and energy to them that can be lost as we slowly morph into embittered grown-ups. Relearning how to indulge in this sort of mark-making can invigorate your art.

Right: These panels display a variety of texture-making techniques.

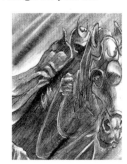

THE DEVIL IS IN THE DETAIL:
TEXTURE: DIGITAL

Texture: Digital

TIP 083

Using Photographs

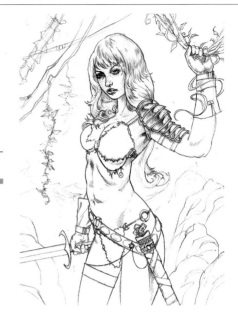

As you'll see in other work featured throughout this book, photographic textures can be used in a number of ways in digital art. It's one of the principle attractions of working digitally and, indeed, represents something of an innovation exclusive to modern art-production techniques.

For this painting I was inspired by a number of subjects and techniques that I wanted to marry together using Photoshop, including Baroque painting, fantasy art, Photoshop filters, and of course, photographs.

I began with a pencil drawing on canvas board inspired by that evergreen fantasy staple, the scantily clad female barbarian warrior, which I scanned into Photoshop. I tidied the image up a little, allowing the texture of the canvas to remain in places. I'd recently been studying some paintings by the Italian artist Caravaggio, an infamous painter active from around 1590 until his death in 1610. His work marked an incredible upheaval of contemporary style, combining fierce, naturalistic portrayals of his subjects with intensely dramatic use of chiaroscuro (a term meaning "light-dark," which, in painting, was exploited using bold contrast between tone extremes—usually dark backgrounds with pale bodies). The resulting paintings were striking, so I thought I would attempt to capture

the essence of this approach within this digital painting. To that end, I produced a dark background mask to set the tone.

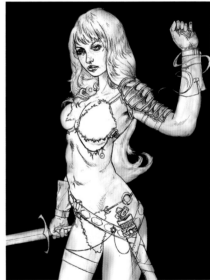

Next, I set about producing an underpainting using red tones painted on a Multiply layer above the pencil art. I couldn't resist the temptation to add a bit of lichen texture from a photograph before erasing some of this red color to hint at lighter skin tones. Next, I broke out the photograph library in earnest, and chose photographs of a cracked earthball fungus, spider webs, a dirty stove top, and a salt-texture photograph. I then incorporated these into the painting using various Blending Modes, layered opacities, and edited selections. My aim was to create a texture "soup" which would influence all the stages that followed as I developed the painting.

Opposite Top Right & Opposite Middle Right:
The pencil and masked background for Blue Jasmin.

Opposite Bottom Right: The photographs chosen to apply texture to the image.

Above: The first stages in the development of the underpainting.

Right: The completed underpainting, incorporating parts of each photograph.

THE DEVIL IS IN THE DETAIL:
TEXTURE: DIGITAL

TIP 084

Digital Chiaroscuro

With the texture undercoat complete, the "light-dark" chiaroscuro effect was ready to be created. Applied digitally, this effect could only ever be an approximation of the authentic method, but my aim was to experiment with the concept in the hope that it would be an opportunity for a few new lessons and encourage the natural development of a new skill set.

To this end I created a new layer and painted the pale skin tone over the background, being careful to work around the pencil art. The characteristic blue hair was also added, although the precise hue might be subject to change as the painting developed. I didn't want to paint in a classical style, simply capture the tonal contrast between background and subject.

When the skin tone was blocked in roughly, I then painted over the background around the character to sharpen the periphery between light and dark tone before developing the skin tone a little more and adjusting the hair. Blue can be something of an alien color when applied to hair, so I didn't want it to seem too garish or unreal. Painting a little greenish tint into the hair, plus subtle hints of the background tone, helped to ground the color. Next, I painted touch-up detailing into some areas of the background using the photographic textures as guides.

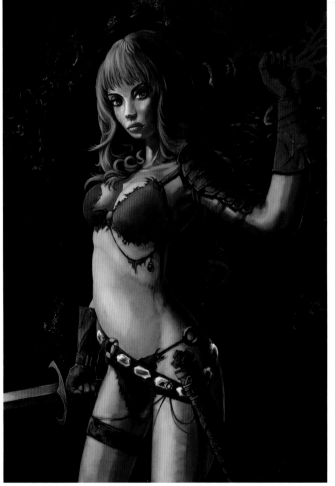

Above Left: Skin and hair color are added in transparent layers.

Above Middle: The background around the character is sharpened.

Above Right: The skin and hair are adjusted.

Left: Detail is added into the background.

Left & Below: The final stages of the painting the Blue Jasmin included hand-painting techniques mingled with digital trickery, finished with the addition of a designed border.

TIP 085

Digital Finishing

Long before Photoshop existed I began to learn how to paint using watercolors and inks. There was no safety net of "Control Z" to rescue my work from a fatal mistake, and no quick opportunity to experiment with color schemes before committing. I am a child of the old school in this sense, and it took a long time for me to warm to the many possibilities Photoshop presented. (I still remember being stunned while working through Photoshop 3 training tutorials that showed how to turn a green pear red. It seemed like dark magic to me back then, and I was instantly hooked!)

However, as I familiarized myself with various art produced using the software, it seemed to me that it betrayed its methodology rather too much; it looked too obviously digital. In spite of that, I was never interested in simply reproducing traditional styles digitally. Instead, I wanted to use Photoshop to produce art that was unique, and had some kind of integrity that I felt would justify using it instead of resorting to traditional media. These final stages of the Blue Jasmin painting shown here incorporated some aspects of traditional painting that were transferable to the digital medium, but then bedded down using the powerful features unique to Photoshop, including layered Filters and texture manipulation. Tone was built up layer after layer, with free reign given to my proclivity for detailing as I went.

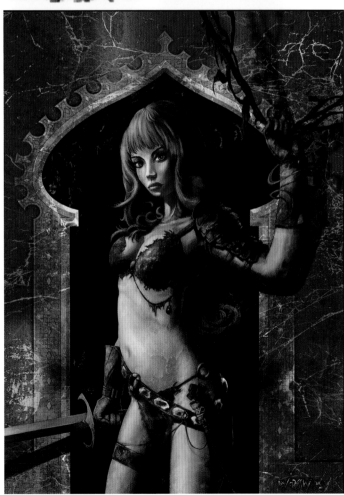

THE DEVIL IS IN THE DETAIL:
ADDING DEFINITION

Adding Definition

TIP 086

Brief 12: The Nitty Gritty

Finally, the Four Horsemen of the Apocalypse painting comes to a conclusion. Every painting has a "nitty-gritty" stage, meaning the end game—the final flourishes and detailing that bring the painting to a natural conclusion. Clichés like "a piece of art is never finished, it is abandoned" ring particularly true during these latter stages, as it can sometimes be difficult to tell when it is time to wash the brushes and cut the painting from the board.

These photographs capture parts of these final stages, including detail work, depth adjustment using dark washes of pigment, and a final glaze to pull everything back together.

Whenever I think I've finished a painting I tend to leave it on the board, but stored somewhere I can't see it for a few days. I will then come back to it with fresh eyes and scrutinize it to make sure I haven't missed anything. Only then will I cut it

from the board and call it finished. That said, I will almost always see something I would have done differently when I look at a painting years later. Such is the curse of the short-falling perfectionist!

Below: Details of the finishing process.

Opposite: The final painting.

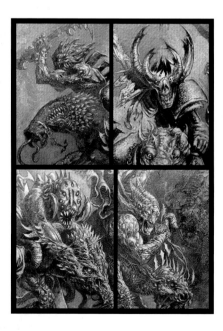

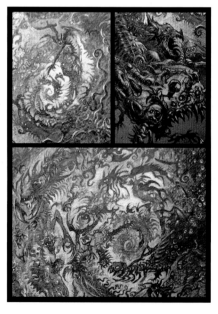

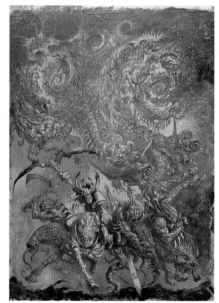

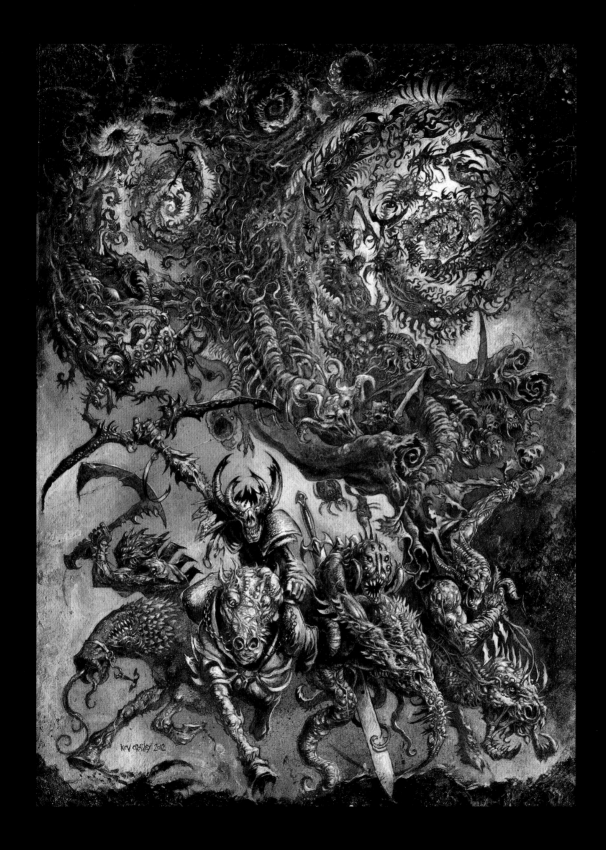

Kev Crossley 2012

THE DEVIL IS IN THE DETAIL:
ADDING DEFINITION

TIP 087

Learning Scales

Drawing dragons is cool. This is true. But where there are dragons there are usually scales, and they can be time-consuming things to draw and paint (although the end result is usually worth it). There are, however, a few tricks you can use to speed up the process a little. The following tip shows how easily and quickly skin can be made to look lumpy and scaly. From sketch to finished painting, the process took about 30 minutes, but the more time you spend working in the detail, the greater the results.

Once again, I plundered the sketchbooks for a likely doodle and, sure enough, found a vaguely dragon-like sketch lurking near a page corner. The muscular folds around the neck and the stocky, crocodilian aspect to the head promised a fine surface on which to develop some severe reptilian epidermal texture.

With an HB pencil I started drawing guide lines over the surface of the skin. Scales are often laid out in a grid-like fashion, which can be particularly evident across expansive areas such as the bellies of snakes and lizards, so the idea was to break up the featureless skin surface into gridded areas. Obviously, natural scales are rarely positioned in such a perfectly regimented layout, but it is merely a place to start. I continued to add crosshatching lines, paying close attention to the folds in the skin, ensuring the lines followed the direction of these fluctuations. I also added some definition to the drawing, and used the flat side of the pencil to pick out the shaded areas.

Next came the color. I added a greenish tint to the entire image, then a 30% opacity brush was used to paint slightly darker tones onto the interior of the mouth and the other darker areas. With the brush mode set to Multiply, the color was laid down progressively darker, but allowed the detail beneath to show through. A little reddish ocher was brushed around the mouth and eyes, and the shadows were made deeper with light strokes of brown. To pick out the lighter surfaces of the head a lighter yellowish green was painted on with brush opacity at 20% and the mode set to Lighten. When I was happy with the colors, I selected a medium blue and, with a normal hard-edged, 85% opacity brush I painted a background around the head.

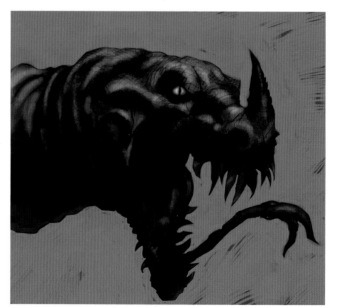

Top: A basic sketch provides a good starting point for a scaly encounter.

Above: A flowing, organic grid is drawn over the surface of the dragon head.

Left: Color and shadows are added, and a background is painted in.

Opposite Left: Each scale is defined by individual shadows and highlights.

The final stage can be as quick or as lengthy as you like. The trick is to think about each square within the gridded areas as an individual protruding mass. To this end, each one will be lit from one side by the primary light source, which, in this case, is upper right, and shaded on the other side. To achieve this I simply used a small brush with mode set to Multiply to methodically paint darker color into the left portion of each grid square. The process didn't need to be exact, and not every square was painted evenly. Next, the brush mode was set to Normal, and a lighter yellowish hue was painted into the right portion of each square. The effect works best if these features are applied in a haphazard way, so I painted swathes of skin color over some areas of grid, and "ad-libbed" freehand scales here and there. A touch of photographic texture and tone adjustment brought the exercise to a satisfactory conclusion.

TIP 088

Lighting Scales

To really add punch to an image, a deeper understanding of light can pay dividends. Understanding and exploiting a main light source is a great start and, often, is quite enough to imbue your art with a level of tonal authenticity, with shadows and highlights positioned in logical oppositions. However, when you throw in a second light source, things get interesting!

To illustrate this, I took the scaled dragon head from the previous tip, which I purposefully left at a stage at which only one light source was evident. As it is, it looks okay, but perhaps the shadowed areas are a little dark and give the image a slightly flat aspect.

As the background was predominantly blue, I decided to use a blue tone to pick out details in the shadowed areas of the dragon's head and neck. I imagined the light source as being located to the left and rear of the creature, which meant the light would be painted onto thin edges angled to face the light. The result gives greater body to the image.

Below: The final painting with additional highlights to suggest a secondary light source.

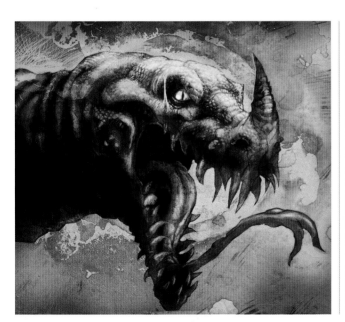

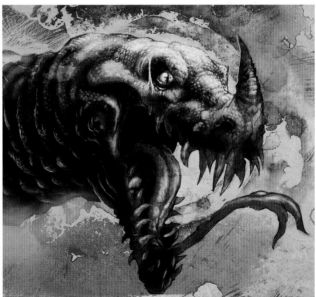

THE DEVIL IS IN THE DETAIL:
AND THE REST . . .

And the Rest . . .

TIP 089

Assorted Fluff

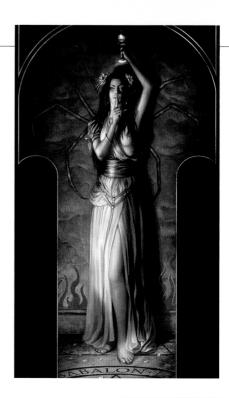

This is a bit of a cluster tip, being as it is the home for numerous final mini tips that never quite seemed to settle in anywhere else. It's a bit of a hodgepodge grab bag of ideas and expansions on tips previously discussed. "All filler, no killer" would be a good way to describe these tipettes, but I think there are a few nuggets worth a penny or two among them. (Although I think this stunning opening painting by Aly Fell is enough to justify everything that follows!)

This painting by the incomparable Aly Fell has so much to teach us, that as soon as I saw it I knew I wanted to give it a little corner in the book. The image is all about duality. Note how the dual background color schemes of sandy ocher and blue provide tonal contrast, yet are complementary, colorwise. The painting shows a clever use of graphic elements—the spider legs and flames on the wall act as points of focus and interest, but also hint at the character or nature of the woman holding the chalice, as do the subtly different colors of the flowers in her hair. Although the finger against pursed lips might warn of some nefarious secret purpose behind her allure, the Babalon signage and arrow pointing toward her feet would appear to lay it bare. Add to all that the eye-catching presentation and you have a really exceptional image.

Next up, is a creature called a phrensy, completed as a pencil drawing for Malhavoc Press in 2004. A few years later I revisited it as a subject for a bit of digital-painting practice for techniques I was developing at that time. After darkening and tinting the pencil background, I added a favored banana-skin texture onto a Multiply layer, turned it blue, then flattened it to the background. Dark tones were quickly brushed over the shadows suggested by the pencil, and yellowish tones picked out the highlights before bright, hard strokes etched a secondary light onto the edges of the dark areas. Finally, the background was defined with a quick brushing of greenish yellow, some of which was also washed over the tendrils and limbs behind the creature, emphasizing a sense of depth. It's useful to experiment like this, as a lot of tricks can be picked up in one fell swoop.

Top: The Chalice by Aly Fell marries exceptional painting skill with beautiful presentation.

Right: The stages of a speed painting experimenting with dual light sources, texture, and depth creation.

Opposite Top Left: X marks the spot where darkness will dwell.

Opposite Top Right: An eye. A vile, severed eye.

Opposite Bottom Right: A faerie drawing illustrates compositional standards

Opposite Middle & Opposite Bottom Far Right: Pencil work for Angelic Corruption and the touched-up painting.

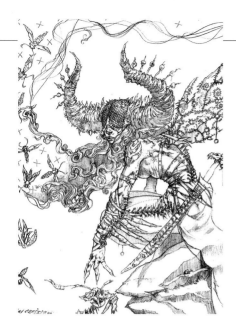

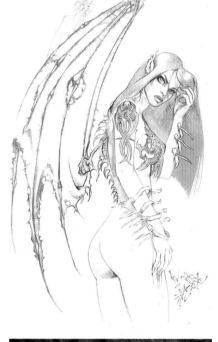

This (right) was a fun painting I did for *Imagine FX* magazine, where the brief was "how to paint a severed eyeball." I think this started as a scanned pencil sketch that I then painted over in Photoshop. The most successful aspects were the various liquids involved, so here's a tip for when painting goo and such: all liquid has surface tension, which causes a "skin" on the surface that will curl up to meet any other object it comes into contact with. (You can see this easily in a glass of water.) This slight up-turned edge will catch and reflect light, resulting in thin strips of bright tone along contact perimeters, and it is these bright highlights that create the convincing illusion of gooey, visceral wetness. Nice.

Above is a pencil drawing of a character called Hornet that is due to be painted in oils and acrylic. As such, I didn't need to finish it to a high standard, which also meant there was no need to block in all the black areas. Instead, I simply etched in little X marks in the areas that will be black. This is a tip I learned from Liam Sharp, then lots of other comic artists, as it's a standard technique used by pencilers to let an inker know where they should block in black. I've always liked the intuitive simplicity of it as a visual notation, and I tend to use it frequently in all sorts of work.

Lastly (right and below right) is the pencil drawing and a remixed version of a painting that appeared earlier. Drawing in Blue Col-Erase pencils is a tip passed on from the animators I worked with during my years as a video-game artist. They are great for layout work, but are also fabulous to draw with, as they maintain a good point while retaining the ability to lay down rich, dark tones. They also come in a vast range of colors. The painted version was enhanced with graphic overlays of distorted letters from gothic typefaces that were arranged, hand-painted, and bedded into the image in duplicated rings.

This next image (right) relates back to the chapter on composition (see pages 58–93), featuring as it does strong visual cues that promote balanced dynamic posture. In this example the figure etches a classic feminine S shape, with hips and shoulders asymmetrically angled on either side of the horizontal that sits at the lower ribs. Penciled details within the composition then describe a series of twirls and reactive curves, which both pull the gaze into the center and encourage it to wander toward the image extremities.

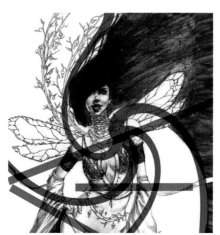

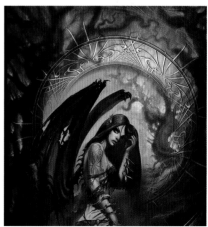

Art
Masterclass

Following from previous chapters where we looked
at building images from the ground up, this small
section offers a few simple glimpses beyond the
basics, but retains some level of accessibility so
beginners needn't feel intimidated. As with all
subjects, you'll find some tips more useful than
others, and in time you'll no doubt devise your
own way of doing things and achieving creative
solutions, but here are a few eye-openers to get
things rolling . . .

Right: The figure of this
character was built using
Photoshop to manipulate
and reposition different parts
from several sketchbook
doodles. The finished body
was then used as a basis
for a new drawing.

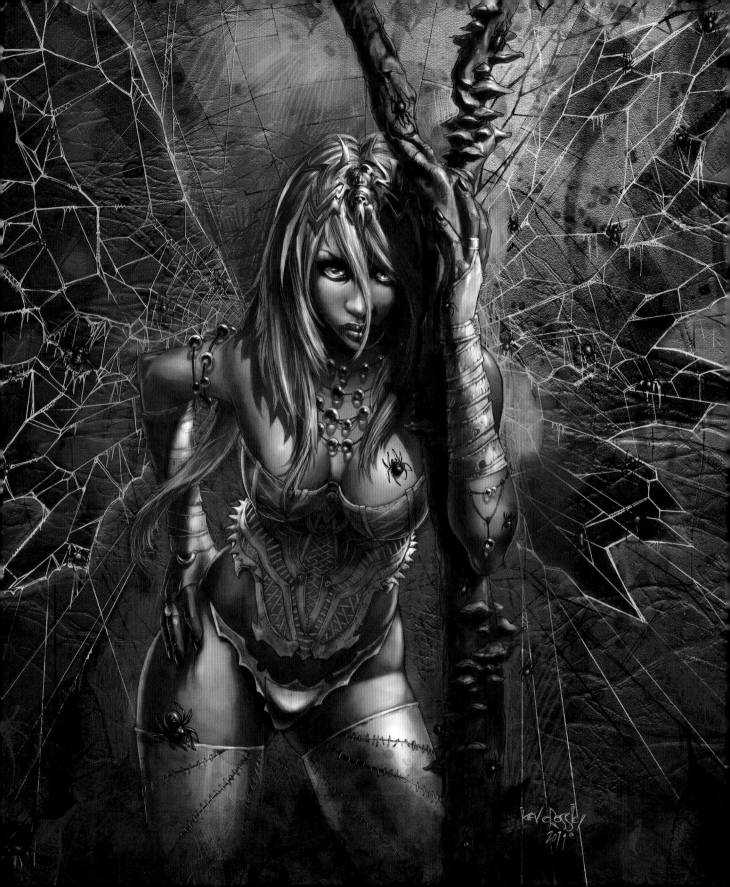

ART MASTERCLASS:
SPEED PAINTING

Speed Painting

TIP 090

Fast Portraits

Sometimes, waking to the prospect of a day of heavy painting can be a little intimidating, particularly if it involves faces, which can be difficult to get just right. Such mornings are when the hour-long paint sketches come in very useful, as there is no pressure to produce "finished" art, yet the simple process of working colors together functions as a great warm-up for the real work ahead. Although I sometimes use acrylic paint, I usually use Photoshop as it is a much quicker process, plus you don't have to worry about mixing colors, etc.

For the example shown here I started by finding a digital photograph taken from a TV show years ago. (I have no idea who it was, or what show it was taken from; it could have possibly been an ad.) This was then loaded into Photoshop, and a canvas of the same dimensions was opened next to it. For the first stage a standard brush with 80% opacity was used to block in the main tonal areas. This stage took between 10 to 15 minutes, and the resulting mass of lurid blobs provided a sound base on which to build further detail.

I then turned my attention to the main features—nose, eyes, and mouth. I took a little time to refine the shapes and details, still using a hard brush, but adjusting the size, as well as constantly varying the colors used to suggest form

and tonal variation. After around 20 minutes the initial splodges of color have been turned into a definite face, providing a focal point for the painting.

Next, the broad areas of color that still remained were broken down into a greater number of tonal pieces. This began the process of blurring the lines between the colors, which, in turn, started to meld the painting into a cohesive whole. The light sources were suggested by the shadows and highlights, which define the face, while detail was added to the hair and background.

From this point on the brush opacity was varied, as the different hues of the skin were painted into one another, softening the feel of the image and reinforcing the definition in the important features of the eyes, nose, and lips. The background color balance was strengthened to give the painting more weight, which provided essential contrast to the finely rendered face. Finally, just for fun, armor was added to the shoulder and forehead. This was painted on in stages that were identical to those of the painting as a whole. First, blocks of dark, medium, and light gray were used to define the plates of armor and their shadows and highlights. These colors were then broken down into a broader range of hues, and variable brush sizes added texture to the metallic surface. The shapes were refined, shadows

were added to the face and shoulder beneath the armor and, finally, soft suggestions of skin and background color were brushed into the armor to suggest the slight reflectivity of the brushed metallic surface.

The whole painting took 60 minutes, and even though it is rough around the edges I still have a completed painting, and the cobwebs have most certainly been cleared from the head. This is one of the most useful exercises I know.

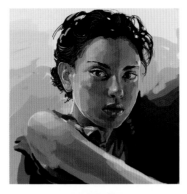

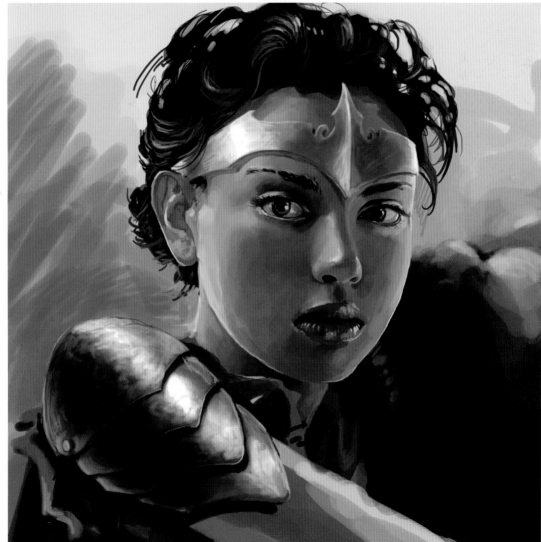

Opposite: The main color areas are blocked in.

Top Left: Definition is added to the features.

Top Right: Detail is developed, and the colors are broken down into a greater tonal range.

Right: Further detail and definition is added, and armor is quickly painted over the brow and shoulder.

ART MASTERCLASS:
UNDERSTANDING LIGHT

Understanding Light

Being able to paint is one thing, but a good understanding of light can make the difference between a good painting and a great one. Light can be a tricky thing to get to grips with. At a basic level, an image will work fine with a single light source, usually coming from the top of the painting, off to one side. This is a standard way of defining where the shadows and bright parts of an image will be, and is a good place to start. However, to add a little extra depth to an image, multiple light sources and even different colored lights can work wonders and, with practice, it becomes fairly straightforward to give any painting a boost in this way.

TIP 091

Single Light Source

Shown here (above and right) is a selection of paintings, each featuring a single light source. The dog portrait from my post-university year was very simply executed; I had no idea about multiple light sources at that point, but it doesn't suffer too much because of it.

Knock Before Entering is an abstract horror, acrylic-and-digital painting inspired by a terrifying, half-collapsed hut I discovered while walking in some deep, dark woods. I opted for a single light source to emphasize the stark character of the object.

Mermaid by Manon is a different kind of painting entirely, but, again, benefits from one main light source. It doesn't always pay to have numerous lighting options.

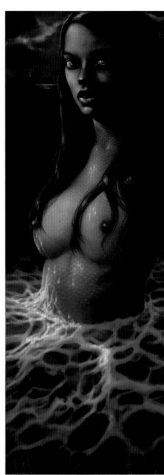

Top Right: This dog portrait was painted with a single light source in mind.

Above: This abstract multi-media painting relies on a single bold light source.

Right: Mermaid by Manon, painted using a single light source.

TIP 092

Painting Ambient and Reflected Light

To convincingly paint with multiple light sources requires a certain amount of understanding about how light works upon objects within an environment. For example, a sunlit scene will feature shadows in areas shielded from the sun, and these are usually painted as darker, less saturated hues. However, colors and surfaces don't just catch light, they reflect it, too, and although this "reflected" light is weak in comparison to the primary light source (i.e., the sun), it can become visible in places where the sun does not reach, such as shadows.

To illustrate this, I took an hour-long Photoshop portrait sketch and decided to enhance it by introducing a second light source. The primary light was located in the upper right of the image, so I imagined a secondary blue light situated to the left and slightly below the subject. This could be generated by the sunlight bouncing from a blue object, such as a curtain or painted wall. With this in mind, I selected a medium-soft brush with 75% opacity and chose a purplish-blue color. (This color choice also complements the eyes and the flowers in the subject's hair.) I then added this color into the shadows on the left side of the face, taking care to think about the lower eyelid, lips, and neck. I also brushed a little into the hair and other areas. This process results in shadows with more depth, which adds greater dimension to the overall image and hints at the complexity of the lit environment.

TIP 093

Extreme Lighting

Definition within an image can be enhanced in a number of ways. In a low-light environment, a single, sparse but bright light source can create fantastic, stark effects, and is worth thinking about if you ever want to do any Film Noir-style imagery. Once again, I used the hour-long Photoshop portrait sketch as a starting point, then increased the brightness and contrast (Image > Adjustments > Brightness/Contrast). This created a sharper edge between the light and dark areas. I then painted more dark color into the background and darkened the shadows further before adding thin lines of white light to pick out the contours of the face and hair in the darkness. This resulted in a striking study of light and shade, which was created in under ten minutes!

Below: This painted sketch is lit with one light source coming from top-right.

Right: Soft blue reflected light is painted into the shadows.

Below: The light and dark areas starkly contrast.

ART MASTERCLASS:
UNDERSTANDING LIGHT

TIP 094

Creating Light Shafts and God Rays

This is a nice little digital trick in my toolbox for creating shafts of light, or "God rays," as they are also known. The digital light-shaft kit makes light work (ha!) of God Rays, and is made up of various shaped distorted rectangles of white or yellowish hue which fade to become transparent.

These are created by using the Marquee tool to make a rectangular selection within a new layer. The Gradient tool is then used to fill the selection. These constructs can then be layered on top of one another, and lengthened or manipulated to create everything from searchlights to sunbeams. This was one of the first digital techniques I ever developed, and I keep finding new uses for it 15 years later!

I produced this assortment of elements for an *Imagine FX* spread, and used them to illuminate the cave scene. Similar graphic constructs were used to populate this view of Sensod City from the *Sidhe* story. Although I don't always rely on this method, it does happen to be a quick-fix way of creating light beams if a deadline is tight, and it's a great tool for concept images, too.

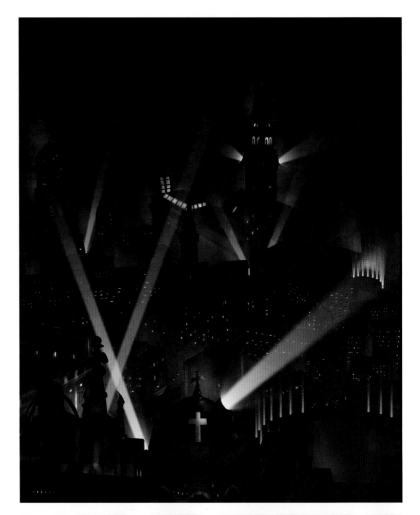

Above Right: The city from *Sidhe*, on features numerous light shafts.

Right: This cave interior also utilizes digital shafts of light.

Far Right: The digital light-shaft kit.

Light Work (Using Refractive Materials)

This digital painting of a spider faerie was produced for a calendar, but I was initially stuck for what to put around her neck. An idea occurred to me while drinking a tumbler of rich, red Bruichladdich Whisky one glorious sunny afternoon. When I placed the glass on the white table, the bright sunshine passed through the amber liquid and painted dancing, fire-like patterns onto the tabletop. This gave me the notion she could have jewelry made of polished amber threaded onto twine, with an ancient preserved spider imprisoned in each piece. To create the impression of their glass-like reflecting and refraction, I simply refilled my whisky glass and made a few paint studies based on how the refracted light spilled onto the table. Mastering a new technique requires diligence and perseverance, so it took numerous tumblers before I felt confident enough to press my new trick into service. I realized that not only would the amber beads reflect light and display highlights and shading, these aspects would be cast onto the skin beneath, and distorted, depending on the angle of the light source as it fell through the amber onto the skin. It's such a simple trick, but delivers great-looking results.

All: This spider faerie wears transparent amber jewelry, which refracts light as if it were glass.

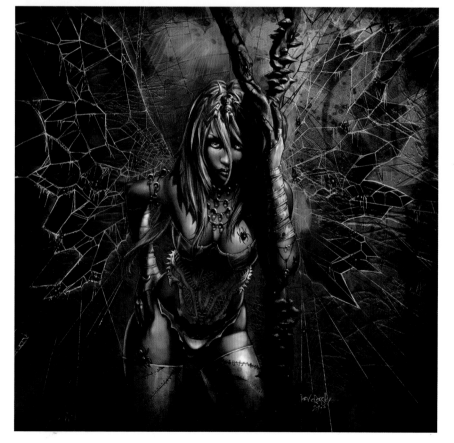

ART MASTERCLASS:
COLORING GRAPHIC NOVELS

Coloring Graphic Novels

TIP 096

Coloring Comics 1: *Judge Dredd*

These are panels from a *Judge Dredd* story featuring fully painted art from Lee Carter. As with some of the pinup paintings featured earlier in the book, Lee often begins by producing a grayscale tone painting to establish the values and shading, before using various techniques to create texture and add color. Photographic reference is augmented with hand painting and blending effects, with a spot of color-balance adjustment to finish.

Below: This panel from *Judge Dredd*, drawn by Lee Carter, shows the coloring progression.

Right: The coloring stages of a more complex Lee Carter *Judge Dredd* panel.

Bottom Right: These panels show a view of Mega City One.

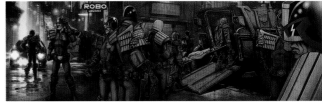

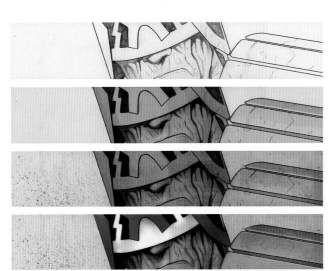

TIP 097

Coloring Comics 2: *Sidhe*

Finally, here's another page from the *Sidhe* story, seen here for the first time. The initial pencil drawing was quite rough and unfinished, as I knew it wouldn't require too much detail early on. In Photoshop I began with large areas of flat color, to which I applied the Lighting Effects filter to create a glow around the cross. To develop the colors I used a combination of brushwork, Dodge, and Burn, and the Levels function helped to darken the border of the main image, before the faces of the worshippers were each hand painted as if illuminated by the cross. A slight bluish tint was painted into the shadowed areas of the people with their backs turned to the viewer, and the eyes were given a supernatural brightness. I had a bit of fun applying photographic texture in the final stage.

Below Left: The scanned penciled art for page 3 of the *Sidhe* graphic novel.

Below: The line art is tidied and tinted with adjusted flat colors.

Below Right: Painting begins and tone is applied.

Below Far Right: The faces are then painted, each lit as if from the cross.

Right: Final detailing and graphic flourishes complete the picture.

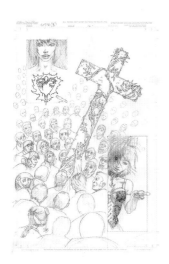

Finishing Touches

The old adage that a piece of art is never finished but abandoned has never been truer than when applied to digital art! While it can be tricky to know when to leave an oil painting alone and call it a day, a digital approach literally never exhausts the number of changes and effects that can be applied to an image. Knowing when a painting is finished is a particular skill in itself, but it can be rewarding to indulge in a finishing touch or two, even if just to experiment with new techniques or tricks. What follows are a few such explorations, where the unique properties of software such as Photoshop are allowed off the leash.

Right: This pencil drawing was colored digitally, then completed with the addition of graphic overlays utilizing various Blending Modes.

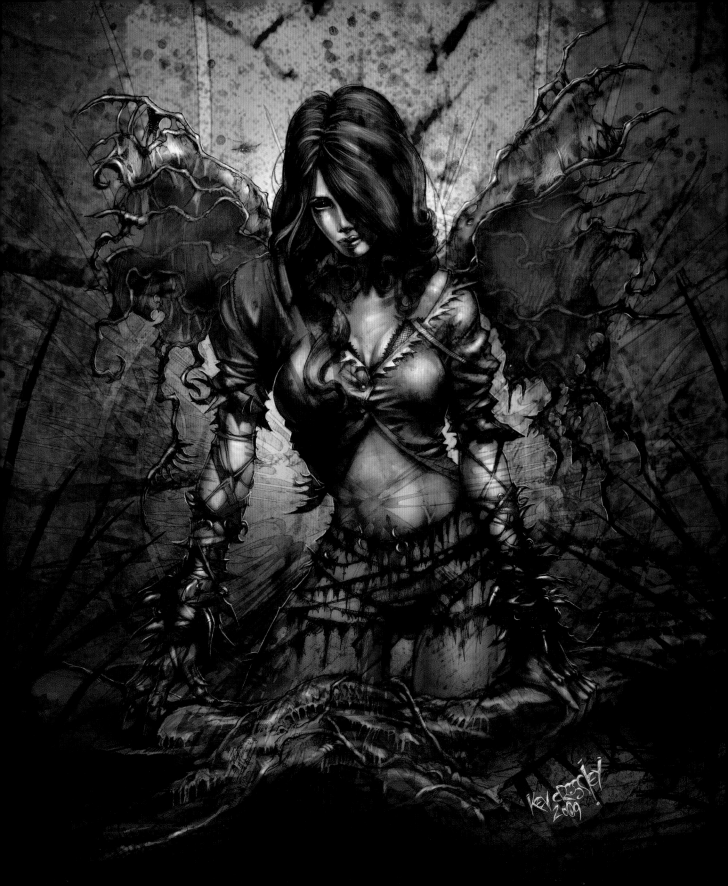

FINISHING TOUCHES:
PRESENTATION TECHNIQUES

Presentation Techniques

TIP 098

Graphic Overlays: Sequential Art

Fantasy-art techniques are easily transferable to the medium of comics and, although tight deadlines tend to impose more expeditious coloring methods, it is always fun to let rip and just paint the pages, if time is available. Here is page 2 from a graphic novel I was working on called *Sidhe* (pronounced "She," as in "Banshee.") I had the luxury of spending as much time as I needed on the art (a potentially ruinous concession from the publisher) so I spent a lot of

time producing highly detailed pencil-and-inked art, which I then spent even more time painting digitally.

In this page a character looks down onto a fantasy cityscape in an alternate reality. I painted the city by hand, breaking it up into different layers to denote distance, and adding elements such as smoke, illumination, and searchlights over and between the layers, gradually building a sense of depth into the scanned 2D ink

art. This process took hours and hours, but while working on this graphic novel I was, in fact, more interested in the presentation of the finished pages than the minutia of rendering the art. I treated the presentation part of each page as a reward for all the long hours going slightly mad during the painting stages, and it began with panel boxes imported from a template and reshaped to match the panel sizes within the page. For this book the panel boxes were augmented with

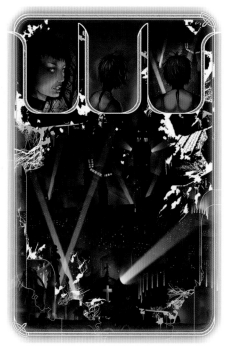

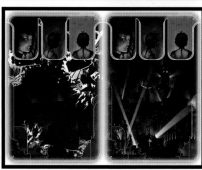

Above Far Left: The first stages during the completion of page 2 from the graphic novel *Sidhe*.

Below Far Left: Graphic overlays are applied in the next stages.

Left: The final page, complete with panel effects and overlays over the fully painted art.

Above: Page 1 of the *Sidhe* story underwent a similar process to page 2.

simplified Celtic knot designs, and set in white over the art, with a bit of dark Outer Glow added in the Layer Style dialogue box. This separated them from the art, and kept them visible over white areas.

Another feature I wanted to include in the graphic presentation of the pages was graffiti, created using a mixture of photographic reference, scans of paint splats and scrawls, and adjusted elements from the art itself. This would reflect the chaotic meeting of cultures and worlds as featured in the story, and result in eye-popping pages that, hopefully, would give the viewer reason to pause.

For this page I chose photographs of winter trees framed against clear skies, which enabled me to isolate the branch elements easily. At the time I was painting my son's bedroom, so I took the opportunity to randomly splat paint all over the walls, which I photographed and mixed with the tree graphics. I also added a photo of an apartment block.

From these various graphics I created two layers, one colored a deep yellow to complement the colored art, and the other colored white. I then rearranged, edited, and deleted parts of each layer until I felt I had a balance that worked.

Some pages featured less graphic additions, but I felt it helped create character, a design personality that ran throughout the book as a connective thread. It built into an abstract narrative, too, as the photographic content used to create the graphics gradually changed as the book progressed.

Also included here is page 1, with similar graphic additions in place. This approach to art is always interesting, as it allows the intermingling of traditional and digital art, with an ever-evolving set of techniques. Such pieces are always experimental, and are tremendously useful in advancing your skill set, as well as ensuring your passion for creating art remains piqued.

Having Fun with Element Layering

This is another spread from the *Sidhe* story. The process behind this image reflects benefits of the digital times we live in, as I didn't draw the elements in the arrangement they would be when published. The large head of the demonic villain of the story was drawn in HB pencil, which I left uninked, and the smaller "TV" heads were drawn in biro pen. Finally, the TVs themselves were completely drawn using Photoshop. Photoshop was used to composite all these elements before graphic overlays were layered on, along with photographic textures, hand painting, various layer effects and Blending Modes, and a few other tricks. The 1970s style TV was colored using Filters to create a convincing wood effect (taking all of two minutes), and some interesting panel construction finished it all off.

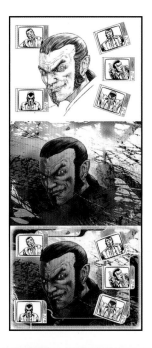

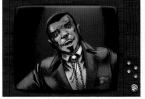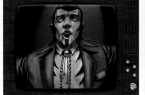

Top: *Sidhe*, page 14, was a mix of pencil-and-inked art, digitally manipulated .

Above: The TV elements were constructed separately using filter texture effects and drop shadows, created using Layer Effects.

Right: The TV elements are dropped into place, and assorted detailing is added.

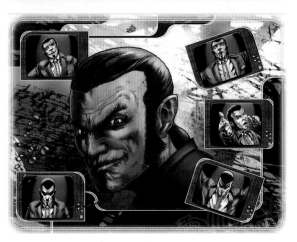

FINISHING TOUCHES:
COLOR BALANCE AND TONE

Color Balance and Tone

Frequently, one of the final finishing touches I add to an image is to adjust the color balance, contrast, and saturation. This is an obvious process for a digital painting, but I find it useful for sprucing up my traditional art, too, as my scanner tends to import rather dull scans of the art. Usually, I will apply such changes subtly, sometimes all you need is a slight adjustment to make a great improvement but, occasionally, these attributes can be changed quite dramatically and still work.

TIP 100

Adjusting Color Balance and Tone

Here is a pencil drawing of a rather dark-looking faerie with ragged wings and attire, called Thorny Issue. After scanning it into Photoshop I produced a digital grayscale tone then overlaid a photographic stone texture with Multiply Blending. The color was adjusted to create an "unhealthy" greenish base tone for the image. This was duplicated, and the lower version was flattened onto the base art layer. The duplicate layer was then shifted to a contrasting blue color, and the Eraser tool was used to uncover the pencil-art elements. Using the Lasso tool with feather set to 100, I made a selection around the upper body of the faerie, and used the Hue/Saturation dialogue box to adjust the brightness and saturation of the duplicate layer, creating a striking background to play against the figure. A mixture of Dodge, Burn, and hand-painting techniques added definition and tone to the character and, as a finishing flourish, a few graphic elements were added as overlays with various Blending Modes. However, I felt that perhaps the graphic overlays were a bit intrusive over the art, and the image itself was all a little too dark. So, I made the central graphic elements more subtle and less distracting, before brightening the entire painting using the Levels function.

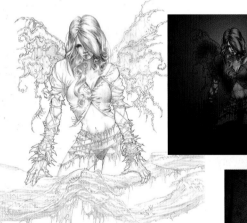

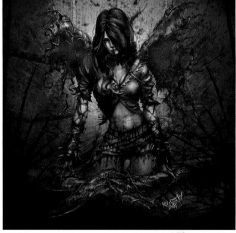
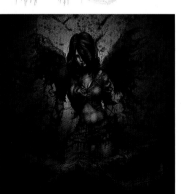

Top Row: The initial stages of Thorny Issue including pencil, tone painting, and the first colors.

Far Left: The addition of a background color clarifies the figure. Shading and detail work completes the painting stage.

Left: Graphic overlays and lightening the tone are the final touches.

Afterword

If you've come this far, I hope you've enjoyed some of the art featured in the book, and learned a few tricks along the way.

The eagle-eyed among you might be wondering why there have only been 100 tips featured so far. Where is the titular tip 101? Well, here it is, buried in the afterword. It's actually the very first tip that came into my head when I began writing this book, and seemed so fundamental to everything that should drive an artist, it really needed to be set apart from the rest of the book. It's more about state of mind than physical technique, and if absent from the process it will be apparent in the finished art. So what is it? Well . . .

TIP 101

Enjoy Yourself!

I make no apologies for what might appear to be a cheap and obvious statement. Indeed, if you're young and full of enthusiasm for your art (as I was 20 years ago), you might be justified in thinking such a statement is utterly redundant. "Of course I enjoy what I do! Obviously I do!" you might cry, but pause, and be aware that the line between something changing from being enjoyable to becoming a chore is finer than you think, and if you are unlucky enough to find yourself trapped in the drudgery of something you used to effortlessly love, your work will be empty of energy and passion, and you might struggle to reverse the situation.

I speak, of course, from experience. I can't figure the reasons now, but for three long years I produced nothing of much worth, and nothing I did could help me find that old spark again. It was a miserable time, when I felt like a prisoner to the very same thing that had been my salvation from childhood into adulthood. Eventually, it was a concerted effort to bring about a renewed state of positive thinking about art and how I approached it that began the slow process of "rehabilitation."

In closing, I'll leave you with another adage I saw on one of those tear-a-day office calendars, the ones that have a different saying or quote for every day. "Adopt, adapt, improve." I saw this when

I was 14 years old and, being impressionable and prone to cliché, I immediately saw the value in such a statement, and it has been a subtle mantra underpinning everything I've done ever since. Don't be scared to adopt new ideas, new ways of thinking and working. Adapt them or yourself to get the best results, then improve these techniques until they become new tools and methodologies unique to yourself, which might, in turn, inspire similar creative evolutions in others.

Above: If a picture paints a thousand words, then a pencil drawing probably draws one or two. Here, I let the medium I love the most have the last word!

Further Reading

Alphonse Mucha:
Any collection you can find!
Mucha was the master of his age, and is still revered over a hundred years later, with good reason.

In Search of Forever / Last Ship Home:
Rodney Matthews
Rodney's style is unique, and his technique, while crisp and precise, never deadens the energy and movement within his work.

Warriors and Warlords:
The Art of Angus McBride
A fabulous overview of a great artist, sorely missed. His technique, skill, and discipline is a wonder to see.

Icon: Frank Frazetta
Arguably the father of modern fantasy art, this painter needs no introduction, but of the many books out there, this one is perhaps the best.

Monstruo: The Art Of Carlos Huante
A true master of twisted horror, with killer skills to back it up

Bodies: Boris Vallejo
This is a collection of photography by the renowned artist which provides valuable anatomical instruction and reveals some of the inspiration behind his painting.

Offerings: Brom
Another contemporary master. Of his numerous books, this is my favorite.

Fantasy Art Now:
Edited by Martin McKenna
Fantasy Art Now 2:
Edited by Aly Fell and Duddlebug
Two essential collections of contemporary fantasy visionaries.

Dream Makers / The Guide To Fantasy Art:
Edited by Martyn Dean
Two great collections featuring various masters of fantasy and sci-fi art, including Berni Wrightson, Charles Vess, Boris Vallejo, Michael Kaluta, Syd Mead, and Chris Foss.

Magnetic Storm:
Roger Dean & Martyn Dean
The influence of Roger Dean's fantasy visions resonates throughout the genre. This is a great overview of his painting, sculpture design, and set-dressing.

Sentinel: Syd Mead
Syd Mead is simply amazing. Track down this book if you can, but any of his others are well worth a look too.

A Diversity Of Dragons:
Anne McCaffrey and John Howe
Dragons. John Howe. I rest my case.

Girls On Top! The Pin-up Art of Matt Dixon
A collection of Matt's fabulous, curvy creations.

Faeries: Brian Froud & Alan Lee
A classic book with some of the most exquisite pencil and watercolor art you will ever see.

2000 AD
The legacy of the British weekly comic anthology can't be understated. It was the testing ground for a generation of singularly talented and visionary writers and artists, who in turn went on to inspire generations of kids to follow in their footsteps, myself included! Now 35 years old, the comic remains as relevant and cutting-edge as it ever was, with stoic lawman of the future, Judge Dredd, continuing to lead an ever-evolving stable of innovative, evocative, and incendiary characters and stories. Scrotnig!

ABC Warriors: The Black Hole
Slaine: The Horned God:
Illustrated by Simon Bisley
These two stories from *2000 AD* feature the incredible art of Simon Bisley, in inked form and fully painted color. Simon's energetic style and often haphazard yet precise anatomical extravagance would inspire a new breed of artists who now forge ahead with their own legacies. A genuine Primary Mover; these titles are where it all began.

The Art of The Lord of the Rings
All three of the movie art books feature hundreds of pages of fabulous creature and environment designs, headed up by the mighty John Howe and Alan Lee. Utterly essential.

Strength Training Anatomy:
Frederic Delavier

This is actually a book designed for those interested in body-building, but it is illustrated throughout with exquisitely realized artwork portraying the human body in every posture imaginable, and every muscle group finely and expertly rendered in a bewildering range of motions, contractions, and extensions. One of the finest anatomical guides there is, I can't recommend it highly enough.

Visual Dictionary of the Skeleton:
W Ellenberger

An atlas of animal anatomy for artists.

Anatomy for the Artist

Three useful and insightful resources for understanding how the skeleton works and fits together, including humans and animals.

Horses and Other Animals in Motion:
Eadweard Muybridge

A collection of the very first photographs which captured precisely how animals arrange their legs and bodies while in motion. A fascinating historical document but very useful reference too.

Watercolour: Practice and Progress:
John Blockley

It's well worth tracking this book down. Although it doesn't cover fantasy art, the techniques and ideas presented offer astonishingly unique approaches to using watercolors.

Drawing and Painting Fantasy Beasts:
Kevin Walker

A superb guide by one of the best fantasy painters in the business.

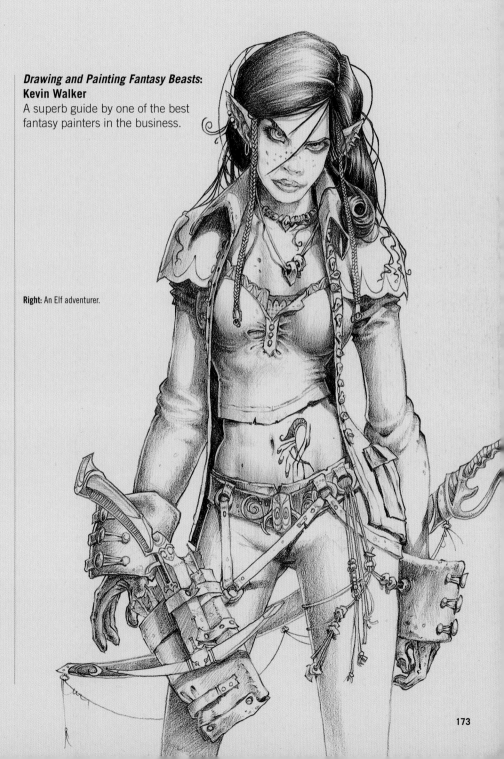

Right: An Elf adventurer.

APPENDICES:
INDEX

Index

Artists' Details

Kev Crossley: www.kevcrossley.com
Greg Staples: www.gregstaples.co.uk
Aly Fell: www.darkrising.co.uk
Gary Tonge: www.visionafar.com
Manon: www.artbymanon.com
Matt Dixon: www.mattdixon.co.uk
Rodney Matthews: www.rodneymatthews.com
Liam Sharp: www.liam-sharp.com
Dave Millgate: www.davidmillgate.com
Lee Carter: www.lee-carter.co.uk
Glenn Fabry: www.glennfabry.co.uk

Ilustration Details

All illustrations and copyrights owned by Kev Crossley, with the following exceptions:

Page 2: Judge Dredd wraparound by Greg Staples. Copyright © 2012 Rebellion A/S. All rights reserved. www.2000ADonline.com.
Page 4: City Docks by Gary Tonge. Copyright © Gary Tonge.

PREFACE:
Page 7: Siren by Manon. Copyright © Manon.

THE BASICS:
Page 11: Arboreal Corrupter by Kev Crossley. Copyright © Malhavoc Press.
Page 16T: Vampire by Manon. Copyright © Manon.
Page 16B: Inverted Landscapes by Rodney Matthews. Copyright © Rodney Matthews.
Page 17: Grimoir by Kev Crossley. Copyright © Malhavoc Press.
Page 18T: Slaine by Greg Staples. Copyright © 2012 Rebellion A/S. All rights reserved. www.2000ADonline.com.
Page 18BL: Judge Dredd by Liam Sharp. Copyright © 2012 Rebellion A/S. All rights reserved. www.2000ADonline.com.
Page 18BR: Soul Catcher by Aly Fell. Copyright © Aly Fell.
Page 19TL: Zombie from Nemesis the Warlock by Kev O Neill. Copyright © 2012 Rebellion A/S. All rights reserved. Www.2000ADonline.com.
Page 19TR: Lake and Fish by Rodney Matthews. Copyright © Rodney Matthews.
Page 19B: Colony by Gary Tonge. Copyright © Gary Tonge.
Page 20: Medusa by Aly Fell. Copyright © Aly Fell.

SKETCHING AND DRAWING:
Page 37: Machine Punk concepts by Dave Millgate. Copyright © Dave Millgate.
Page 47: *Iron Heel* sketch by Dave Millgate. Copyright © Dave Millgate.
Pages 48–49: *Grey Area* cover stages by Karl Richardson. Copyright © 2012 Rebellion A/S. All rights reserved. www.2000ADonline.com.

COMPOSITION AND CONCEPTS:
Page 59: City Docks by Gary Tonge. Copyright © Gary Tonge.
Page 75TL Hypnolox by Kev Crossley. Copyright © Malhavoc Press.
Page 76T Bog Salamander by Kev Crossley. Copyright © Malhavoc Press.
Page 78BR Demon Soldiers by Kev Crossley. Copyright © Green Ronin Publishing, LLC.
Page 79: *Iron Heel* concepts by Dave Millgate. Copyright © Dave Millgate.
Page 91: Eventide by Gary Tonge. Copyright © Gary Tonge.

BLACK-AND-WHITE ART:
Page 102: Judge Dredd wraparound stages by Greg Staples. Copyright © 2012 Rebellion A/S. All rights reserved. www.2000ADonline.com.
Page 103: Saber Tooth Squid Girl grayscale by Matt Dixon. Copyright © Matt Dixon.

DEVELOPING A PAINTING:
Page 106T: Saber Tooth Squid Girl rough painting by Matt Dixon. Copyright © Matt Dixon
Page 106B: *ABC Warriors* rough painting by Kev Crossley. Copyright © 2012 Rebellion A/S. All rights reserved. www.2000ADonline.com.
Page 109T: *ABC Warriors* Underpainting by Kev Crossley. Copyright © 2012 Rebellion A/S. All rights reserved. www.2000ADonline.com.
Page 109B: *Iron Heel* underpainting stages by Dave Millgate. Copyright © Dave Millgate.
Pages 112–113: Saber Tooth Squid Girl stages by Matt Dixon. Copyright © Matt Dixon.

USING COLOR:
Page 125: Werewolf by Manon. Copyright © Manon.
Pages 128–129: *Iron Heel* stages by Dave Millgate. Copyright © Dave Millgate.
Page 131: *ABC Warriors* stages by Kev Crossley. Copyright © 2012 Rebellion A/S. All rights reserved. www.2000ADonline.com.
Page 135: Martian Ape by Liam Sharp. Copyright © Liam Sharp.

Page 141: Werewolf stages by Manon. Copyright © Manon.

THE DEVIL IS IN THE DETAIL:
Page 145: *ABC Warriors* texturing by Kev Crossley. Copyright © 2012 Rebellion A/S. All rights reserved. www.2000ADonline.com.
Page 154T: The Chalice by Aly Fell. Copyright © Aly Fell.
Page 154B: Phrensy by Kev Crossley. Copyright © Malhavoc Press.

ART MASTERCLASS:
Page 160: Mermaid by Manon. Copyright © Manon.
Page 164: Judge Dredd panels by Lee Carter. Copyright © 2012 Rebellion A/S. All rights reserved. www.2000ADonline.com.

Thanks to

Fiona and Aidan: My muses, my reason to keep trying. Thanks for putting up with the late nights and also for putting up with the piles of drawings, books, comics, and art materials that litter almost every room in the house!!

Claire Howlett of *Imagine FX* magazine: Huge gratitude for the support over the years, and for allowing me to reproduce and amend many pieces of art originally commissioned by the magazine. The legend of the Carrot Landscape lives anew! ;) Thanks Claire!

Manon: Thanks for the art, friendship, support, cultural reciprocation, and endless positivity. (Still waiting for the Nutter Butter though . . .)

Dave Millgate: Cheers for a great painting, and the lessons it taught me, mate!

Rachel Robbins: For letting me use my art from her fabulous story, *SIDHE*.

Greg Staples: For support, advice, and for continually raising the bar.

Liam Sharp: For giving me my first break in comics, and for generously giving so much time, advice, support, and encouragement. (And that Mars Ape totally RAWKS dude!)

Matt Smith @ *2000 AD*: Many thanks to T.M.O. for allowing me to use his characters in the book!

Rodney Matthews: An old hero and lifelong inspiration, I asked for a painting for the book, he sent me two. Cheers Rodney!

Aly Fell: Animator extraordinaire turned painter exceptionalle!

Gary Tonge: The best "space" artist I know, and generous to boot!

Matt Dixon: A blistering artist not scared of a challenge! Here's to the next one Matt . . . how about an arachnid dragon girl?

Lee Carter and Karl Richardson: Two of *2000 AD*'s finest art Droids, I learned a lot from each during the making of this book!

Hal Mangold @ Green Ronin: For letting me reproduce my very first professional illustrations.

Monte Cook @ Malhavoc: For allowing me to reproduce more of my early professional work.